Alice's World

ALICE'S

WORLD

The Life and Photography of an American Original:
Alice Austen, 1866-1952

By ANN NOVOTNY

Preface by OLIVER JENSEN

THE CHATHAM PRESS OLD GREENWICH, CONNECTICUT

DESIGNED BY CHRISTOPHER HARRIS

Library of Congress Catalog Card No.: 76-18489
ISBN 0-85699-128-7
Printed in the United States of America

In memory of
ELIZABETH ALICE AUSTEN
and her friend
GERTRUDE AMELIA TATE

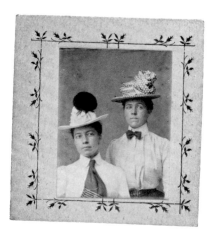

A mile up the shore from Alice's house, Mr. Pickard's studio on Water Street sold small one-cent-a-piece photographic portraits to the delight of local school children. On a warm summer day at the turn of the century, what whim impelled Alice and Gertrude to pose in Stapleton for one of "Pickard's Penny Photos"?

Contents

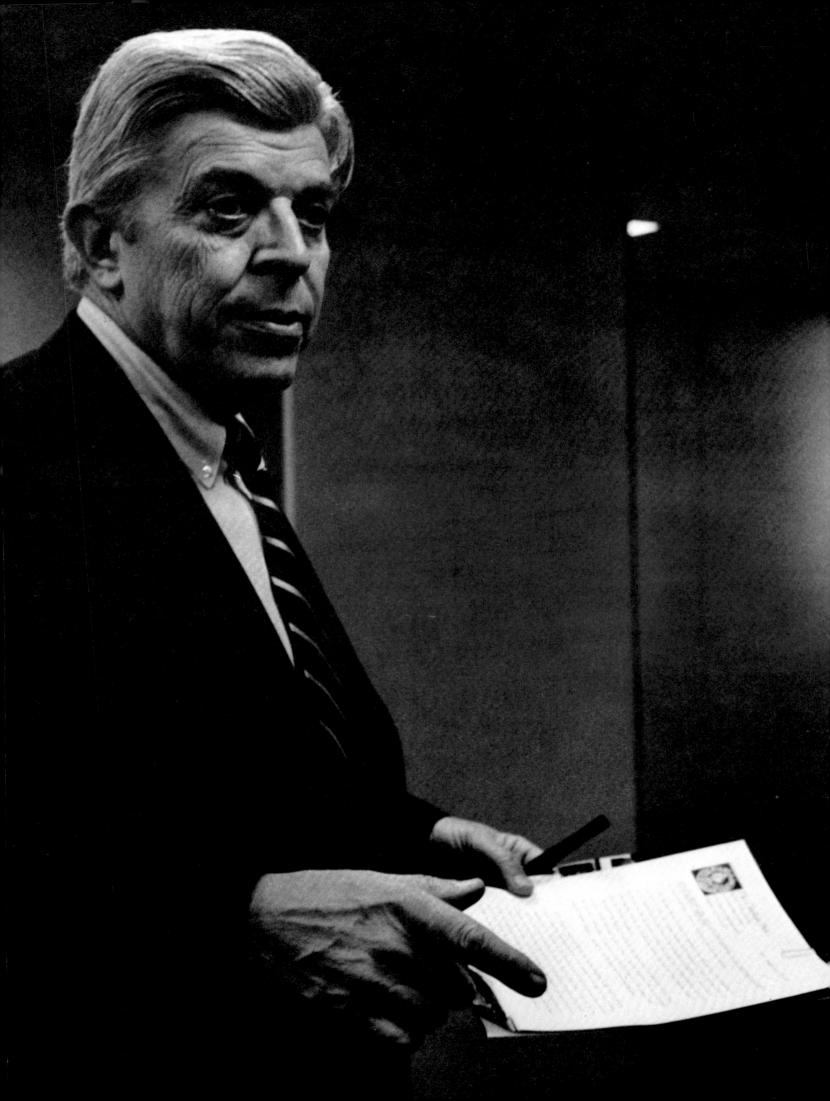

Preface

by OLIVER JENSEN

A century ago, when the camera was a curiosity and had only barely begun to record the world around us, pure chance placed one of these bulky affairs in the hands of a little girl on New York's Staten Island. As Alice Austen remembered it (some seventy-five years later), she was only ten or twelve when her uncle, a Danish sea captain married to her mother's sister Mary, brought a camera home from his travels. Naturally it caught her eye. Active, curious Alice was an only child and the center of attention; it was natural that the captain should show her how to use the new gadget, and leave it with her when he sailed away. It was 1876 or a little later. From that moment on, for the rest of her long life, Alice Austen was rarely without a camera. This book bears eloquent witness to the results.

Photography was an odd hobby for a young lady of that era, especially one from such a sheltered background. The Austens were a well-to-do family who lived, three genera-tions of them together, in a beautiful old house on Staten Island overlooking the Narrows, the approach to the Upper Bay of New York Harbor. Here all the ships of the world seemed to pass by in thrilling procession, carefully recorded by Alice. In the days of her youth, Staten Island was a resort of some style, frequented by Roosevelts and Vanderbilts; it was the first American home of tennis, for which the young photographer developed a great zest. Yet this was the day before light-weight cameras and "snap-shots," and it must have been strange to watch this otherwise proper young lady lugging about the elaborate cameras, tripods, and boxes full of heavy glass plates which repre-sented the state of the art in the 1880's and 1890's. Naturally there was a great deal of teasing and pretended shrinking from her lens, but she kept at it. Her friends let her

Oliver Jensen in the offices of the American Heritage Publishing Company, 1976. (Photo by Raimondo Borea)

arrange her tableaux, they held their serious or comic poses, they endured the long waits required in that era of photography.

What she was preserving on her plates, whether in Staten Island or across the bay in New York, or wherever her travels took her, was what is widely known today as "social history" (although no one in that era would have employed so pretentious a term for the daily life in her photographs). One can call all this carefully composed and superb work a hobby, but it seems in retrospect more like a career, even though it was not done for money. Yet it was very nearly a buried career. Like so many other photographic records of that era of horse-hair, plush and fringes, Alice Austen's plates, freighted with images of forgotten ways, were nearly lost to history. They might have been thrown on the scrap heap, or bought for the roof of some greenhouse (the emulsion scraped away to admit light), had it not been for last-minute intervention by friends at the Staten Island Historical Society. That moment came in 1945 when, down on her luck in the worst way, a penniless and confused Miss Austen was being evicted at seventy-nine from her lifelong but now shabby old home.

The tragic sequence of events which brought a half-numb old lady to this pass, Ann Novotny describes in this book. I myself knew nothing about Alice Austen or her buried career when, by chance, I stumbled briefly into the story early in 1951. At the time, I was writing an illustrated history, which was published the following year as *The Revolt of American Women*—almost twenty years too soon, I must add, for the really active stage which that movement has since reached. Helping me in searching out photographs was Miss Constance Foulk, whom I had known on the staff of *Life* magazine; she is now Mrs. Jean-Michel Robert. We had the notion that, to find old photographs which no one would have seen before, we should scout the smaller and lesser-known historical societies. In this pursuit we sent out a mailing to some fifty of them, stating our interest in the life of women long ago. One card came back from the Staten Island Historical Society in Richmondtown, signed by C. Coapes Brinley, who had already done some sorting. Miss Foulk went over to look, and soon called me in some excitement: in the basement of the Society's building there were uncounted thousands of glass plates of just what we wanted.

Soon the two of us were down in that ill-lit and rather dank cellar, holding negatives up to the light and picking out a selection for the book. Although a few were cracked and peeling, each negative had its brown jacket, captioned and dated, with plate, lens and exposure neatly recorded. Unfortunately the captions, if sufficient for Miss Austen's purposes of identification, told far too little for historians or journalists. Here and there were brown original prints and great stacks of film negatives from a later period, a great deal of the latter hopelessly stuck together. It was clearly a treasure trove but so vast that I could only sample many of the boxes. We had, however, sufficient for our purposes. I had some fine prints made in Manhattan and then made an arrangement to go to one of the Staten Island Historical Society's occasional meetings, to see whether anyone there could give me a little more information about the people and places in the pictures of this (as I supposed) long-dead photographer.

At the meeting, while I was engaged in that effort without very much success, one

of the older ladies wondered aloud what was keeping me from asking Miss Austen herself. And thus I learned to my surprise that she was alive, very old and crippled, in the poorhouse—or (since harsh terminology distresses modern America) the Staten Island Farm Colony. And so, with the new prints and the old information on the jackets, I headed for that woebegone institution, a cluster of brick buildings looking rather like a boarding school. Inquiry took me to a ward on the second floor. There, in the last of a long row of beds, Miss Austen, once so stylish and lively but now eighty-five and withdrawn, lay silently. The room was noisy with the disjointed chatter of the old and generally feebleminded inmates. Over each iron bed hung an electric wire from the ceiling with a naked light bulb at its end. Flies buzzed around the wires and two table radios competed for attention.

I found it difficult, for some minutes, to open any kind of conversation with the old lady, although she was not asleep. Could I have the wrong person, I wondered? Could this be another Miss Austen? Nor did I succeed in getting her attention until I thought of passing a few of my prints, which were fortunately big 11 x 14-inch enlargements, rather rudely in front of her nose. Then she stared at them, sat up, fished some glasses off her table, and studied the pictures intently. Why! she said, this was Trude Eccleston, and someone's bedroom; here was her house, and the tennis courts at the Cricket Club. How hard it had been to get them all to hold still! She acted, as the very old sometimes will, as though I knew all the people and what she was talking about, and she showed almost no curiosity about who I might be.

For a time I accepted these ground rules and resigned myself to asking questions; at least I had the right Miss Austen. After a while, as her spirits rose in looking at the old familiar scenes, she roused herself, and wondered what I was doing there with these strange prints from her negatives. But I was only part of the way into my story, which seemed to confuse her, when the attendant came and said I must leave, since something or other was now scheduled for Miss Austen. And she began heaving the old lady into her wheelchair. Would I come back, Miss Austen pleaded? Indeed I would, and did.

Walking out of that bare, unhappy room as fast as I could, looking away from the beckoning fingers of several of the ancient crones, trying not to hear the meaningless monologues they conducted, smelling the disinfectant and longing for fresh air, I was full of the normal embarrassment of youth and health in the presence of age and sickness. The Farm Colony was kind enough in its dreary way, I reflected, perhaps not too bad if one had never known much better. But what a fate it must have been for one so gently reared, as they used to say, as Alice Austen! What an ending for one who, as her photographs attested, had spent most of her life in comfortable circumstances; indeed for one whose forgotten photographs, if they could be brought to light, could very well bring her considerable fame. *And*, it suddenly struck me, fortune—or at least better fortune than this. It made me feel better, I must confess, when I realized that I could just possibly do something about it.

From the good people at the Staten Island Historical Society, including Mr. Brinley, Mr. Loring McMillen (who had spirited boxes of plates away from Miss Austen's house before they might have fallen into unappreciative hands) and, above all,

from Miss Austen's long-time friend, Miss Gertrude Tate, I pieced together the story of how Miss Austen had been wiped out financially in the crash of 1929, of how she had struggled through the nineteen-thirties and early 'forties selling off furniture, running a tearoom with Miss Tate, of how in the end she lost her house and how, the year before I met her, she took a pauper's oath to live on the charity of the city.

The next stop for Constance Foulk and myself was the Historical Society's basement for more afternoons among the plates, selecting several hundred negatives which might make magazine articles about Miss Austen's life, her times, and her travels. Our book was delayed a little as we dragged the boxes of plates to Manhattan, made prints and returned the boxes to the Society. I would stop by the Farm Colony and go over the captions with Miss Austen. I hardly dared tell her what my scheme was, and I did not know whether it would produce the needed funds. But the Society's officers agreed to my plan (they were now the legal owners of the collection). Such was the wealth of material that I was able to sell totally different selections to *Life*, to *Holiday*, to *Pageant*, and several other publications, until there were some five thousand dollars on hand, part of which was used to move Miss Austen into a private nursing home. She was, of course, too ill to live without care. Even though it took a month or more to attend to the formalities of her release (which required the help of Miss Tate and a young lawyer who made the arrangements), Miss Austen's spirits went only up. We were able to take her out to restaurants and for drives around Staten Island where, despite an occasionally failing memory, she liked to point out places where she had taken this or that photograph. One had to agree with her that most of the changes in the landscape had not been improvements; we visited her house, by then badly run down, and she had her picture taken there (and at the Farm Colony) by the noted *Life* photographer, Alfred Eisenstaedt. The Farm Colony scene, with Miss Austen looking forlorn and frail in her wheelchair, made a somber end to the story in that magazine.

Except for the few pictures she took for a friend's book on bicycling for ladies in the 1890's, Miss Austen had never, I believe, had a photograph professionally published, nor had she wished to. But with the *Life* and other stories, her pictures were suddenly being published everywhere as 1951 rolled on. Indeed, in the 25 years since, they have become relatively well known. At the Historical Society her glass plates came out of the basement, and on October 7, 1951, a great exhibition of our big prints (plus a few of her surviving originals) was mounted there. It opened as "Alice Austen Day" and was covered extensively by newspapers and magazines. Even though she was worn down a little by all the excitement, the speeches, the crowd, the reporters' cameras, and the attentions of old friends, Miss Austen was jaunty in a new hat and enjoyed herself hugely. She was glad, she told me, that I had found her pictures, and she wiped away another of that day's many tears. Then she roused herself and told a busy young man with a camera, "If I were a hundred years younger, I'd be taking these pictures." The old, self-confident Alice was coming back to life. Then there was another toast, and Miss Austen remarked to the guests how glad she was that the hobby which had once brought her so much pleasure now seemed to please so many others. I forget now much of what happened, and what was said, and the comparisons with Mathew Brady and

other great photographers and the rest, but I do vividly remember thinking that this was a happy ending such as one normally finds only in the fiction of Dickens.

The happy ending came, of course, in the nick of time. Life had worn the old lady down. In the beginning of the next year she suffered a mild stroke, rallied to enjoy her new fame for a few more months, then died on June 9, 1952, while sitting in her chair on the porch. But her pictures, breathing her own special kind of life into a vanished world, will never die.

Old Saybrook, Conn., 1976

Oliver Jensen visits 85-year-old Alice Austen at the poor house, the Staten Island Farm Colony, in the early summer of 1951. (Photo by Alfred Eisenstaedt, Time-Life Picture Agency, © Time Inc.)

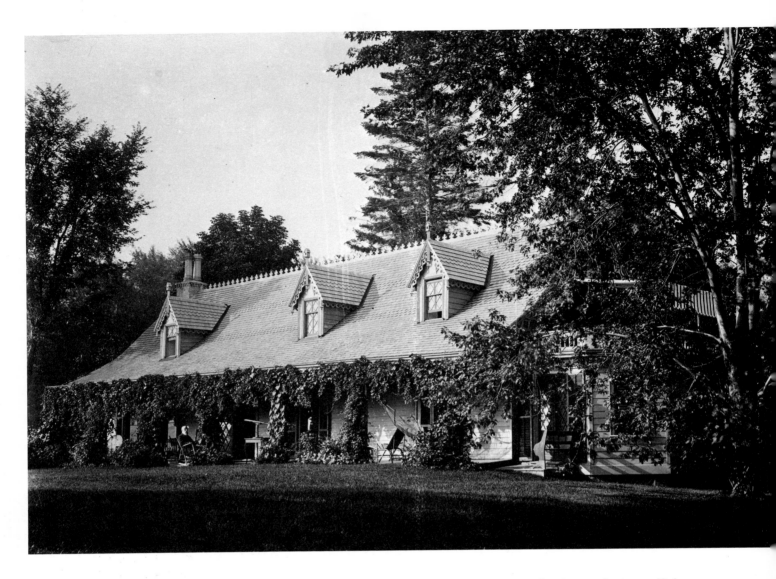

"Clear Comfort" in the 1880's. The photographer's grandfather, John Haggerty Austen, rocks on the porch near his telescope.

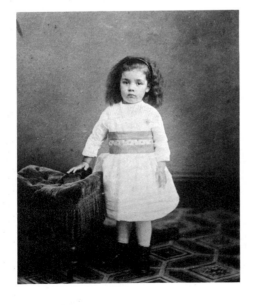

Alice Austen Munn, aged three, when she and her mother moved to "Clear Comfort." Some twenty years later, Alice pinned this studio portrait to their coach-house wall, and copied it with her own camera.

CHAPTER ONE:

Alice, Her Family and Friends

The white cottage still stands at the water's edge. Transatlantic ships, Alice Austen's favorite photographic subject, still steam past the small garden that slopes down to the Narrows, the entrance to New York City's busy harbor. The view from the Austen garden, a panorama sweeping from Brooklyn to Manhattan's skyscrapers ten miles away, is as spectacular as ever. But the business of the waterfront has changed the old Staten Island neighborhood of Clifton, and a large sign at the nearest intersection of what was once Pennsylvania Avenue (now renamed Hylan Boulevard) directs today's driver only to a commercial destination: "Piers 19 to 25." The water off the stony beach is too polluted for swimming, now. Alice Austen's once-prized flower beds and the gravel driveways around her cottage have vanished into unkempt lawn and wild shrubbery, and the spectacularly beautiful Japanese wisteria and Dutchman's Pipe vines that used to climb to the roof have been uprooted, by municipal order, to preserve the weathered gingerbread woodwork and crumbling masonry of this acknowledged landmark from further destruction.

The garden well, with the hand pump at which Alice spent so many hours washing her photographic prints and glass negatives in icy water, has long since been filled in. And her tiny darkroom, with deep shelves and remnants of Victorian linoleum, is now a storage closet on the upper floor, which is left vacant by the present tenants comfortably accomodated in the ground-floor rooms (Alice's grandparents, her aunt and uncles, friends and servants have all gone, too, and what family today needs all that space?).

Trees and shrubs screen the unwelcome sight of commercial wharves to the north. Waves slap gently against the rocky beach and against cement breakwaters constructed

15

to halt the erosion that has already shortened the garden since Alice's youth. When the sounds of distant traffic fade at dusk, and sea mists roll in from the Atlantic to dim the lights on the Verrazano-Narrows Bridge and of high-rise apartments across the water in Brooklyn, a visitor standing in the darkened garden can be carried back, with remarkably little effort of imagination, to the time one hundred years ago when Alice Austen was a child in the Victorian cottage her grandmother proudly named "Clear Comfort."

Alice was born on March 17, 1866, in the area of Clifton known today as Rosebank, in northeastern Staten Island. She was not born in her grandparents' house, but in "Woodbine Cottage", about a quarter of a mile away. "Woodbine Cottage", however, turned out to be a very temporary home for the child whose legal name was Elizabeth Alice Munn. Just before or just after the time of Alice's birth, her father, an Englishman named Edward Stopford Munn, deserted her mother. Church records show that little Alice's mother, Miss Alice Cornell Austen, married Mr. Munn in the local Episcopalian church of St. John's on June 1, 1863. Reading between the lines of entries there and in the family Bible, one might suspect that Miss Alice, the older of the two Austen daughters, had been understandably jealous when her vivacious younger sister Mary, twenty-two years old, upstaged her by marrying Samuel Hicks of Manhattan in the same church the previous October. Gossips may have whispered that twenty-six-year-old Alice Cornell Austen looked as if she were well on the road to becoming an old maid. Whatever the reasons, Alice made an unfortunate choice when she married the Englishman about whom nothing is known for certain (one rumor says he was an alcoholic) except that he came from London and that he proved to be a bad husband. The newly-married Munns presumably rented "Woodbine Cottage" in order to be near the bride's family. The marriage deteriorated rapidly. At some point between the summer of 1865 and young Alice's birth in the spring of 1866, Edward Munn vanished.

The most reliable story about his disappearance is that he sailed for England, telling his wife that he would send for her as soon as he established a home in London, and that he failed to keep his word. He probably never saw his daughter. When little Elizabeth Alice Munn was christened in St. John's Church on May 23, 1866, her father's name was not recorded: only her mother's name, given simply as "Alice," appears in the space for Parents' Names in the church register. Mr. Munn, from that time on, was an unmentionable subject in the Austen family.

The deserted Mrs. Munn, nearly thirty years old, with a small baby but no means of support, made the only possible move: she left "Woodbine Cottage" and returned to her parents' home nearby. She must have realized, somehow, that her husband had deserted her, and that he had not simply been lost at sea or been the victim of some disease or accident before he could send for her. She abandoned the surname of Munn (informally rather than legally), and her bitterness toward her former husband communicated itself to her daughter. Small playmates in the neighborhood of "Clear Comfort" discovered that one sure way to enrage the little girl known as Alice Austen was by calling her "Alice Munn." As the years passed and she grew up, Miss E. Alice Austen remained so resolutely silent on the topic of her father that many Staten Islanders came to assume that she had been an illegitimate child.

As a little girl in her grandparents' home in the 1860's and 1870's, Alice was the center of attention, the only child in a household that came to contain six adult residents, many visitors and servant girls. Apart from her mother, the two people who devoted the most time to her were her grandparents, Elizabeth Alice Townsend Austen (after whom she had been named) and John Haggerty Austen, both then in their fifties. An adored figure in Alice's life was their youngest surviving child, only thirteen and a half years older than Alice herself—her young Uncle Peter, who assumed for her the combined roles of older brother and substitute father. When Alice had just passed her fifth birthday, and Peter was still only eighteen, the household was joined by her widowed Aunt Mary with her second husband, the Danish sea captain Oswald Müller, both in their early thirties.

For these six members of the Austen household—all of them trying their best to compensate for the painful absence of the child's father—Alice was the focus of fun and love. They called her "Lala" or "Loll" (probably derived from childish efforts to pronounce her first given name, Elizabeth), and also nicknamed her "The Brat," no doubt with reason. They played games with her, humored her fits of temper, bought her books of stories and puzzles, encouraged her natural abilities at sports and mechanical skills, and helped to form the unusual woman Alice became.

The adult Austens themselves formed an unusually talented family. They sent young Alice off to the fashionable Miss Errington's School for Young Ladies until she was sixteen or seventeen (at which time the school stopped operating). But she probably learned much more about world geography and history from her well-traveled grandfather and Uncle Oswald, more about science from Uncle Peter, the chemist, about art and literature from her mother, good manners from Grandma, and music from Grandfather and Aunt Mary (who played the flute and piano), than she ever gleaned from the "two old English women" she remembered as trying to instruct her at school.

It was her Danish Uncle Oswald, bringing home a camera in 1876, who changed the very nature of Alice's life. His camera (long since lost, and its make forgotten) was a bulky wooden box, and it enchanted Alice. She watched, intelligent and patient, as Oswald Müller experimented with the new gadget and demonstrated it to the family in the garden. Although she was only ten years old, Alice was strong enough to hold the camera steadily on its tripod and her hands were naturally skillful at adjusting the simple mechanism. When Captain Müller's ship sailed again, he gave her permission to play with it in his absence. She received further help and encouragement from her Uncle Peter, who may have realized that in Alice's hands the camera was something more than a toy. Peter was a good amateur photographer himself. In his mid-twenties in 1876, he was a chemistry instructor at Dartmouth College, and just about to begin a teaching career of many years as professor of chemistry at Rutgers. During his frequent visits home to "Clear Comfort," he showed his enthusiastic young niece how to use chemicals to develop the negative images on the dry glass plates she exposed. He and Oswald may well have helped her further by building the home-made darkroom at the top of the stairs. But Alice, reminiscing 75 years later, staunchly insisted that, except for the very first demonstrations, she was self-taught and simply "learned by doing."

The first camera she called her own she received when in her 'teens, as a present from a male cousin (almost certainly her Great-uncle James' son, Lewis H. Austen, an attractive young Staten Islander who escorted Alice to at least one ball). This camera (also now lost) seems to have held four-by-five-inch plates, and to have been manufactured by the Scovill Company (which later introduced the Waterbury models she particularly favored).

By the time she was eighteen (the earliest year from which any of her photographs survive), Alice Austen was an experienced photographer with professional standards. Her family, luckily, had enough money to indulge her in the best of the cumbersome equipment she required. The subjects on which her camera was most often focused in these early years were the people and places closest to her—particularly her aunt and uncles, her grandparents, and their house as seen from every possible angle of driveway, garden and water's edge. Because her family and her home were so important to her, photographically as well as emotionally, information about them will add to the interest of the pictures on the following pages.

Of all the members of a loving, fun-filled and occasionally boisterous household, Alice's mother is the one whose personality is most difficult to assess, from either the few surviving photographs of her or from her daughter's own reminiscences in old age. Alice Cornell Austen may very well have been a retiring person by nature. She enjoyed sketching and making watercolors, which were good enough to frame and hang in the house. She loved to read, and many of the books she collected were first editions. She read French as easily as English. And that is almost all that is known about her. She was the first-born child, almost inevitably jealous of her younger sister Mary (born when she was two and a half) and of Peter, her parents' longed-for son and heir, born (after two other boys died in infancy) when she was fifteen. In none of the photos do her eyes shine with the merry twinkle of Mary's, and she must have found it impossible to forget that Mary had married twice, successfully and happily, while her own former husband was a disgrace and an object of derision. Her own travels to Europe—once with her daughter in 1892—must have seemed tame compared to the exciting sea voyages her sister made to the Orient. She died too long ago to be remembered by any of the living relatives and friends for whom the figure of her younger sister stands out clearly among childhood memories. It is pure speculation to suggest that she and her daughter did not always get along very well or to think that she may have withdrawn into a shell of bitterness—or, perhaps, of illness. One fact is that she died in 1900 when she was only sixty-three, considerably less long-lived than either of her parents or her sister.

Her sister, Alice's Aunt Mary, known to the family as Minn or Minnie, was a fun-loving and funny woman. She had an impish expression on her face as she cheerfully posed for Alice's camera, with an oriental dagger stuck in her belt, holding a Japanese parasol, or wearing a nautical straw hat emblazoned with the name of Müller's ship. Her first husband had lived for only eight years after their marriage in 1862; Mary's own Bible records the death of Samuel Hicks while traveling with his wife, on a journey they made together, "at sea off Batavia of consumption July 5th 1870." But Hicks' last voyage, presumably undertaken for his health, was only the first of many that

Twenty-two-year-old Miss E. Alice Austen poses in her Sunday best—a smart overskirt, and a hat decorated with white lilacs. She holds a parasol and a silver change purse. Photo taken in June 1888 by Captain Oswald Müller.

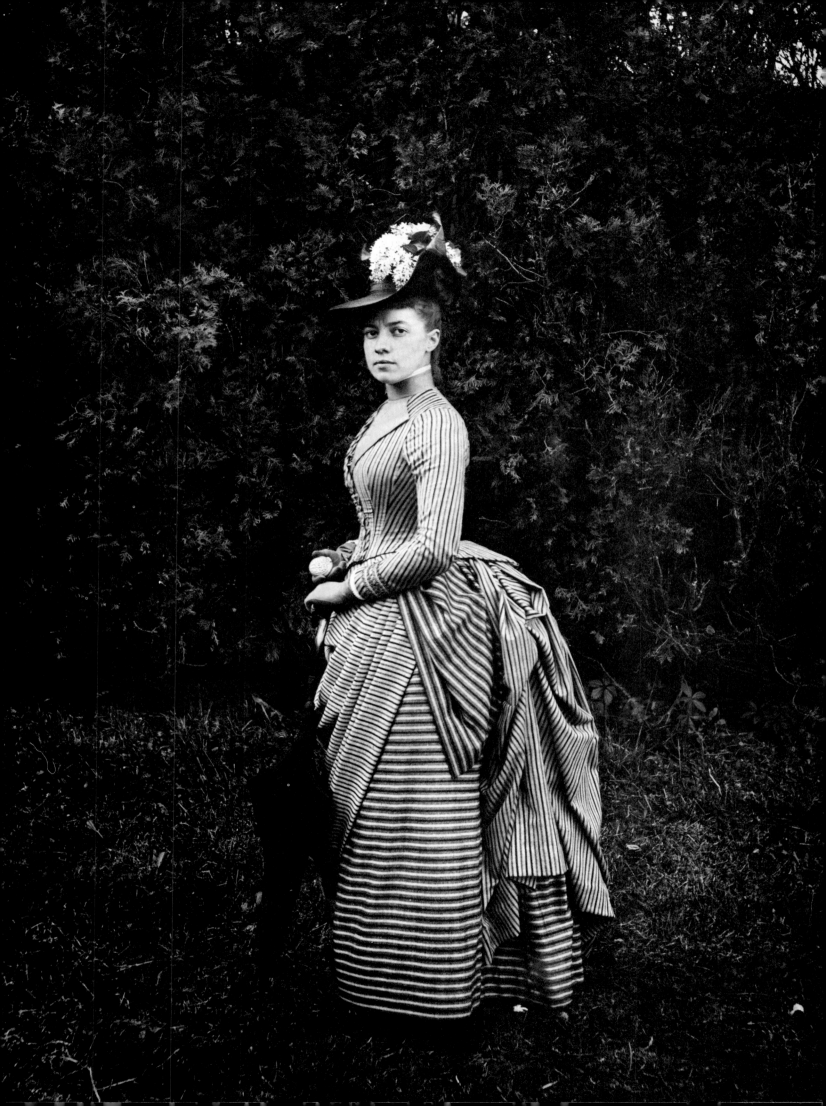

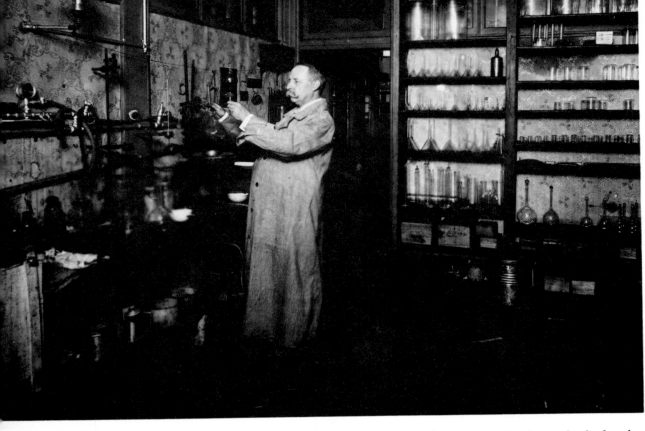

Dr. Peter Townsend Austen, the young uncle who taught Alice how to develop her glass negatives, working in his chemistry laboratory at the turn of the century. (Courtesy of Elizabeth Patty Austen Miller)

Eighteen-year-old Alice, holding the pneumatic cable to release her camera's shutter by remote control, makes a portrait of herself, her dog Punch, Auntie Minn and Minn's husband, Oswald. 1884.

Oswald Müller on the lawn at "Clear Comfort," photographing the sailing ships in the Narrows. (Courtesy of Elizabeth Patty Austen Miller)

The photographer's mother, Alice Cornell Austen Munn, in the garden at "Clear Comfort," twenty years after being abandoned by her English husband. The black cat was named Tristan because her daughter enjoyed the American première of Wagner's opera. (*Mamma & cat. September 6, 1887*)

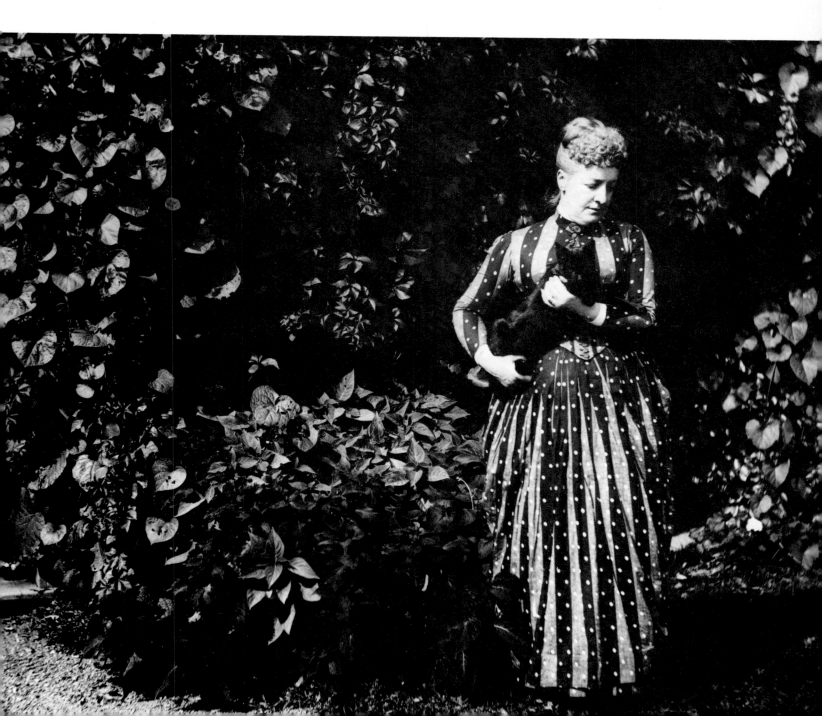

Mary was to make to this part of the world, sailing as far east as China and to the Japanese ports opened by Perry in the 1850's. The thirty-one-year-old captain of the ship on which Hicks died, Otto Oswald Müller from Copenhagen, cast a sympathetic and perhaps an admiring eye on the American widow who was only a year and a half his junior. In any event, gossip soon spread around the ship: that the lady from New York had two husbands on board, the old one in his coffin in the hold, and the new one in the captain's cabin. Before long this rumor came true. On March 30, 1871, Minn and Oswald Müller were married in the Austens' house by the Reverend John C. Eccleston from St. John's Church. Alice, aged five, was no doubt a flower girl and a central participant in the proceedings.

Oswald Müller, a lean, energetic man with unexpected humor in the eyes of a somewhat stern Scandinavian face, was warmly accepted into the Austen family and home. "His courtly, old-time manner" was described by one of his Staten Island acquaintances, years later. And his father had indeed been a kind of courtier, an Etatsraad or Counsellor of State in Denmark, a Knight of the orders of Guelph and of Danebrog, moreover decorated with the Silver Cross. Captain Müller had been a master of British merchantmen, and his ships had been caught up in naval skirmishes in the Crimean War and the American Civil War. In the United States, he served as captain of the clipper ship *Samar* for R. W. Cameron & Company.

The captain's arrival at Clifton caused a certain amount of excitement in the neighborhood, and it added the presence of a firm, mature man to the Austen household (Alice's grandfather was sixty years old, and her Uncle Peter was only eighteen, when Oswald married Minn). His presence gradually altered the physical appearance of "Clear Comfort," as he and Minn returned from voyages to the Orient bearing teakwood furniture, prints, and porcelain vases of all sizes to adorn the parlor and even (interspersed with Japanese stone lanterns and metal urns) the northern slope of the lawn. When they were not at sea, the Müllers occupied rooms at the northern end of the upper floor, with their own exterior staircase leading up to the glassed-in porch they called "the quarter-deck." They scandalized some neighbors, and amused others, by hanging, at the foot of this staircase, a large ship's bell with the instruction, "Ring the Bell and Ring Like Hell!" They decorated their bedroom and porch with a preposterous clutter of oriental fans, vases and teapots, face masks and nautical knicknacks, tusks and seashells, corals and sponges, landscape prints and a picture of Minn at the ship's wheel. The most memorable decorations, in their bathroom, were almost two hundred little ceramic objects—miniature chamber pots, miniscule outhouses, and figures of children and animals of every possible description squatting on an equivalent array of pots. The collection, covering the walls on specially installed shelves, was punningly named The Potter Family in honor of one of Minn's dear friends, the Episcopalian Bishop Potter of New York. The fact that Uncle Oswald secreted "naughty" literature in their rooms is recalled to this day by Alice's Cousin Patty, Uncle Peter's only daughter. It may have been their irreverent sense of humor, as much as their serious admiration for the East, that prompted Oswald and Minn many years later to have their graves in the conservative Moravian Cemetery marked with oriental sculptures.

Self-portrait of 26-year-old Alice, posing on the porch in her favorite yellow dress with red trim. (*E.A.A., full length, with fan. Fine day, in shade on piazza. Monday, Sept. 19th, 1892. Seed 23, Perken lense, 32 Stop, 3 secs.*)

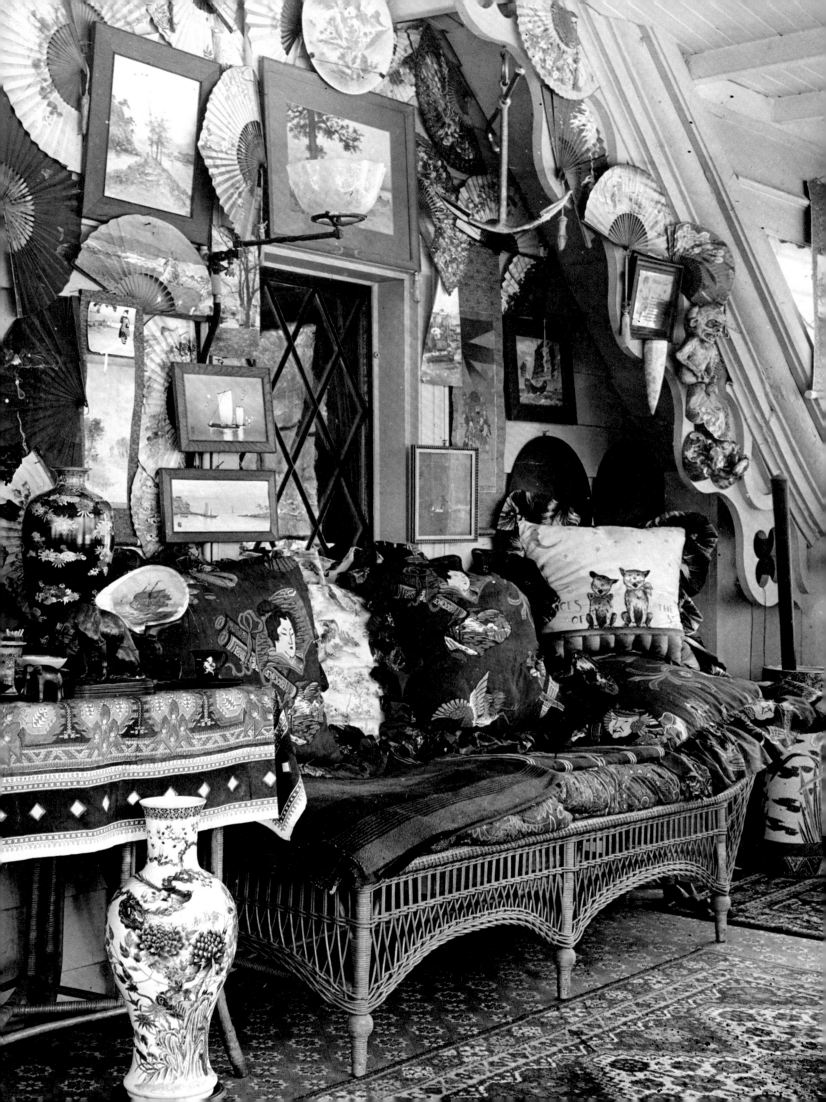

OPPOSITE: The sun porch (or "quarter deck") of the upstairs apartment, which the Müllers occupied for more than forty years and crammed with oriental souvenirs. (*Auntie's roof. Sofa and tea table. March 6, 1911*)

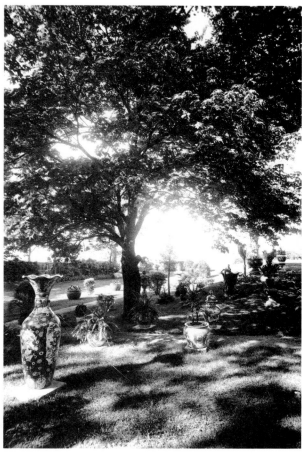

The lawn at the north end of the Austens' cottage, with the Narrows in the distance, is covered with vases and urns the Müllers brought home from their voyages to the Orient.

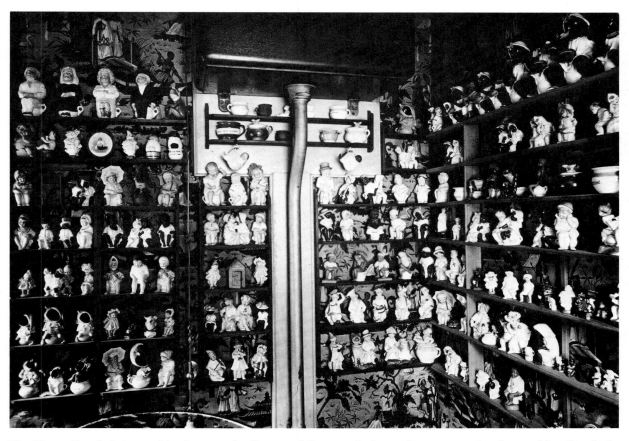

The "Potter Family," Auntie Minn's unusual collection of Victorian bathroom humor, named in honor of her friend, the Episcopalian Bishop. (Courtesy of Elizabeth Patty Austen Miller)

Whenever Captain Müller went to sea, his wife seems to have accompanied him. In May 1872, just a year after their marriage, Minn tore a page from the ship's ledger to write this greeting to her twenty-year-old brother Peter (whom she nicknamed Tim). The silly poem reveals as much about affection in the Austen family as it does about Minn herself.

Open this paper, and you will find therein
A Chinese coin, from your sister Minn,
Picked up in the City of 'Canton,'
And sent to you, your chain to hang on.
Hoping soon to see your Mustached Mug,
And inflict upon you, a tremendous hug,
I now must draw this to a close.
We are 'hove to' because it blows.
With love to Pa, Ma, Alice & Brat,
But, I must include yourself in that.
And now dear Tim, keep a good look out for Me
And I will keep my eye skinned for Thee.
Your sister Mrs. Oswald Müller,
Great on the pen, but poor at the tiller.

More than eleven years later, in her mid-forties, Minn was still sailing around the world with Oswald. The hardships of those voyages come to light in another of her notes scrawled to "Dearest old Pete" in some haste: ". . . We did not expect to heave to here, but as we have not tasted vegetables for 89 *days*, it is better to get a few potatoes. I hope to be with you all early in December. . . . Abreast of St. Helena, Oct. 22nd, 1883."

The years at sea extracted their toll from Minn, and by the time she posed as a subject for her niece Alice's camera she was completely bald, wearing an elegantly curled wig that she stored at night on a stand in her bedroom. Oswald, promoted after fifty years at sea to the post of Port Superintendent at New York for the U.S. & Australasian Steamship Company, died at seventy-three in 1912. Minn lived on in their upstairs apartment for another six years, reading and knitting on the "quarter-deck," occasionally playing the piano downstairs. She would peer through the telescope on the porch at ships steaming through the Narrows, remembering an amazing number of them from her own visits aboard in foreign ports, and naming their captains to her niece, with whom she now shared the house alone. When the weather was bad, she burned a signal light in her window through the night. Seamen sailing into and out of the harbor affectionately called it "the Widow's Light." Minn's warm, cheerful presence in the household had great influence on Alice in her formative years, an influence that could be seen particularly in Alice's affectionate nature and sense of fun. In a way, Minn took the place of Alice's mother after the latter's death in 1900 (when Alice was thirty-four). She

lived until 1918, the last of the Austens—except Alice herself—to leave the home they all loved so much.

"Clear Comfort" was owned and inhabited by Austens for just over a century. It was bought in 1844 by Alice's grandfather, John Haggerty Austen, then a prosperous businessman aged thirty-three. During the first few years of owning the house, he and his family used it simply as a vacation cottage. These were years when many city-dwellers from Manhattan crossed the bay in summertime to enjoy Staten Island's hotels, bathing beaches and rural scenery. John Austen's younger sister, Sarah, her husband William Hawkshurst Townsend, and their three small children were among a steady stream of family visitors to the new cottage when a new member abruptly joined the clan: the Townsends' last daughter, Grace, unexpectedly came into the world on August 30, 1846—in the lighthouse at Fort Wadsworth, just over a mile down the shore from "Clear Comfort."

The time came, around 1850, when the Austens decided to move permanently across the harbor to the cottage they had enlarged and made comfortable during half a dozen summers. In this decision they joined substantial numbers of former Manhattanites who were attracted by Staten Island's fresh environment, and by the new and increasingly prosperous society establishing itself there. Sarah and William Townsend joined the exodus from the city to Staten Island in the early 1850's, establishing themselves and their four children in a residence they called "Hawkshurst," a family name. John Austen's youngest brother, James, also moved his family to the island. The Austens and Townsends were fond of one another and spent much time in each other's company—due to the curious fact that three Austen siblings (John and his younger sisters Sarah and Mary) had married three Townsends of the same generation (Elizabeth and her older brothers William and Isaac, respectively).

For John and Elizabeth Austen, the decision to move from their residence on Union Place, in the increasingly congested and unhealthy city, may have been peculiarly poignant. They had two daughters, thirteen-year-old Alice Cornell and ten-year-old Mary (Minn), alive and well in 1850. But their first son, John David, born in November 1843, had been buried in Trinity Cemetery just after his fourth birthday, dead from a disease of the lungs and throat. A second son, John Herbert, born on Christmas Eve of 1848, baptized in the newly completed Grace Church on lower Broadway, also died in the city from bronchitis, in March, 1850. He was little more than a year old when he was buried beside his brother. To the mourning parents, both nearing forty, the cottage on Staten Island must have looked like an increasingly attractive refuge from city-bred illnesses that killed small children.

The Austens' property had once been part of a 114-acre farm, previously owned by the Barton family; half of its acreage had been in orchards and woods, the other half cleared and cultivated. The whole farm had changed hands for a mere $3,500 in the early years of the nineteenth century, when the first small groups of prosperous off-Island visitors were just beginning to arrive. By 1835, the price had risen to $10,000 when the place was bought by Daniel Low, a prominent Staten Islander. A speculator

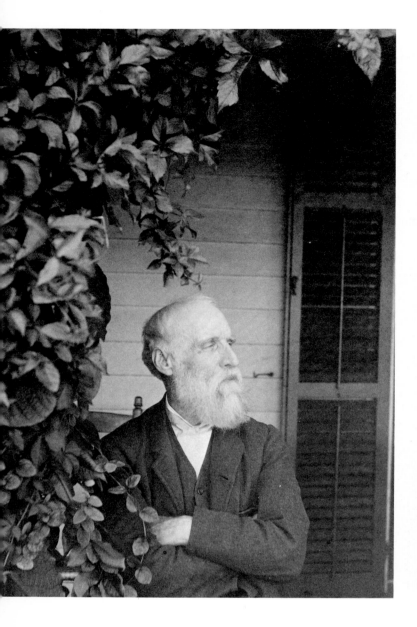

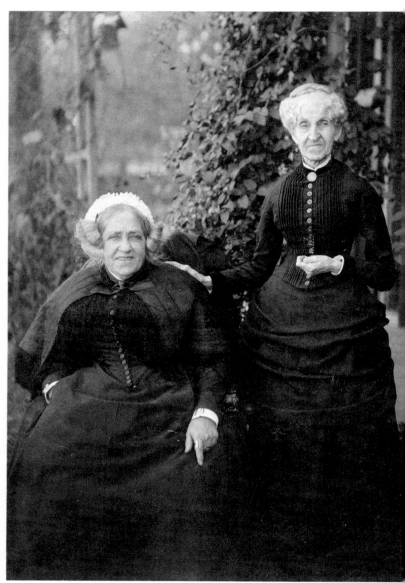

LEFT: John Haggerty Austen, Alice's grandfather, rests on the porch at "Clear Comfort," the farmhouse he bought in 1844 and remodeled into a Victorian Gothic cottage.

RIGHT: The photographer's grandmother, Elizabeth Alice Townsend Austen (left), with her friend Miss Eliza Ann Binns (standing). Being a Quaker, grandma wore plain clothes and little jewelry except for a mourning ring, inscribed with the initials of her two dead sons.

with a sure eye for a profitable trend, Low formed a real-estate development company called the Staten Island Association, and he engulfed the old farm as part of an 828-acre tract near the Narrows. Roads were laid out. The land was subdivided and sold, and on October 10, 1844, John Austen purchased the old farmhouse and half an acre of land for $2,500. He later added adjoining plots until his new home, bounded on the east by the waters of the Narrows, was surrounded by about one acre of Austen land.

The simple old farmhouse bought by the Austens in 1844 had been undergoing structural additions and changes for almost 150 years when they set about transforming it into a Victorian T-shaped cottage of some elegance. The oldest part of the house, now the central section behind the three-inch-thick Dutch door facing the water, was originally a low one-room frame dwelling. The best guess is that it was built between 1691 and 1710, but it may possibly date back as far as 1669 (as Alice Austen always insisted it did). A southern extension, which became the Austens' parlor, was added some time before 1730. The occupant at that time is described in several sources as being a Dutch merchant-farmer, and he may have been the person who imported from Amsterdam the blue-and-white Delft tiles (decorated with Biblical scenes) that once framed the parlor's large fireplace. The tiles were removed by Alice Austen herself in 1944, but visitors to the house can still admire the massive oak beams spanning the width of the house, as well as the floors made of deal boards reputed to have been stripped from the cabins of captured ships.

Some time before the Revolution, a stone section was added to the rear of the house, turning the building into an L-shaped structure (with the corner of the L pointing towards the northeast). This stone wing houses the kitchen, with deep window seats in the three-foot-thick walls, and the dining room that connects it to the oldest, central part of the wooden house. A clapboard laundry room was for many years attached to the western extremity of the stone wing (it was destroyed by the hurricane of 1944). By the early nineteenth century, this long, low-built structure was the main building on the farm, which also had a number of out buidings and at least one smaller house built almost on the beach.

When the farmhouse was purchased by the Austens, it was already old enough to have historical anecdotes and legends attached to it. During the American Revolution, it was said, the house sheltered patriots as well as British and Hessian officers, in succession. Because of its strategic position as a command post overlooking the Narrows, and proximity to a good landing place on the shore, the house is likely to have been the scene of some fighting: several shots that apparently missed the building were recovered from the grounds in the nineteenth century. But there is no factual basis at all to legends that the house served as temporary headquarters for General William Howe (who settled himself in the "Rose and Crown" tavern on the Richmond Road in New Dorp), or that Benjamin Franklin came there to confer with him (Franklin, in 1776, dicussed peace terms with the general's brother, Lord Howe, Admiral of the Fleet, in the Billopp or Conference House at the Island's southern tip). It is equally unlikely that the house was ever visited by General Washington (who did make a quick inspection trip of the Island in the spring of 1776) or by General Lafayette (who apparently never set foot there until

years after the Revolution was over). Sir Henry Clinton and Baron Wilhelm von Knyphausen are sometimes included in the doubtful list of visitors on the British side.

A ghost from Revolutionary times is another alleged presence in the house—a presence in which Alice Austen herself apparently believed (although she vigorously denied it to nervous waitresses in her tearoom), as did at least one psychic visitor in the 1930's. The ghost is a lovelorn British soldier, spurned, of course, by a patriotic maid, and his clanking spurs and heavy boots have been heard on the staircase ever since the night he hanged himself from a hook on one of the oak beams downstairs.

The most famous Staten Islander of them all, Cornelius Vanderbilt, has a real connection to the Austen house. At nineteen, he was a ferryman and entrepreneur, proud owner of his own two-masted gaff-rigged boat; he carried farm produce and passengers (human or animal) to and from a point on the eastern shore (in the village of Stapleton) that became known as Vanderbilt's Landing, about a mile up the shore from the house. He was already known as the most skillful boatman on the Island when, in 1812, he used to walk down to the farmhouse to court Sally Lake, daughter of the current occupant. Mr. Lake cast a skeptical eye over the muscular youth, descendant of Dutch boatmen and farmers. He pronounced that young Vanderbilt would never be good enough for his Sally. His verdict held, even when "Corneel" produced a diamond ring, and scratched her name and his initials with it on a small window pane—largely to prove that the stone was hard enough to be genuine. Did Mr. Lake live long enough to watch ruefully as Cornelius Vanderbilt, shipping and railroad magnate, amassed the largest fortune in America?

Years after his unsuccessful courtship, the old "Commodore" (who lived until 1877, aged 83) chuckled as he told this story to Alice Austen's grandfather John, who was himself, in large part, a self-made man. The two men encountered each other occasionally, but were not close friends. The Vanderbilts and other prosperous Dutch- and French-named Staten Islanders, who could trace their families back through five or six generations on the Island, were on cordial terms with the more prominent of the new residents from Manhattan, but never really accepted them as social peers. John Haggerty Austen and Elizabeth Townsend Austen, however, held their heads as high as anyone and had sufficient reason to be proud of their own families.

When Alice Austen spoke of the past, in later years, she would often remark, casually, that her ancestors could be traced back to William the Conqueror. This may be true. The most accessible genealogical record, in her Aunt Minn's Bible, traces her Grandfather John's family (on both his mother's and his father's side) back to New Jersey in the mid-eighteenth century and to Alice's great-great-great-grandfather, Hugh Haggerty, who came from Ireland in the early 1700's. Alice's grandmother's ancestors, Townsends and Cornells, had been established on Long Island since the 17th century and were even more distinguished, the Townsends being related by marriage to the august Van Rensselaers themselves.

Memories of these families' participation in the Revolution—on both sides of the conflict—were still very sharp a century later, in the years when Alice was growing up. Alice's great-great-grandfather, Patrick Haggerty, born on Hugh's 500-acre farm in

New Jersey's Sussex County, had signed up as an infantry captain in the British army. When the fortunes of war went badly, Captain Haggerty was forced to flee with other retreating Loyalists in November 1783, taking his wife and three young children to Digby, Nova Scotia—where they had four more children. The first of these four children, born in exile in 1785, was Mary Haggerty, who was to become the great-grandmother of the young photographer she never met. When political conditions in the United States permitted the Haggertys' return, they came home to New Jersey when Mary was five or six.

In a rather dramatic ceremony twenty years later—beside her father's deathbed in Manhattan—Mary Haggerty married 26-year-old David Austen. David's father, Moses Austen of Elizabethtown, had been a patriot hero of the Revolution: in 1780, as a 29-year-old volunteer soldier in the New Jersey Militia, he had led half a dozen local youths in the daring capture of a group of General Knyphausen's soldiers from under the very nose of the enemy's cavalry, at Gulleping Hill. It is not known whether Moses Austen, nearing 60 when his son married, could bring himself to attend David's wedding to the daughter of a Tory officer. But David himself, after his marriage, was tolerant enough to welcome into his household his widowed mother-in-law, a Pennsylvania Quaker named Sarah Dennis Haggerty, who received a military pension from the British government until her death in 1827.

David and Mary Austen settled into a residence in lower Manhattan and were happy enough to produce ten children between 1811 and 1829. Their first-born was John Haggerty Austen, Alice's future grandfather. David went into partnership with his older brother-in-law, John Haggerty, and they established (in offices at 82 William Street) the family auctioneering firm known by various names through the years—first as Haggerty & Austen, then as Austen, Austen & Wilmerding, Austen & Spicer, David Austen Jr., and Hadden & Co. David Austen was a successful merchant, remembered for his unusual generosity in helping many young businessmen to make a good start in life. David and his brother-in-law parted on unfriendly terms. But the auctioneering business they founded, specializing in "dry goods" (textiles, especially French silks, and carpets), was taken over by David's sons, John Haggerty Austen and David Austen Jr., and it prospered into the 1880's.

When John Haggerty Austen was a young businessman of 25, in 1836, he married Elizabeth Alice Townsend, another Quaker woman, whose father's ancestors, the Townsends, had arrived in Massachusetts from Norfolk, England, in 1630 and established themselves in the Oyster Bay area of Long Island a few years later. Her mother's family, the Cornells, had owned land on Long Island since the 1670's. Elizabeth herself was born in Chester, Orange County, N.Y., in a Townsend house said to have been visited by Washington, Lafayette, Rochambeau and other important figures during the recent war. Elizabeth's own grandfather, Peter Townsend Sr., is listed in every roster of patriotic heroes of the Revolution. In late January 1778, Col. Timothy Pickering rode to Chester to visit Townsend, who was a partner in Noble, Townsend & Co., and owner of the well-known Sterling Iron Works, fourteen miles away. Pickering told Townsend that Congress (on the urgent recommendation of General Washington) had ordered the

construction of a giant chain to block the Hudson River at West Point—and that the chain was to be twice as strong as the broken one strung the previous year from Fort Montgomery to Anthony's Nose. Townsend and Pickering, reaching an agreement, left at once for the iron works, riding after midnight over the wooded hills through a violent snowstorm to reach the site on Sterling Lake (near present-day Tuxedo Park). At daylight the next morning (even though it was a Sunday), the furnaces were fired and all available men were put to work on the project—with guarantees that they would be exempt from service in the Continental Army. More than sixty men (twenty of them needed to cut wood, and five to haul away the coals) worked at the labor of keeping the fires burning, forging the iron into long bars two and a quarter inches square, then welding them into two-foot-long links. Seven fires burned continuously for the forging, ten for the welding. The men toiled day and night, for six weeks, until they had finished all the links, their connecting swivels and clevises, and the heavy anchors needed for the monstrous chain—500 yards along, and weighing 180 tons. In small sections, the parts of the chain were carried by mules and dragged by oxcarts to New Windsor, then on yawls down the river to West Point. On the last day of April, 1778, the chain was finally assembled, floated on log rafts that spanned the river to Constitution Island, and anchored at each shore. British war ships were prevented from sailing up the Hudson for the rest of the war, and the fighting ended sooner as a result. In 1783 the obstruction was removed and segments of it were treasured by the Townsend family and others into whose hands they passed.

One of the prized iron links was handed down to Elizabeth Alice Townsend Austen, granddaughter of its maker. She installed it in her house on Staten Island, in the central place of honor—above the fireplace in the parlor. Immediately above it, she fastened to the ornamental carving of the mantelpiece a small door knocker from the old Townsend home in Chester. To the right of the hearth hung a portrait of her father, Peter Townsend Jr., matching one of her mother, Alice Cornell Townsend, on the left, both paintings in ornate frames. From his position above the sofa, David Austen (painted toward the end of his life) smiled benevolently down on his son and family whenever they gathered in the parlor. The old man was a frequent visitor to the Staten Island cottage, and it was at "Clear Comfort" that he died as a widower of seventy-nine, in the autumn of 1863—just three months after his granddaughter Alice Cornell Austen married Edward Munn, and two and a half years before the birth of his great-granddaughter, the photographer.

The parlor, with its dark red Victorian wallpaper, was a comfortable room. The massive pieces of dark furniture look heavy to the modern eye, but Elizabeth Austen was well pleased with them—the table, with small faces carved at the top of each ornate leg, had been made by an itinerant French-Canadian who lived one winter in their barn. The furnishings won the warm praise of a journalist from *Harper's* who visited the house in 1878. The parlor was "warm in color, brilliant in effect, and cozy in arrangement," he reported. "Cheerful is an adjective that applies to every part as well as the hall," he continued. "The sunshine streams in copiously and the bees find passage from front to rear. . . ." There were no window screens to keep out insects, of course, and no running

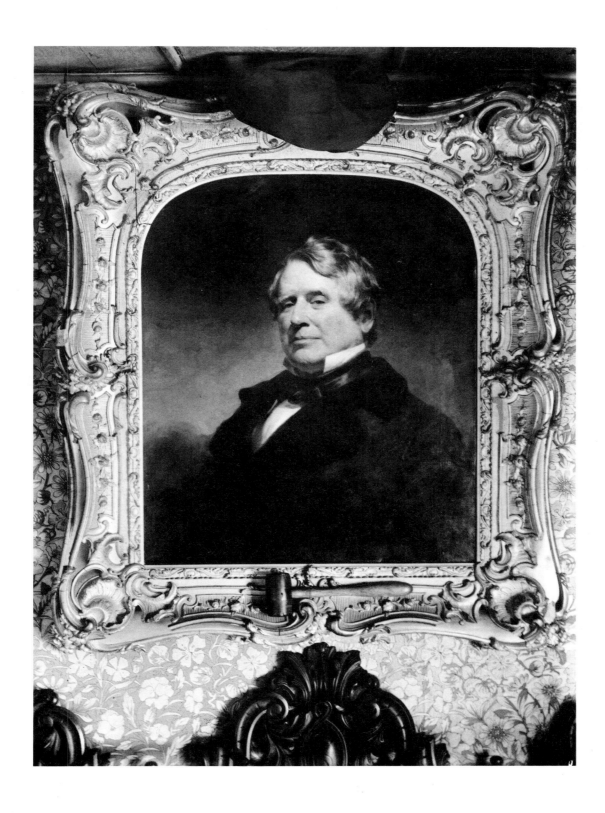

Alice's great-grandfather, David Embree Austen (1784–1863), son of a Revolutionary War hero and founder of the family business (note the auctioneer's hammer attached to the frame). (*Copy of Grandpa Austen's portrait. In parlor, on wall. 8 a.m., Thursday, March 1st, 1894. Seed, Perken lense, 6 mins, Stop 16, Instantaneous*)

OVERLEAF: Mrs. Rusten Van Rensselaer and her daughter Emily (distant cousins of Alice's grandmother on the Townsend side) at "Presqu'isle," their mansion in Fishkill-on-Hudson. (*Cousin Emily, Cousin Emmie & "Beauty." Fine, clear sunny day, taken in shade. 5.20 p.m., Sat., Aug. 25th, 1888. Seed 23, Perken lense, 2 secs short, Stop 22*)

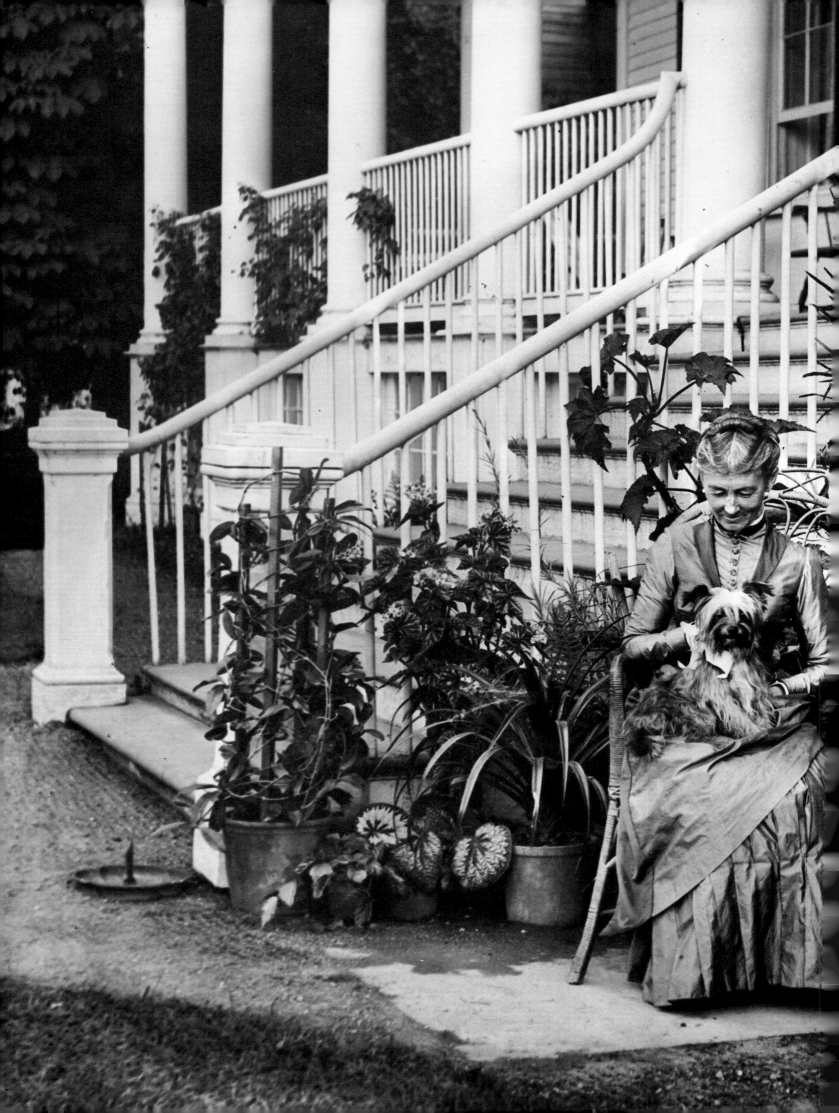

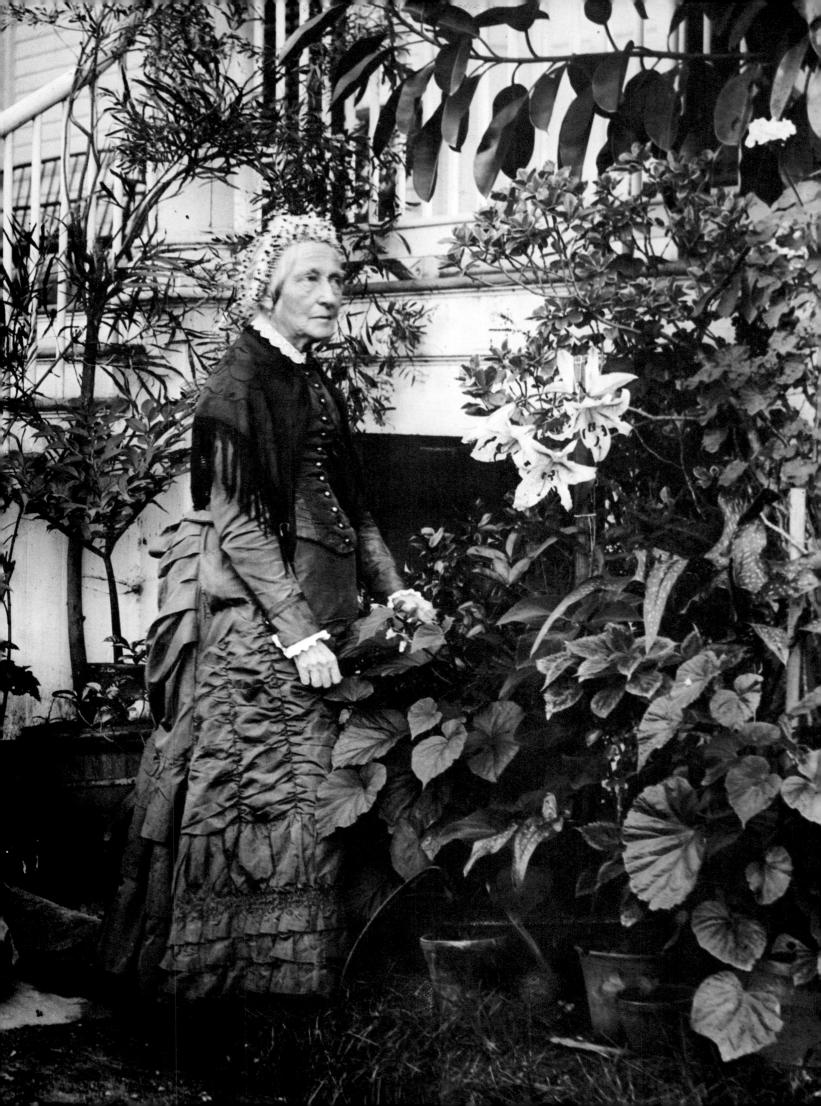

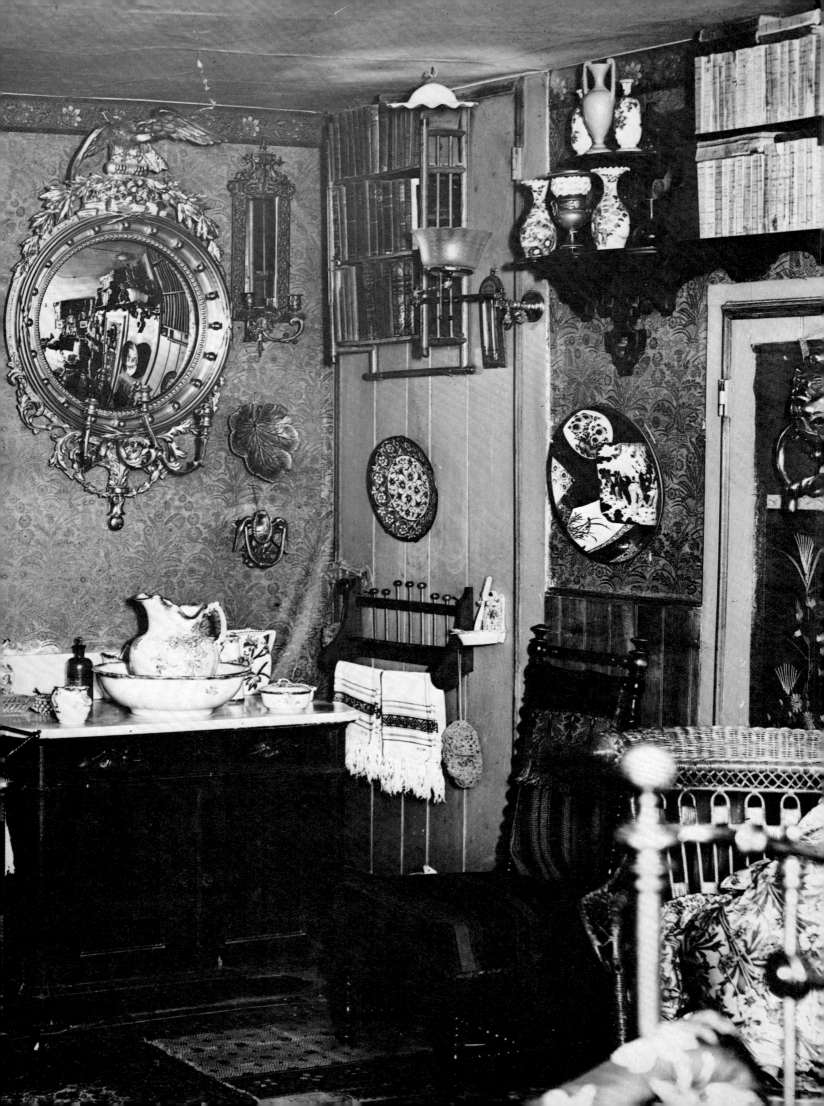

water in the house, either. But the waterfront garden sloping down to the low seawall, and the fresh breezes cooling it in summer, made up for any nineteenth-century rustic inconveniences. "The lilacs were in bloom when we called and the long grass rippled in the wind, and shook the golden chalices of the buttercups that opened in the sunshine," rhapsodized the same magazine writer. "Patriarchal shade trees flickered over the shingled roof. . . . A hardy vine interwove its twisted branches up the supports of the wide porch, under which the gentle mistress sometimes sits with her embroidery or book."

To that mistress, sixty-five-year-old Elizabeth Austen, the house by 1878 was "Clear Comfort" indeed. As she whiled away those afternoons on the piazza—comfortably equipped with wicker chairs and hammocks, a spyglass for watching ships, and a cage for a songbird—she must have surveyed her present circumstances with some satisfaction. Her forty-one-year-old daughter Alice kept her company in the house. Her granddaughter, young "Loll," was forever rushing off with a tennis racquet in her hand, splashing into the water at the foot of the garden, or tinkering with Captain Müller's camera—but at twelve years of age she showed hopeful signs of growing out of her tomboy stage, and it might yet be possible to turn her into a young lady. The return of Oswald Müller and Minn from their current voyage was an event to look forward to with pleasure and some curiosity: what souvenirs and tales would they bring home this time? In the meantime, her daughter Minn's letters were entertaining and reassuring. Peter, now 26, had recently returned from Europe with a fierce Germanic mustache, letters of glowing recommendation from the great Professor August Wilhelm Hofmann for his post-graduate studies in chemistry in Berlin, and a degree of Doctor of Philosophy from the University of Zurich. He was now Assistant Professor of Chemistry at Rutgers College, and it was only a question of a little time before he would become a full Professor there. He was engaged to be married that winter to nice Nellie, twenty-three-year-old Ellen Middleton Munroe, daughter of Mr. and Mrs. Thomas Munroe who also lived in Clifton on nearby Townsend Avenue. Peter, the son born in "Clear Comfort" itself, the heir for whom she and John had waited so long, had more than fulfilled the dreams they had had for him, she must have thought. John himself, now sixty-seven years old, was beginning to cut down on the traveling he had done for forty years. Soon they would be celebrating their fiftieth wedding anniversary!

John Austen shared his wife's pleasure in their house, and when he was away from home on his business trips he mentioned "Clear Comfort" with pride in many of his letters to her. He took a particular interest in the garden. His teenaged daughter Minn, writing to Paris in the 1850's, dutifully reported to him: "The garden is now in fine order, indeed it never looked better. . . . Ma and I work an hour every morning in it and another hour in the evening. The grass has been mowed all over and looks lovely. The Virginia Creeper has come out splendidly on the old Mulberry tree." Writing to his wife from London in June, 1867, John inquired: "How does the grass look? I shall never forget the day I passed out of the Narrows how lovely the old cottage looked. It was much admired by the passengers who stood near me. The Captain ordered the ship run close to our side when I told him I wished to make a signal to you." Again, from Paris two years

Alice and her mother shared a bedroom on the ground floor of "Clear Comfort." The Victorian wash-stand remained in the northwest corner during all the years the house had no running water. Alice's mother particularly treasured the convex mirror on the wall.

later, he wrote her: "From the deck of our steamer . . . our place I think I never saw looking so perfectly beautiful. The passengers after spoke of it during the voyage as being most lovely. The fact of being the owner of such a spot gave me quite a position among them at once." The ships he traveled on sailed so close to the bottom of the garden that his wife and children were able to signal to him by waving and raising their flag; on at least one occasion, the captain obliged Mr. Austen and thrilled his children by saluting them with the ship's gun. Even when the other passengers' attention was not attracted to the house by these dramatic greetings or farewells, they naturally admired the place. On a business trip through the western States in 1874, John wrote home from Salt Lake City in July: "I have met many acquaintances on the cars. . . . One very handsome young man of about twenty five was ten days ago in the *Scotia* & told me he was so charmed with the looks of a long low house on Staten Island all mantled in vines with three Gothic dormer windows. The terrace in front was perfection. When I told him that was my house & that I looked at him that morning with my glass, we seemed to be old acquaintances at once. He said all the passengers were admiring our house & talking about it."

The perfection of the terrace, of the vines and the Gothic dormer windows was something in which John and Elizabeth Austen could justly take pride. As well as being patient gardeners, they had spent substantial amounts of money on improving and enlarging the house almost from the day they bought it. By 1846, they had given the building its present T-shape by adding a room to the northern end. The new room (which became a bedroom shared by young "Loll" and her mother Alice) had a fireplace installed in its northern wall, and fine chimney-pots then appeared at the north and south ends of the roof. New dormer windows were added, with plenty of gingerbread trim around them and along the ridge of the grey shingled roof. Small wooden bird houses were attached at every peak. Inside, some of the rougher beams were boxed in, and new flooring was laid down over the old boards. The staircase was reversed, to lead up from the rear of the hallway instead of from beside the front door. The finishing touch, installed on the front door itself, was a formidable knocker shaped like a griffin's head, brought from an old chateau near Rouen.

The conversion of their old farmhouse into a Victorian "Gothic Revival" cottage may very well have been helped by informal advice from a knowledgeable friend of the family—the young architect James Renwick, later to become famous for his designs of the Smithsonian Institution in Washington and St. Patrick's Cathedral in New York. In his late twenties at the time when the Austens began remodeling their house, Renwick was architect of the fashionable Grace Church on lower Broadway, a church which John Austen's father David had helped to finance, and in which (after its completion in 1846) John's second infant son and at least 30 other Austens had been baptized and confirmed.

John continued improving the house and its grounds for almost as long as he lived. By the mid-1880's (perhaps earlier) he had enlarged the ground floor of the house to the north by adding an extension, which was a five-sided sitting room or conservatory, used by "Loll" and her mother. At the rear of the house, an exterior stairway led up to the sunporch naturally formed by the roof of the extension. Then awnings were put up, and

one of the windows of the upstairs bedroom the Müllers occupied was changed into a door for easy access. In the late 1890's, the sunporch was covered with a flat roof and enclosed with large-paned windows, to become the "quarter-deck" sunroom so much enjoyed by the Müllers. (Damage in the 1940's and 1950's necessitated its removal.)

The Austen's obvious enthusiasm for gardening was observed by their neighbors, and led to John's appointment as head of the committee responsible for maintaining the two acres of grounds at the Yacht Club, for several years the Austens' next-door neighbor to the south. The clubhouse had been built as a Victorian residence at about the time that the Austens bought their house. For more than twenty years the mansion—complete with stables, an ice house, a fishpond, two greenhouses and a cottage for the gardener—served as an elegant home for a wealthy family. Then in 1868 the New York Yacht Club moved there from New Jersey. For the sake of neighborliness, perhaps, John Austen joined the club that year, although he cared much more for gardening than for sailing—or for the other members, to whom he referred in one letter as "old fogies." The roster of nearly 300 members glittered with such names as Vanderbilt, Astor, Tiffany, Dodge, Lorillard and Livingston, and between them they had a fleet of forty-two vessels, from sloops to steam-powered yachts. The regattas they held in June 1869 and 1870 were exciting occasions, although in the second summer the Austens were so cross at "intruders" tramping across their garden that they posted a guard at their gate. The most exciting event of all was the America's Cup Race on August 8, 1870, when the Royal Yacht Club's *Cambria* made Britain's first challenge for that trophy (it had been carried away across the Atlantic in 1851 by the schooner *America*). About 50,000 spectators lined the shore from Vanderbilt's Landing to Fort Wadsworth, and cheered as seventeen of the finest yachts from the New York Yacht Club successfully defended the cup. As the victorious *Magic* sailed back through the Narrows she was greeted by thunderous cannon on the Club's grounds, by the whistles and sirens of crowded steamers and steam-driven yachts (some of them with bands aboard), and by cheers and waving handkerchiefs from all the small sailboats, sloops and schooners, flag-bedecked, that crowded the water of the Narrows.

The Austens' four-year-old granddaughter "Loll" could hardly have forgotten all the noise and excitement, or the stirring sight of the yachts themselves. The Club transferred its headquarters to a more convenient location in Manhattan the following year, and sold the old clubhouse, maintaining only a shore station up in Stapleton for another few years. But the dock and the neighborhood's small sailboats remained, as well as the memories, and Alice Austen grew up to be a skilled and enthusiastic sailor. In October 1892, when she was twenty-six, she went on a ten-day trip in a ketch from New Brunswick, New Jersey, down the canals and across the Chesapeake to Annapolis, with her Uncle Peter's wife Nellie and Nellie's brother. Sailing was an enthusiasm that lasted well beyond the years of her youth. In September 1901, Nellie's teenaged daughter Patty recorded in her diary that she "went sailing every day with Cousin Loll and Miss Tate," and again in September 1904 she recorded that her twenty-one-year-old brother Munroe "spent afternoon sailing with Cousin Loll" (who was then thirty-eight).

With the Narrows fifty yards from her front door, Alice naturally became a strong

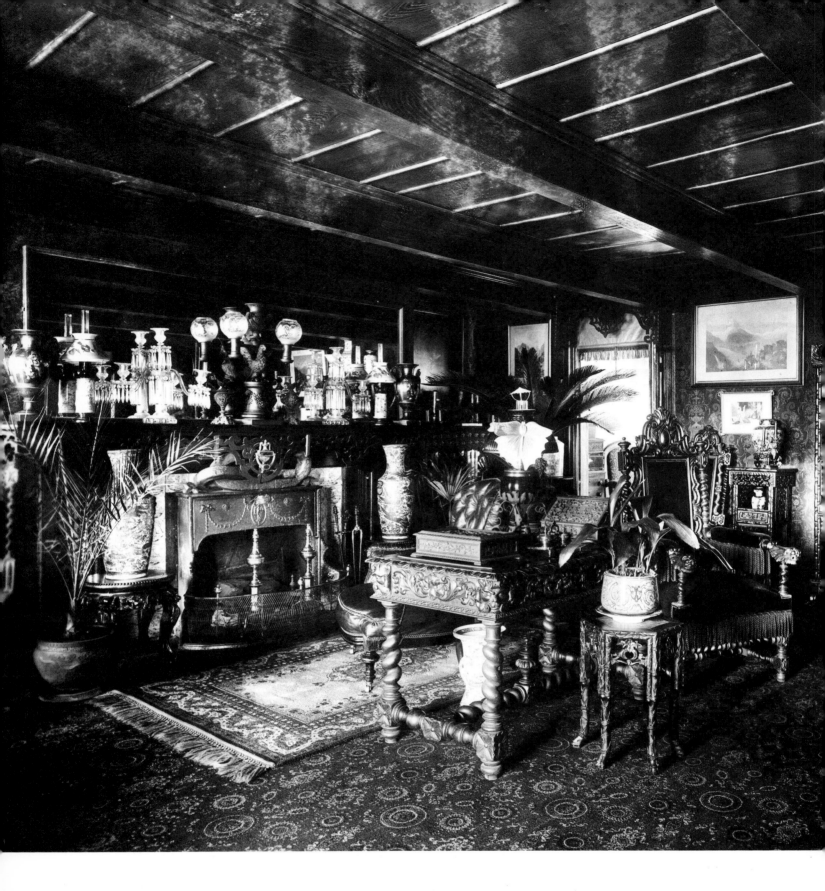

A link of the Hudson River chain and the door knocker from the Townsend house in Chester hang below the mantelpiece of the Austens' living room. (*Our parlor. Fine bright day. Sunday, March 7th, 1897, 9.40 a.m. Stanley 50, Ross Interior lense, 1 hour, Stop 5. Window: covered window with green shawl & slumber robe, 15 secs, removed shawl, drew up shade*)

ABOVE: The southeast corner of Alice's bedroom.

BELOW: A wrought-iron knocker, shaped like a griffin's head from a chateau in Rouen, was acquired by Grandfather Austen in Europe. It adorns the old Dutch door, facing the water. (*Our old knocker. 10.40 a.m., Wed., Nov. 6, 1890. Seed plate 23, Perken lense, Stop 32, 2 secs. Threw sun on it with looking glass*)

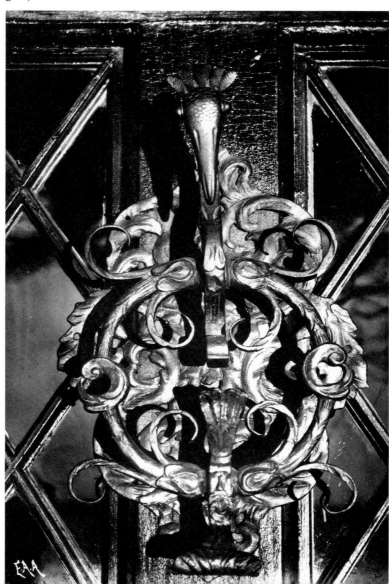

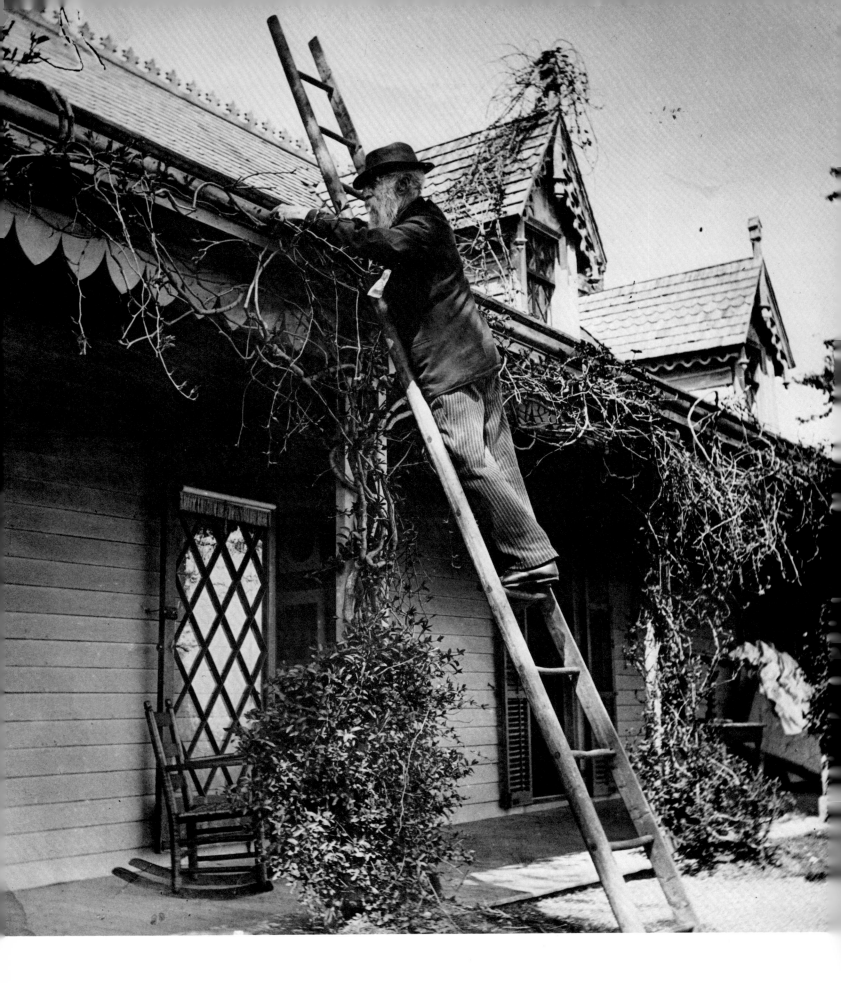

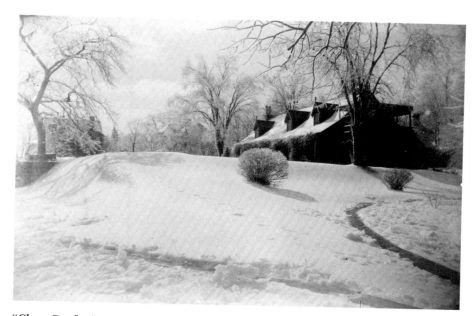

"Clear Comfort" in winter is buffeted by icy winds off the Narrows, heated by wood-burning fireplaces and stoves.

OPPOSITE: John Haggerty Austen, pruning the big-leafed Dutchman's Pipe vines that grew over the porch. (*Grandpa on ladder. Fine sunny day. 9.30 a.m., Mon., May 4th 1891. A&R 40, Waterbury lense, Instantaneous, 12 ft.*)

The landscaped grounds of "Clear Comfort"—seen here from the sea wall in 1891—come to life in Spring at the hands of the Austens, all of whom are skilled gardeners.

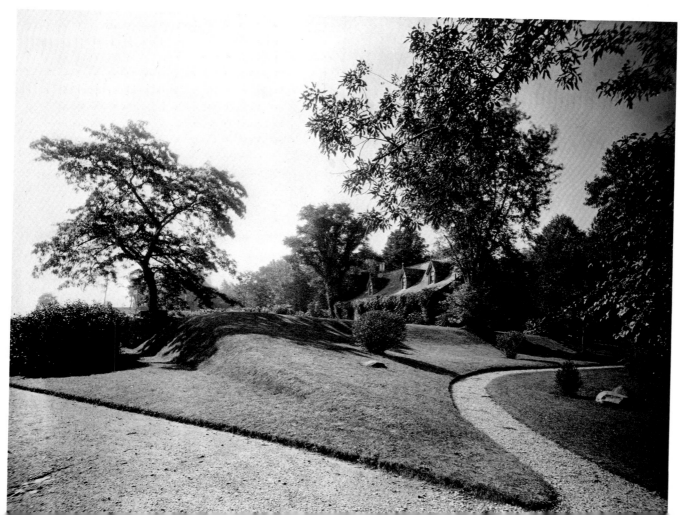

swimmer with absolutely no fear of the water. Even when hampered by a long-skirted traveling dress, she did not give a moment's thought to the obvious risk of crawling along a rotten log into the middle of a rapid stream in pursuit of the perfect photograph. On hot summer afternoons in the 1880's, the front lawn at "Clear Comfort" was often the scene of bathing parties for Alice's young girl friends, all of them clad in decorously skirted costumes, complete with short bloomers and stockings. In the winter, she went to skating parties on the Island's frozen ponds and creeks, and to bowling parties such as those given in the private alley of the Marsh mansion, nearby. She threw herself energetically into the exercises with dumbbells and Indian clubs, rings and archery sets,· high ropes and parallel bars, all prescribed by professional gymnast Miss Daisy Elliott, whose classes for young ladies she attended with her friends Violet and Carrie Ward. When golf became popular, she excelled at that sport too. The exciting new game of lawn tennis, introduced to Staten Island (and to the U.S.) when Alice was nine years old, was the sport she enjoyed with the greatest enthusiasm. "I played tennis from almost the day I could walk," old Miss Austen reminisced to Oliver Jensen, with only slight exaggeration. She was certainly one of the youngest amateur women tennis players of her generation, and she became one of the best. She won many prizes at the courts of the Staten Island Cricket and Baseball Club, including one special belt buckle that had to be won for a number of successive years before it became the winner's personal property. As the popularity of the new sport spread, Alice traveled "around the country" (she didn't say exactly where) to play at other clubs. She kept a scrapbook, in which she recorded her own triumphs and the scores of the women's championship matches in the 1890's. She even beguiled her family into marking out a small tennis court, of unorthodox dimensions, on the low-lying north end of the lawn at "Clear Comfort"—and there she would mount her camera on its tripod and pose her friends, some twenty young men and women with a few racquets gracefully in hand, on the grass bank against the hedge.

Tennis games at the Club (about five miles away, in Livingston) gave Alice one of her few excuses for being late for dinner—a normally unpardonable offense in the eyes of the Austen adults, who in many ways spoiled her but who were adamant on this matter. No matter how hard she tried, Alice was often late (in later years she was chronically unpunctual). She would be greeted by stony silence around the dining room table. The only way she could soften the adults' hearts was by telling them of her latest triumphs on the court, or—better still—displaying a trophy she had just won. The time-consuming problems of traveling around the Island's roads in a horse and buggy made Alice abandon a project she had cherished for some time: that of photographing all the fine old houses and historic buildings on the Island. It was just too difficult to pack up her fifty pounds of photographic equipment, reach her chosen sites when the lighting conditions suited her, and arrive back home again in time for the evening meal.

She contented herself with photographing the homes of her friends, most of whom lived nearby (these were the years when Staten Island's villages were separate communities, each with its distinct social circle). Because she very seldom went especially out of her way to look for photographic subjects, her pictures are particularly revealing of

her way of life and of her personality. Popular and extraordinarily energetic, young Alice Austen passed busy winters and happy summers in a social life that was, in her own words, "larky," full of carefree sprees and pranks. She hauled her camera and tripod along to picnics, masquerades, and musical evenings in her friends' parlors. She had lots of friends, dashing youths in bowler hats and young women in smart shirtwaists, who posed for her with suppressed giggles or expressions of exaggeratedly solemn resignation. Sometimes they clowned for her camera—pretending to be wildly intoxicated on tea or ginger ale, or to be scandalous women smoking make-believe cigarettes and showing their ankles. No matter how much Alice's friends pretended to grumble about the hours spent in excruciating poses, they agreed willingly enough to her next amusing scheme—a poker game with unbelievable cards revealed to the camera, a mock courtship in a cemetery, or the sport of seeing how many young women could squeeze into one narrow bed. They all had fun with the pictures in which Alice herself posed, an expression of innocence on her face and the bulb of the remote-control shutter release in her hand, the long cable leading to the camera carefully concealed under some tennis racquets or the carpet.

Alice's closest friends in her youth were girls she had met at Miss Errington's School, or at their homes in the immediate neighborhood of Clifton. Some of these friendships lasted a lifetime. Closest to Alice through the 1880's and early 1890's was Gertrude Eccleston, daughter of the rector of St. John's Episcopalian Church. They played tennis together constantly. Alice spent many hours at the rectory, just around the corner on Bay Street, photographing the rooms, family gatherings and weddings, and laughing with Gertrude (whom she called Trude) over their latest "high jinks" upstairs. With two other close friends, Julia Marsh and Sue Ripley, Alice and Trude formed a cooking and sewing club, which undertook its activities in a vacant house owned by Julia's father, Nathaniel Marsh, wealthy president of the Erie Railroad. The four girls spent so much time in each other's company that disgruntled young men referred to "the darned club," a name the members delightedly adopted. Other friends from the neighborhood were Miss Hoyt, who shared Alice's love of horses and dogs, and Miss Julia Bredt, who lived in the former Yacht Club building next door.

Up on Grymes Hill lived Julia Martin, who accompanied Alice on a summer holiday to Vermont. Also on Grymes Hill were the Ward sisters, remembered on Staten Island to this day for their extraordinary eccentricities as old ladies. Maria Emily (known as Violet) and Caroline Constancia (Carrie) lived in their father's eighteen-room Victorian stone mansion (and continued to live there alone into the 1940's, when all the servants had long since gone and layers of dust settled over everything). In its heyday, the house was a showplace, with a fine slate roof and wide porches, surrounded by well-kept carriage drives, lawns, and private tennis courts. Named "Oneota," the house had been built in 1865 by General William Greene Ward (Brigadier-General, First Brigade, First Division, National Guard of the State of New York), a banker who earned a rather dubious military reputation in the Civil War, in the unsuccessful defense of Harper's Ferry and in the Pennsylvania campaign. In a large walnut cabinet at the foot of the main staircase, the General (as he was always addressed) proudly displayed his Civil

War flag and other mementoes of his soldiering days; upstairs, in a gun room with a fine view of the Narrows, hung wall racks and cabinets filled with firearms and sabres. Elsewhere in the house—competing for space with French fruitwood furniture upholstered in chintz, marquetry escritoires, grandfather clocks, a carved highboy from Newport, a mahogany chest with serpentine front, and cupboards full of fine china, glassware and silver (all of which were auctioned when his daughters died)—was the General's library of four thousand books, mostly on military subjects. He discouraged casual sightseers by protecting the estate with a high picket fence, patrolling dogs, and main entrance gates that were always tightly closed. Welcome visitors (and there were many) included figures of national importance, most notably President Ulysses S. Grant.

Alice Austen, too, was a welcome guest at the Ward house. She came frequently (often bringing her camera) to participate in musical evenings, to play tennis, and to talk for hours with Violet about the new enthusiasm they shared—bicycling. They experimented with the clumsy new machines, and probably wished aloud that they had the courage to change their ankle-length skirts for the practical costume devised by old Mrs. Bloomer (to be decorous, ladies had to insert lead weights into the hems of their skirts when bicycling in public). There was much laughter when Violet Ward shakily tried to ride her bicycle so slowly that Alice's camera could capture her in action. When Alice took the photographs for Violet's book, *Bicycling for Ladies* (published in 1896), gymnast Daisy Elliott posed, motionless, her bicycle supported by a stout pole that became invisible when the illustrations were reproduced. As well as writing about bicycles, Violet proposed a practical alteration to their mechanism, an improvement which was almost universally adopted. She was an avid amateur inventor (an ability she inherited from the General, who helped invent the Ward-Burton breech-loading rifle), and Alice shared her interest in all things mechnical. At "Clear Comfort," Alice spent hours with a jigsaw, cutting out elaborate picture frames and wall decorations for her room, and she learned how to bind books in leather with professional skill. As an older woman, she developed a habit of carrying everywhere she went a leather bag containing a wrench, pliers, small hammer and screwdriver.

The friend who shared Alice Austen's older years first met her in 1899. She was Gertrude Amelia Tate of Brooklyn, a kindergarten and dancing teacher then in her mid-twenties. When she met Alice she was recuperating from an attack of typhoid fever at a Catskill hotel known as Twilight Rest—where Alice had come to visit the Eccleston family. The two young women began a close friendship that was to last for fifty-five years. Alice's grandparents were both dead by the time she met Gertrude, so there was room for guests in the upstairs bedroom to the south at "Clear Comfort," and Gertrude became a frequent visitor (Aunt Minn emphatically insisted that the sea air blowing in through the Narrows would be good for her health). Gertrude, in effect the main support of the Tate family since the early death of her father (an accountant from Boston), continued to maintain the household in Brooklyn, but spent as much time as possible on Staten Island and accompanied Alice on holidays to Europe almost every summer until the Great War began. Not until about 1917, when her younger sister Winifred and her mother gave up the Brooklyn house in favor of an apartment, did

Alice, Trude Eccleston, Julia Marsh (left to right) and two other close friends in front of the cedar gates at the northeast corner of the Austens' garden. (*Group in bathing costumes. Thursday, Sept. 17th, 1885, 12.30 p.m. Instantaneous*)

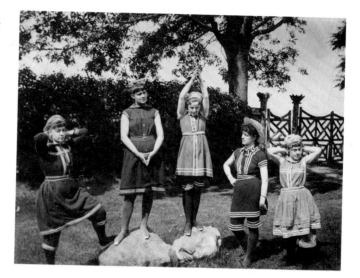

BELOW: A few minutes later, a spectator (Uncle Oswald?) records Alice and her friends in the water off the end of the garden, as a yacht sails out of the Narrows.

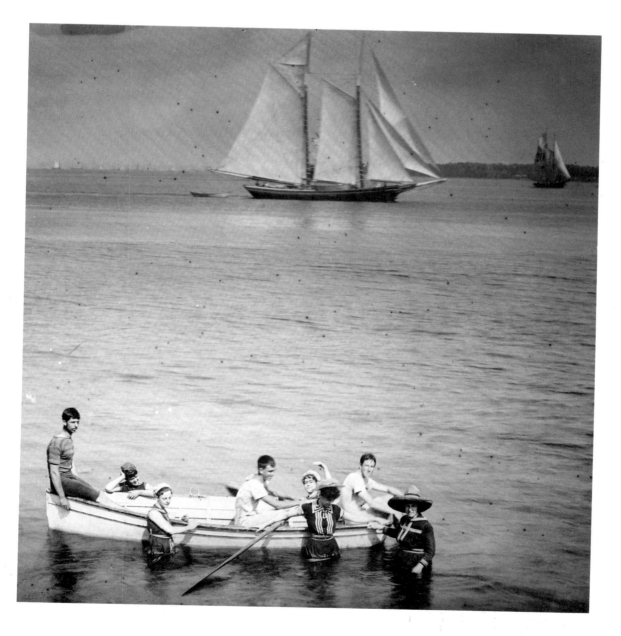

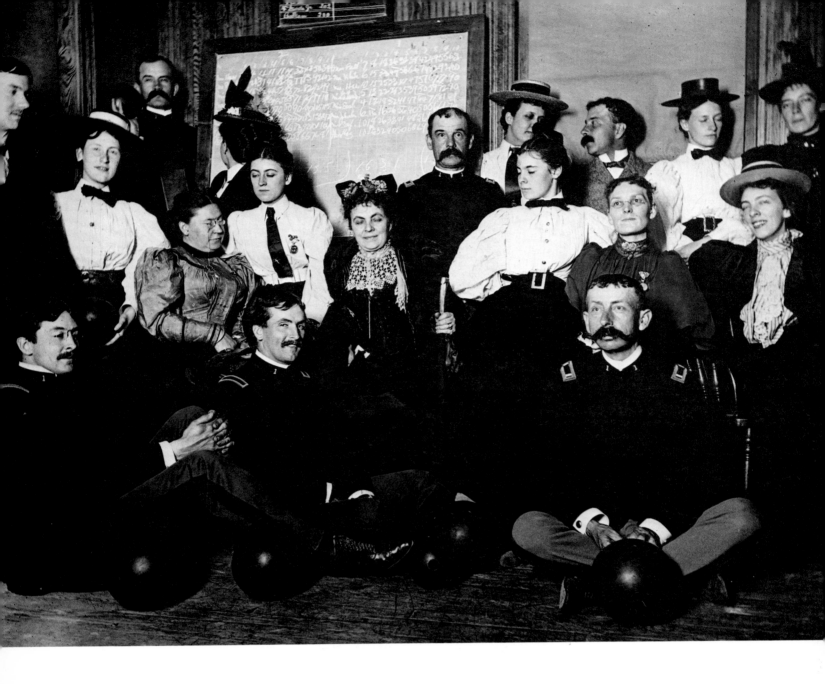

ABOVE: A bowling party in the private alley of Nathaniel Marsh's mansion on Belair Road. Alice has slipped into the picture, back row at right. In the right foreground is Lieutenant Isaac Lewis, inventor of the Lewis gun. (*Bowling Club (self). Tuesday, May 28th, 1895, 11 p.m. Cramer Crown, Flash 1½ boxes, Waterbury lense, 25 ft.*)

OPPOSITE, ABOVE: Alice (extreme left), her friend Bessie Strong (in white dress at center) and others pose beside the Austens' tennis court for Alice's camera—to which the pneumatic cable, imperfectly concealed by a racquet and cover, leads. (*Group on tennis ground. 5 p.m., Thursday August 5th, 1886. About 1 sec. Threatening rain, no sun*)

OPPOSITE: Daisy Elliott, on the rings, Violet Ward (holding the football, at left), her sister and other amateur gymnasts perform for Alice's camera. Miss Elliott appears to have stuck a bunch of sweet peas into the waist of her bloomers, for the occasion. (*Group apparatus. Misses Ward, Lawrence, Elliott. 11.35 a.m., Tues., May 23, 1893*).

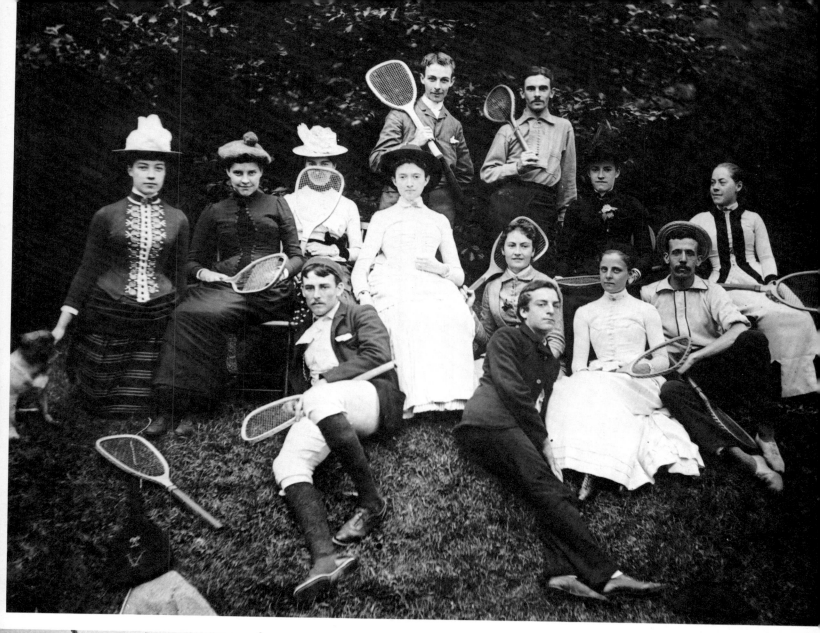

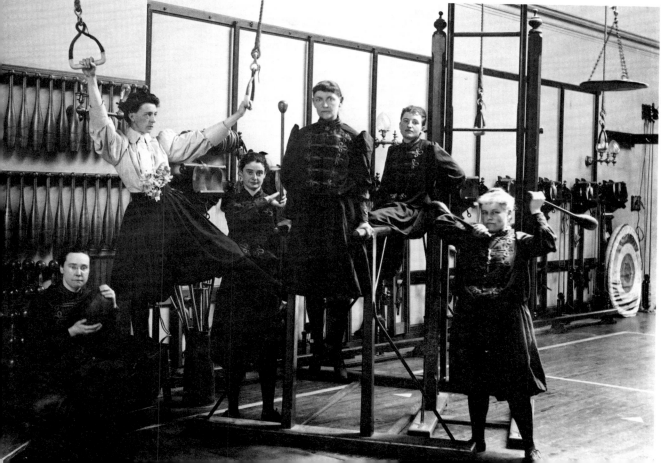

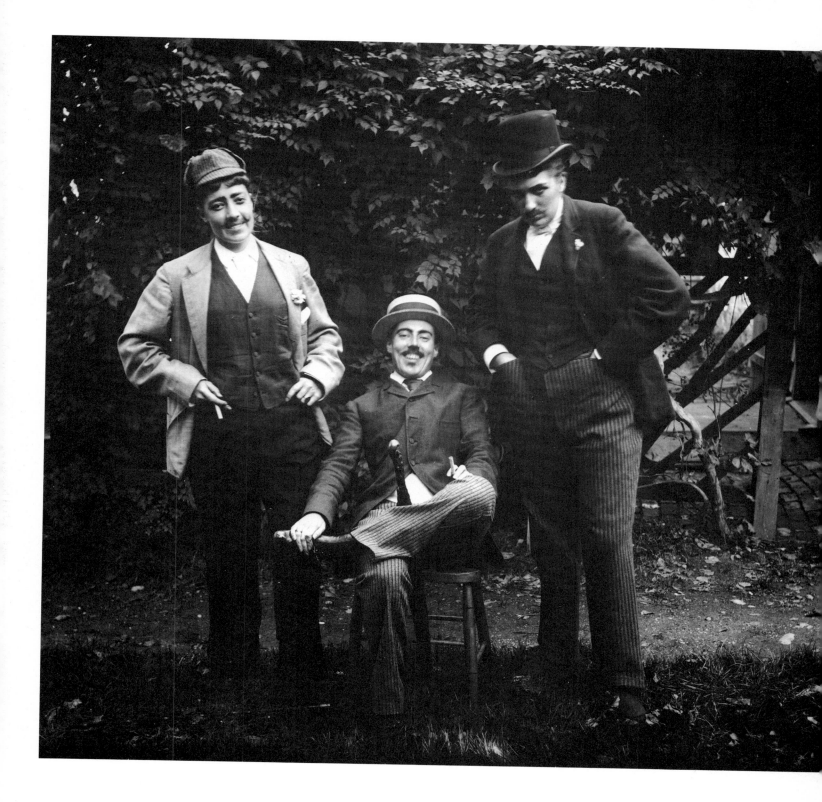

"We look so funny with those mustaches on, I can hardly tell which is which," laughed Miss Austen when she saw this photograph in 1951. "We did it just for fun," she commented. "Maybe we were better-looking men than women." Alice herself, phony cigarette in hand, stands at the left. (*Julia Martin, Julia Bredt and self dressed up as men. 4.40 p.m., Thurs., Oct. 15th, 1891*).

OPPOSITE: Alice, at left, strums the banjo as Bessie Strong, her house guest from New Jersey, plays the guitar on the shaded porch at "Clear Comfort." Behind them are Grandfather's telescope, a comfortable hammock, and the birdcage that housed an Australian parrot.

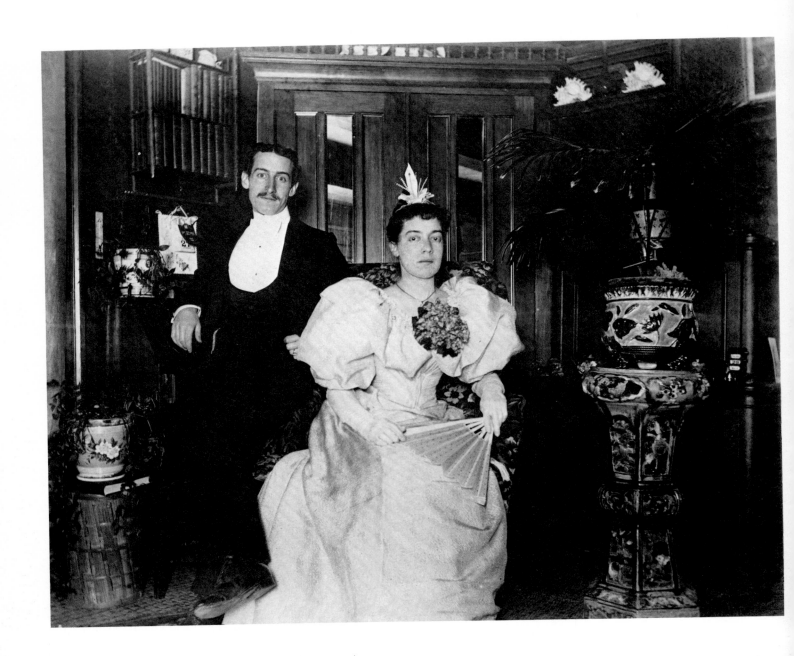

"We were off to the ball, looking as though we were shot out of a gun," old Miss Austen reminisced. "I was nervous because I was so afraid the picture wouldn't come out right." Her escort was her cousin, her gown was of figured satin, and her bouquet was of violets. The Charity Ball, held in the German Club for the benefit of the Smith Infirmary, was the social event of the year. (*Lewis Austen and self, in middle room, dressed for Charity Ball. 9 p.m., Thursday, March 29, 1894.*)

OPPOSITE: Dressed for a dance recital in Spanish costume (skirt of yellow satin, jacket of sequined black velvet) Alice poses, with castanets, on the porch. "A pretty good hat that was, too," she remembered 65 years later. Like all her clothes at that time, it was "run up" by a dressmaker who came to the house. (*Myself in Spanish costume. Cap off and on. Sat., May 29, 1886, 10.30 a.m.*)

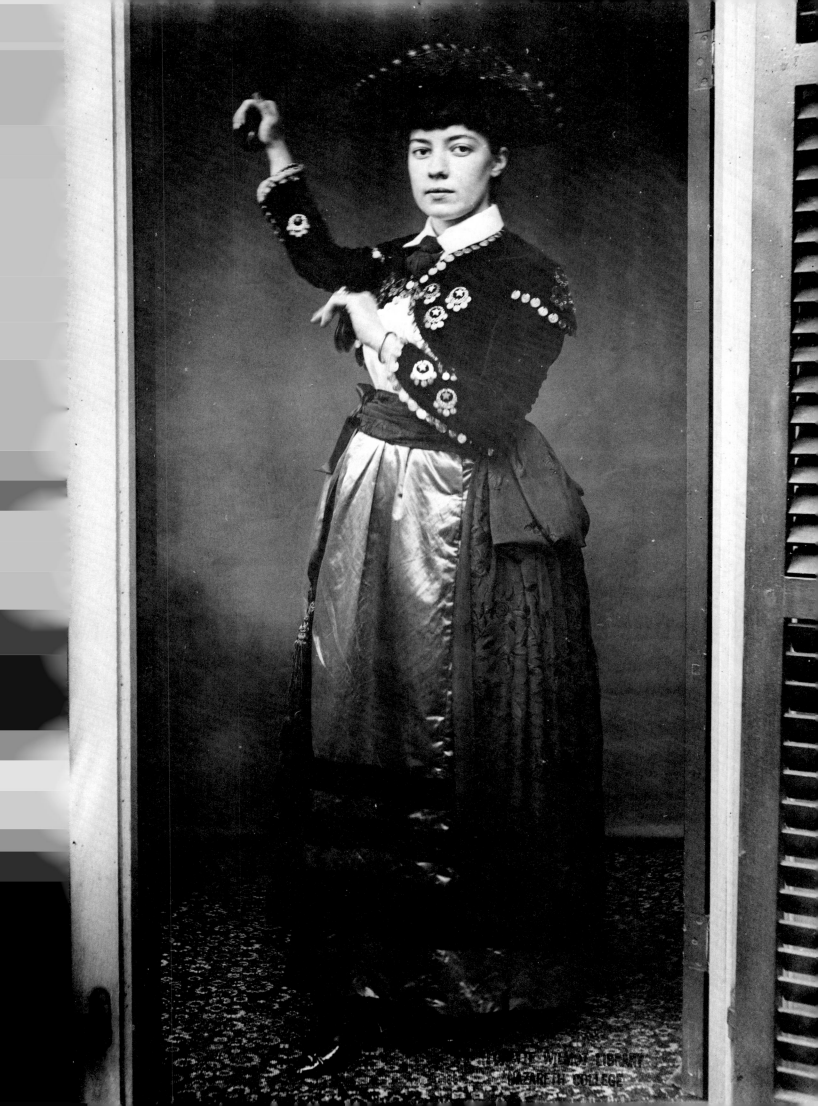

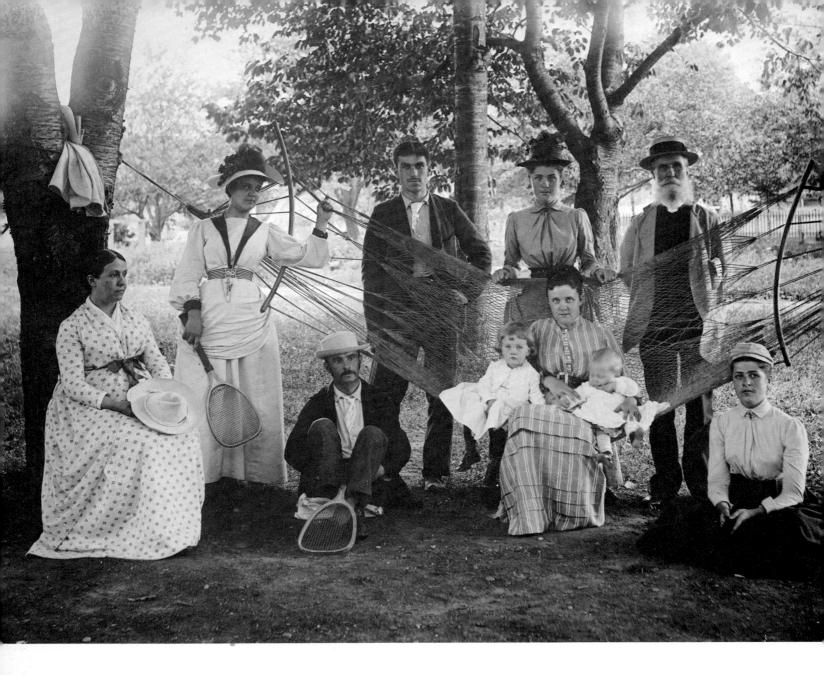

ABOVE: The Eccleston family on vacation in Putnam County, N.Y. Trude stands at the left, behind her mother, while her sister Edith (Mrs. Albert Blunt) struggles to hold little Bertie and Stanhope. At Trude's feet sits Charles Barton, her future husband. (*Group near hammock. Fine clear day, in shade. 2.20 p.m., Thursday, Aug. 9th, 1888. Lake Mahopac. Perken lense, 1 sec, Stop 22*)

Alice, Trude Eccleston, Julia Marsh and Sue Ripley (from left to right) strike a pose of girlish friendship on the Austen lawn overlooking the Narrows. They spent much of their youth in each others' homes, forming a club that was nicknamed by the excluded young men of the neighborhood. (*The Darned Club. 3 p.m., Thursday, Oct. 29, 1891*)

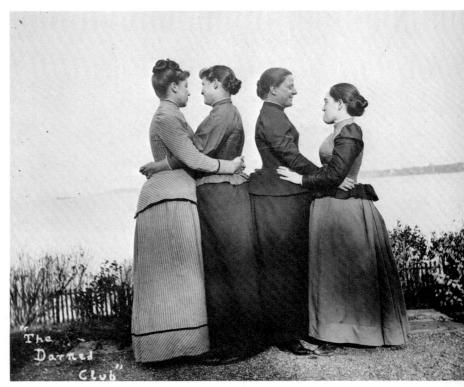

Three hours after the photograph at the top of the opposite page was taken, Trude, her sweetheart and a friend relax in front of Alice's camera in a less formal pose. (*Group on Petria. Trude, C. Barton and H. Wright. Fine clear day. 5.15 p.m., August 9, 1888. Lake Mahopac*)

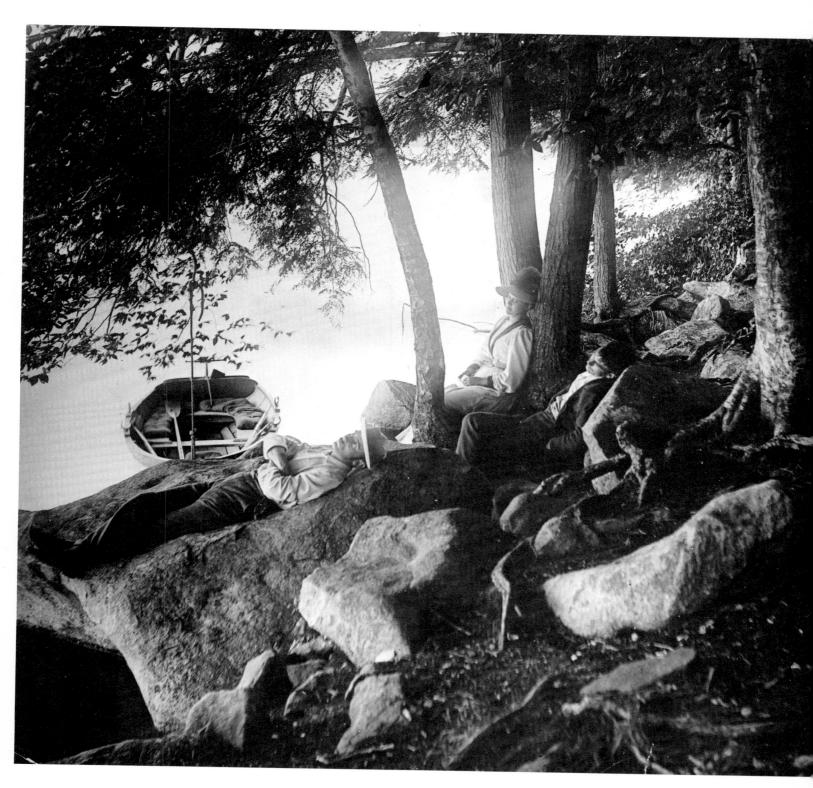

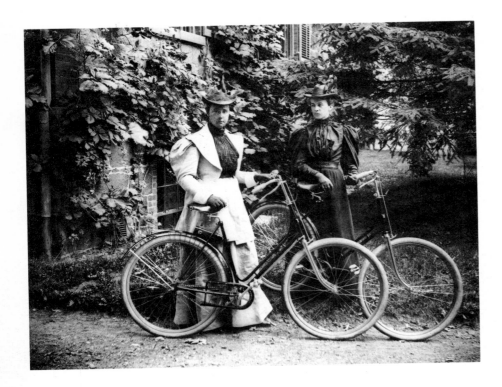

Violet Ward (left) and gymnast Daisy Elliott, who helped Violet with her book on bicycling for ladies, prepare to mount their vehicles in the driveway of the Wards' house.

BELOW: The Wards' mansion was one of many Staten Island homes that boasted private tennis courts in the nineteenth century. Violet and Carrie attend to the net in June 1890.

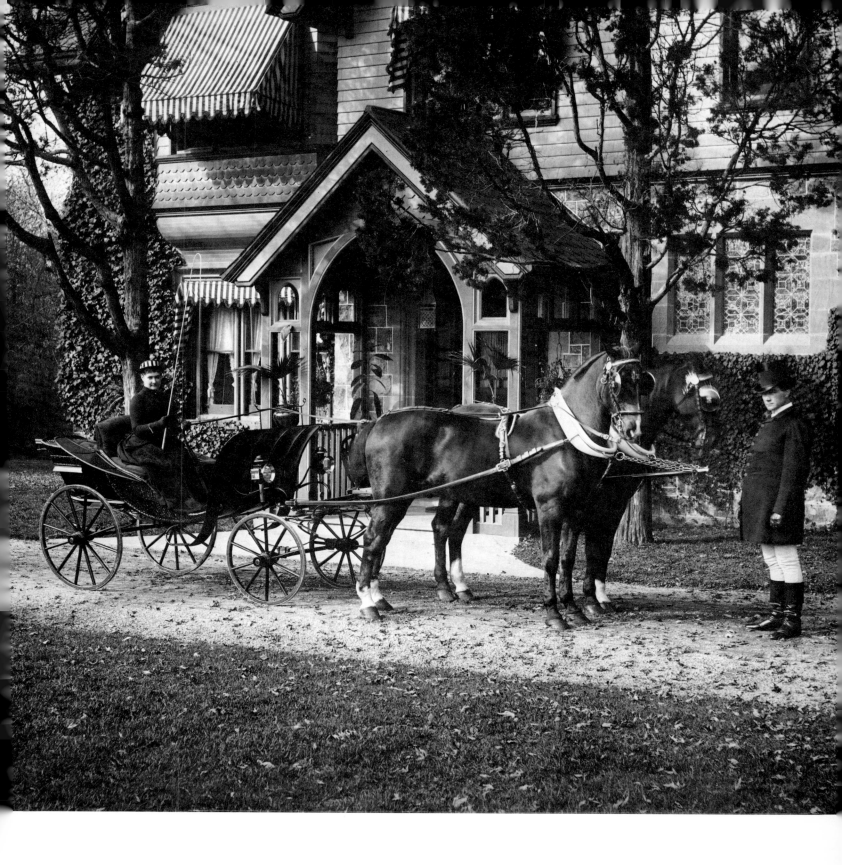

Many of Alice's friends shared her love of horses, dogs and cats, as well as of riding and other sports. (*Miss Hoyt, horses and phaeton. Fair hazy day. November 1, 1889*)

General Ward's carriage at the front door of his mansion on Grymes Hill. (*Wagonnette, V. & C. Ward, and Miss Miller. Fine clear day. 3 p.m., Wednesday, June 11, 1890. Seed 25, Perken lense, cap off & on, Stop 22*).

BELOW: Away from the eyes of coachmen and parents, the behavior of proper young ladies could degenerate into "high jinks." Alice and her friends pretend to be intoxicated on lemonade and ginger ale. (*Party on steps of wagonette. Violet & Carrie Ward, Miss Jenkins, Trude Eccleston, E. A. Austen. Fine, bright sunny day. 2.40 p.m., Mon., Nov. 2nd, 1891. A&R 40, Instantaneous, Waterbury lense, 10 ft.*)

OPPOSITE: A musical evening at the Wards'. The General stands with his trumpet, which he played well. Seated are his brother Charles ("deaf as a post") and Charles' wife. At the right are the General's children, Violet and Frank (standing) and Carrie (seated). (*Group in parlor at V. Ward's. 10 p.m., Sun., March 24, 1889. Carbutt 25 light, Flash, Stop 11*)

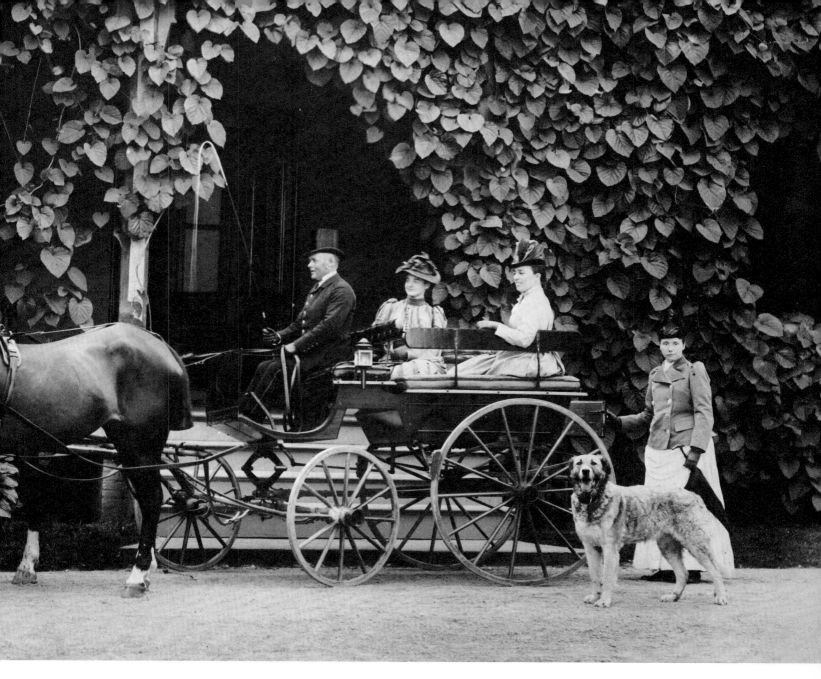
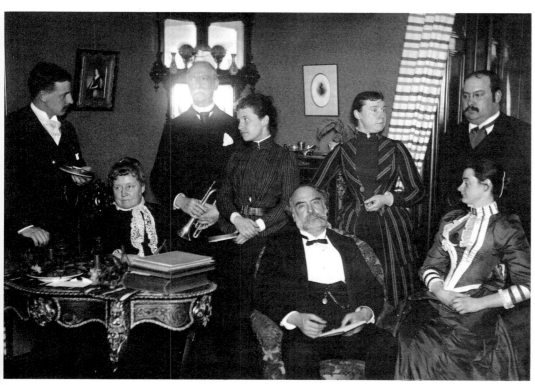

Gertrude move to "Clear Comfort." Gertrude's family was appalled that her move, based on what they considered her "wrong devotion" to Alice, would remove her from the reach of any remaining suitors; but Aunt Minn was delighted that, after so many years, her pressing invitations to join the Austen household had finally been accepted. Gertrude arrived in Staten Island just in time to keep Alice company in the old house, for Minn, aged seventy-seven, died the next year. Alice was then fifty-two, Gertrude in her mid-forties.

Gertrude had one suitor who remained a lifetime friend, even after she firmly rejected him, and he sometimes met Gertrude and Alice during vacations in Europe, where he put his car at their disposal. Alice never lacked for escorts in her youth (and several photographs survive of a particularly handsome Mr. Langford), but she never seems to have considered marriage. From her earliest childhood memories of her mother's betrayal by Edward Munn, she undoubtedly retained some mistrust of men as husbands, even though she enjoyed their companionship. She explained to Oliver Jensen in 1951 that she had been "too good to get married"—too good at sports, too good at photography and all mechanical skills, to appeal for long to the young men about her. A slight note of scorn crept into her voice as she reminisced to Jensen about the young men who were so particularly impatient about holding still for her camera, but pleased enough to receive prints of themselves afterwards.

Alice Austen's fifty-year companionship with Gertrude Tate was for both of them a satisfactory alternative to marriage. By the time the two women had shared "Clear Comfort" for several years, they had drifted into the mannerisms of comfortable domesticity ("Don't *fuss* so, Gertie. . . ." "Alice, do come along; you know you *always* keep people waiting. . . ."). Gertrude was in charge of the kitchen, but Alice always prepared breakfast for her, carrying the tray up to the south bedroom long after arthritis had made the staircase a daunting climb. Their personalities and talents were very different and they seemed to many friends to be naturally complementary to each other.

Because of their closeness, Gertrude Tate was in a unique position to observe and to remember Alice in action as a photographer. She had particular reason to remember Alice's indefatigability in the darkroom, for that closet-like space stood next to the bedroom Miss Tate occupied (as guest and resident), and many was the night when Alice bumped around in there, developing her negatives, until two or three o'clock in the morning. Alice, of course, was a night owl; poor Gertrude Tate an early riser. She attributed Alice's photographic success to a combination of artistic sense (inherited from her mother), the tirelessness of an athlete, and sheer stubbornness of will.

Reminiscing in 1951, Miss Tate repeated to a reporter several times that for Miss Austen a picture always had to be "just so." She was firmly courteous in getting people to pose for her, but she simply did not care how impatient her suffering subjects became. Their expressions had to be right, the overall composition had to please her, and the exposure had to be exactly correct for the light. Her subjects would protest ("Get it over with, Alice!" or "Do come on, Alice!" or simply an agonized "Pleeease!"), but their complaints never had any visible effect on her. She would go to almost any lengths to get the picture she wanted. She once showed Gertrude a beautiful photograph of a moonlit

landscape, explaining that she had noticed the unusual quality of the light as she lay awake in bed, and had rushed out onto the lawn in her nightdress at once, to make sure she got her picture.

That was not the only time she was out on the lawn in her nightdress. More than once, surveyors appeared on the Austen property, armed with official documents and the information that Edgewater Street (which runs south down the shore from Vanderbilt's Landing and turns inland at an abrupt right angle as it meets the Austen fence) was to be continued across the end of their land to join Andrease Street and form a continuous waterfront road. Alice, convinced that the Austens' deed to the property included riparian rights, and damned if she was going to see their private carriage road turned into a public thoroughfare, watched silently as the surveyors from the roads department worked. In the dark of the night she tiptoed out of the house and removed their stakes and flags, throwing them into the water and carefully tramping down the turf to remove any sign of where they had been. Next morning, the road crew arrived, exchanged a few words, sighed, and began their work again. That night, Alice came out of the house again and removed all traces of it. Edgewater Street still ends at the fenceline, and the Austen garden is today a public park extending to the water.

Alice's stubbornness led her into behavior that was often unconventional, frequently admirable, and occasionally foolish. She was independent and proud, and sometimes, especially in later years, people said she was imperious or autocratic. She inevitably made some enemies, many of them simply jealous of her position and her talents. She was a born leader and organizer, always open to the charge of being "bossy." She was favored and gifted in many ways, in her youth with money, all her life with keen intelligence and curiosity, extraordinary physical energy and determination, and the patience of a perfectionist for projects which attracted her enthusiasm. She was impatient with those she judged pretentious or silly. But she had an engaging warmth and sensitivity for people in general, and she had a particular affection for awkward teenaged boys and for very small children (who would run instinctively to hold her hand, or clutch on to her long skirt), as she had for horses, dogs and cats. Her subtle sense of humor, visible in the mischief shining in her eyes in the surviving photographs, tempted her to make fun of unsuspecting victims and to play practical jokes. She was obviously popular, and often the center of attention, but in large groups she would fall silent and leave the chattering to others, since silence came naturally to her. In her relationships with friends, she was direct and frank, sometimes sentimental. She hated to discard mementoes of the past, and her downstairs bed-sitting room became a cluttered repository for old papers, photos, knickknacks and souvenirs, all of which she refused to throw away. She was a private person, with a sense of quiet dignity dictating that emotional vulnerabilities should be, whenever possible, hidden from all but the closest friends. But her affection and loyalty for those close to her are shown by the fact that many of her friendships lasted for life. She was loved.

A century ago, as today, children played on the rocky beach below the Austens' garden. (*Five-masted* (sic) *schooner & children on beach. Fine, clear, day. 2.15 p.m., Sat., Oct. 18th, 1890. A&R 40, Instantaneous, Dallmeyer, 60 ft.*)

Bertie and Stanhope Blunt, in Alice Austen's own express cart, Tuesday, May 14, 1889. Because of her fondness for Edith Eccleston Blunt's children, this was one of Alice's favorite pictures: she submitted it (entitled "A Cartful") to a photographic contest.

BELOW: Alice Austen enjoyed children, and she photographed them—from the era of pony-cart and sail to the age of gasoline and steam engines—for more than forty years. Roger Emmons and his Shetland pony pause by the hitching post and cedar gate on the north side of "Clear Comfort," April 18, 1889.

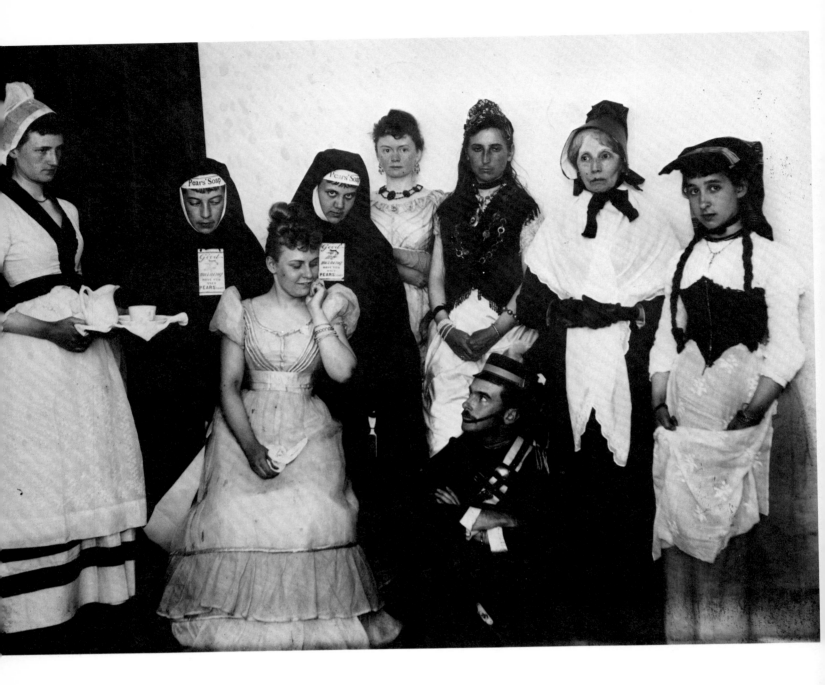

Alice and Trude, dressed as "nuns" for a charade, enjoy themselves on holiday at Twilight Rest in the Catskills. Visiting the Ecclestons again at this resort ten years later, Alice met her closest friend, Gertrude Tate. (*Pears Soap. Misses Brand, Hensley, Smith, Jessup, Eccleston, Austen & C. J. Barton. 11.30 p.m., Thursday, Aug. 15, 1889. Double charge of powder. Gas turned full on*)

LEFT: Gertrude Tate, Alice's intimate friend for more than fifty years, soon after their meeting at the turn of the century. Sitting on the porch at "Clear Comfort," Gertrude's pose is strikingly reminiscent of Alice's self-portrait of 1892.

RIGHT: Years later, Gertrude sits for Alice's camera in the same chair, beside the fireplace in the parlor. She moved into "Clear Comfort" around 1917.

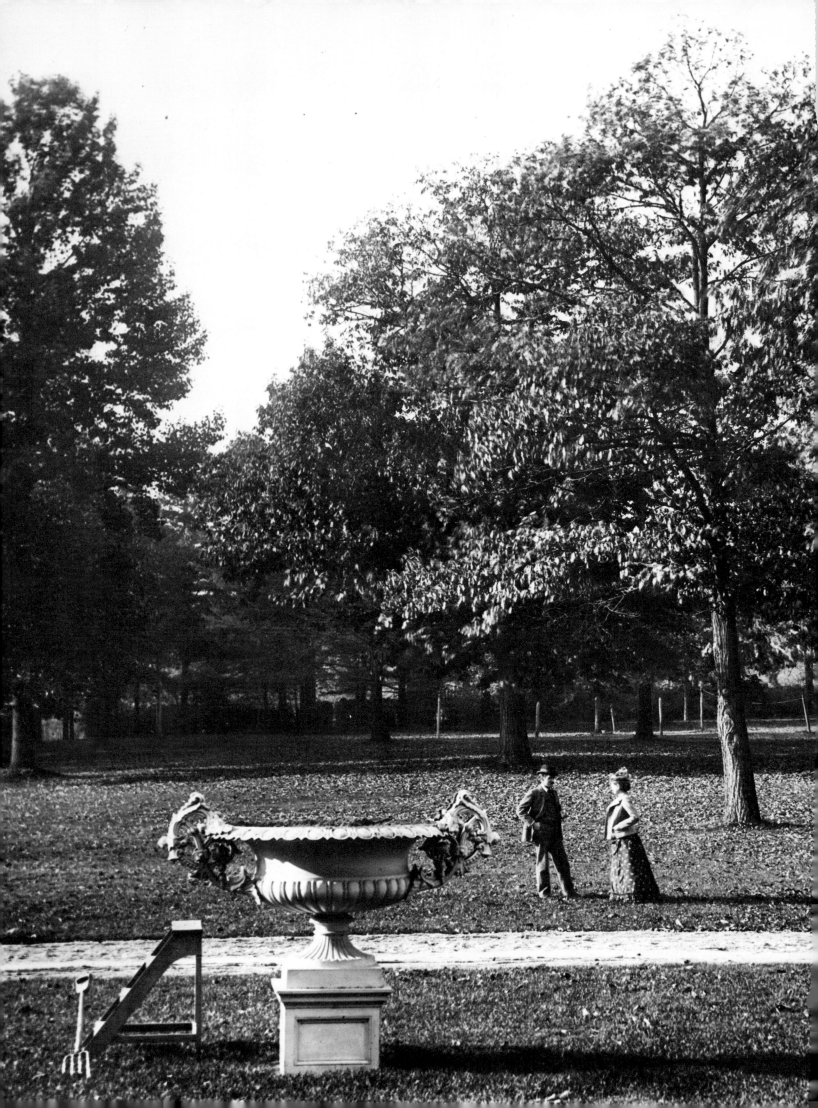

CHAPTER TWO:

Staten Island As It Was

The Staten Island depicted in Alice Austen's nineteenth-century photographs—a peacefully rural place where the well-to-do and the very rich enjoyed a fashionable social life at private clubs and in houses staffed by servants—has vanished into the past. Alice's world has disappeared just as irrevocably as the island's earliest Dutch and French farming settlements, established in the seventeenth and eighteenth centuries among the creeks and wooded hills of the colony named *Staaten Eylandt* (in honor of the parliament or States-General of Holland). Some glimpses of the past may still be seen. Religious and educational institutions have preserved a few Victorian houses, and the island also has more restored eighteenth-century buildings than any other area within greater New York City. But shopping malls and industrial parks now cover old farmlands and marshes, and modern housing developments have crept across the acres of orchards, broad lawns and the gardens that once surrounded the largest homes. Local commuters and long-distance drivers speed to New Jersey and Brooklyn on new expressways and across the bridges that have replaced all but one of the ferries that used to run to the mainland from a dozen villages dotted along the shore. The boundaries of these villages have disappeared into the new geography of the city's fastest-growing dormitory suburb. Home to twice as many New Yorkers as lived there a decade ago, Staten Island has also become the southern bypass route around Manhattan for the heavy traffic that crosses the northeastern United States from New England to the Middle Atlantic States. Giovanni da Verrazano, the Italian navigator who discovered the island in 1524, would regard with total disbelief the world's largest suspension bridge, named in 1964 in his honor, arching high above the Narrows to a point half a

Autumn leaves cover the grounds of the Alexanders' house, "Effingham" in Dongan Hills, which six years later became the Richmond County Country Club. (*View of their place from Lou Alexander's piazza. Fair day, some sun. 3 p.m., Fri., Oct. 30, 1891. Seed 26 plate, Perken lense, Stop 22, 2½ secs*)

mile south of the Austen house. So long that its design had to compensate for the curvature of the earth, with steel towers rising 700 feet above the water, the bridge is able to carry 50 million cars and trucks a year. Verrazano would never recognize "the pleasant place below steep little hills" that he saw from his three-masted *Dauphin*, nor find any traces of its original inhabitants "dressed with feathers from birds of different colors." The ghost of Alice Austen, twenty-five years after her death, might have almost as much difficulty in recognizing the people and landmarks of the quiet island she once knew and loved so well.

"Here were solitude, serenity, relaxation and picturesqueness," in the words of a visiting journalist from *Harper's New Monthly Magazine* who toured Staten Island in 1878, when Alice was twelve. Visitors in the past were always lavish in their admiration; those who stayed, for annual summer holidays or for periods of refuge from political events in the larger world, gave the island much of its social character and historical interest. The defeated Mexican President Santa Anna, Kossuth of Hungary and the Italian patriot Garibaldi all found shelter there, as did many revolutionaries from Germany and Poland, and the Russian writer Maxim Gorky. The small island seems to have been big enough for people of all persuasions: brewers and a temperance camp, prominent abolitionists as well as the families of Southern planters seeking safety from the fighting of the Civil War.

Outsiders of importance first came to the island, in the 1820's and 1830's, as guests of Daniel Tompkins, Vice President of the United States under James Monroe. Tompkins owned land on the northeastern shore, just above the site of the first Dutch settlement and the place where outgoing ships paused to take on fresh spring water. On his acreage he built a flourishing village (naturally called Tompkinsville), a large villa on the hill above it, and one of the island's first elegant mansions, a limestone house in Federal style, as a present for his married daughter. Her "Marble House," as it was called, erected in 1821, was surrounded by landscaped gardens, stables and coach-houses, and it must have been proudly exhibited to General Lafayette, Tompkins' guest in 1824. Tompkins' dining tables could be laden with tasty oysters from the bay, fresh vegetables and fruits from the neighboring small farms and orchards. On the hottest summer days, the sea breeze that cooled the island scarcely ever failed, and from the central ridge of hills the views were spectacular in every direction. Several of the Vice President's guests so admired his agreeable way of life that they built houses of their own on his lands (his hilltop holdings became known as Grymes Hill after the Grymes family arrived in 1836).

To the northwest of Tompkinsville, an imaginative newcomer called Thomas Davis developed a village he named New Brighton, after the English seaside resort made popular by the Prince Regent. Its central attraction was the Pavilion Hotel, designed like a great Greek temple with a colonnade two hundred feet long. The Pavilion became famous as the most fashionable hotel in the country, and its reputation spread to Europe. By the late 1830's, Staten Island's golden age, destined to last until the turn of the century, had begun. Fine carriages with matched pairs of high-stepping horses became as common a sight as farmers' wagons on the once quiet roads. Jenny Lind came

This Rhine castle on Grymes Hill was erected as a monument to his prosperity by brewer August Horrmann, who in 1870 opened the island's most successful beer-making establishment with his partner Joseph Rubsam. Rubsam & Horrmann's beer won gold medals and was famous for decades.

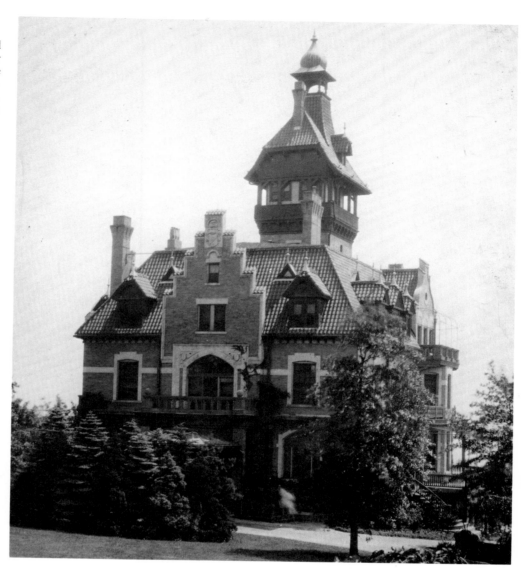

BELOW: Horse-drawn streetcars travel along the avenue now known as Bay Street. (As a youngster, Alice's special treat was to stand behind the driver and hold the reins). (*New York Avenue—election banners and Catholic Church. Fine clear day, breeze. 9.40 a.m., Fri., Nov. 2, 1888. Perken lense, Stop 22, cap off and on*)

ABOVE: O'Connor's blacksmith shop. Wednesday, November 18, 1896.

John Silva's shad-fishing station, on the beach just north of "Clear Comfort," one of Alice's favorite photos, which was published in *Camera Mosaics (A Portfolio of National Photography)*. The photographer and her family, in turn, were great favorites of the old fisherman, who named his son Austen in honor of Alice's grandfather.

OPPOSITE: Staten Islanders carry lumber from a sailing ship that met disaster. (*Wreck off Mike Lyman's Caribbean dock. 2.20 p.m., Sat., Nov. 14, 1897*)

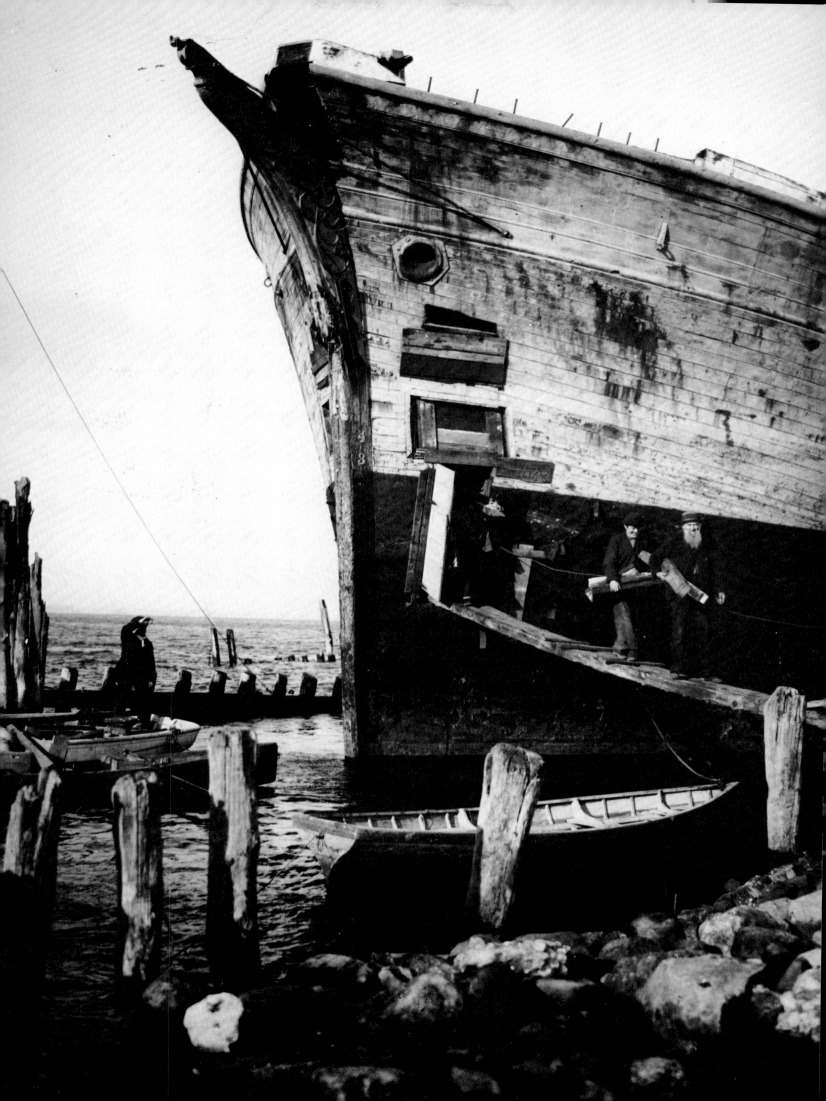

to stay, and to sing, at the Pavilion, and increasing numbers of guests thronged there and to the Castle, St. Mark's and other hotels. Aaron Burr ended his days in an inn at Port Richmond, and the Prince of Wales (later Edward VII) danced until dawn at a ball given in his honor in a private mansion in Rossville. In winter as in summer, the stream of visitors never ceased. Yachting and modest bathing, ice skating and sleighing parties began to supplant farming and fishing as the island's principal activities.

By the time Alice Austen's grandparents moved to the island, many visitors had chosen to stay—as summer or year-round inhabitants—in houses they built themselves. Staten Island society, revolving around families such as the Vanderbilts and Roosevelts, became rich and fashionable, and attracted still more new residents. A mile inland from the Austens' house, Judge William Emerson established himself in an area still known today as Emerson Hill; he brought Henry Thoreau to his house to tutor his children one summer, and invited as guests his younger brother Ralph Waldo Emerson and the family of Thomas Munroe (Peter Austen's future father-in-law) from Concord, Massachusetts. President John Tyler's family moved into a handsome mansion to the west of Grymes Hill, and Sir Edward Cunard erected a hilltop residence from which he could watch the ships of his father's line. Some years later, the Barrymore family had a summer house. Young Frederick Law Olmsted bought an old farm on which he planted thousands of trees and began his experiments with landscape architecture, while on the slopes of the green hills and along the shore other new residents experimented with architecture of a different sort, building Victorian Gothic villas and cottages, English-style manor houses and ornate stone castles with improbable turrets of French or Moorish origins. The owners of these buildings were beer barons and railroad men, bankers and philanthropists, industrialists, importers, editors and physicians. In the north shore community of Livingston, Bard Avenue became known as "the Fifth Avenue" of the island, its most fashionable residential street.

Between Bard and Davis Avenues, after 1885, lay the playing fields and courts of the Staten Island Cricket and Tennis Club, noted as much for its teas and parties as for the exciting matches played there. Founded in 1872 as the Staten Island Cricket and Baseball Club, the organization first used, as a playing field, a piece of flat land down by the waterfront to the east (once a Civil War training ground, today covered by the St. George ferry buildings and parking lots). The character of the club changed quickly and by chance. Mary Ewing Outerbridge went, in the winter of 1874, to Bermuda, where she enjoyed watching British officers and their wives playing the new sport they called Sphairistike (after an ancient Greek hand-ball game), introduced in Wales the previous year. With her steamer trunks stuffed with nets, racquets and balls, Miss Outerbridge sailed home to Staten Island in the spring of 1875, and set to work persuading her brother (one of the officers of the Cricket and Baseball Club) to let her mark out a court and set up a net on a corner of the club's grounds. The new game, renamed tennis, caught on at once that summer: one reason for its success may have been that Mary Outerbridge and the other young ladies of the club found hitting a ball over a net much more entertaining than sitting on the sidelines while the men played baseball and cricket. By 1880, when the first National Lawn Tennis Tournament ever played in this

country took place on the Staten Island courts, the game was so popular that hundreds of spectators, on horseback and in phaetons, drags and dogcarts, drove to the shore to watch. Five years later the club dropped Baseball from its name in favor of Tennis, and moved to its new grounds in Livingston. There nineteen-year-old Alice Austen began to spend countless summer afternoons, on the courts and behind her camera, photographing the players and the crowds of spectators, the band that played for the opening day of the Ladies' Club, and champions like the Misses Grace and Ellen Roosevelt (first cousins of Franklin Delano). "This is not going to be a cricket club, some day," she recalled thinking, "and I'm going to have pictures of how it looks now."

Alice was right, in the long run. The club's grounds today are a public park, and named after Randolph St. George Walker, Jr., a local young hero of World War I. Cricket has not been popular on Staten Island for a long time. But the sports-centered and leisurely social life that Alice and her friends enjoyed did last for many years, until the War and the Depression ended it and changed Staten Island. In Alice's youth, tennis became so popular that courts soon appeared in her own neighborhood of Clifton, at the Richmond County Country Club in Dongan Hills, and in other villages and towns across the island.

In their enthusiasm for the new pastime, many families laid out small courts (of unorthodox dimensions, if need be) on the lawns behind their own houses. Among these families were the Wards and Austens. Even the parade ground in the battery of Fort Wadsworth gave way to tennis courts, with the cannon pushed away to one end of the grass in a rather charmingly peaceful gesture.

Private facilities for sports were not unusual in those days of large gardens and roomy houses. A full-scale bowling alley, for example, occupied a floor of the house owned by railroad magnate Nathaniel Marsh, father of Alice's friend and neighbor Julia. But the mid-1890's saw the introduction of one new sport which could not be accommodated in anyone's house or garden: this was the game of golf, first played on the island by a small group of members of the Country Club. In 1897 the club leased "Effingham," the Dongan Hills residence of the Alexander family, and laid out an eighteen-hole course (it survives as the last private golf club within New York City). This newly rented clubhouse, a handsome building dating from the 1840's, had another asset: brick stables with plenty of stalls for the horses members kept there for fox hunting. Alice loved the horses, and spent hours with the Irish stablemaster, Barney Gleason, discussing and admiring them.

The women of Staten Island society, like their prosperous sisters across the country, participated in the hunts and the games of tennis and golf with special zest—for it was only in the 1880's that they had been released from the steel-ribbed corsets that had prevented them from bending, running, or even walking and breathing easily, and from the social convention that young women should be delicate (for a lady's physical frailty was a sign of her husband's social status). The Puritan suspicion that sports were allied to sin and sloth lingered long into the nineteenth century. But after the Civil War, as Americans discovered the virtues as well as the pleasure of outdoor exercise, women began to play decorous games of croquet, then to participate in mixed

bathing parties, and even to mount tricycles and bicycles (which were faintly scandalous, since they could not be ridden side-saddle). Bicycling was a sport for which the pleasant shore roads of Staten Island were well suited. It was one of Alice Austen's particular enthusiasms: she carried her camera along to cycling races and teas, was proud when the island's club produced a national champion, and did her best to promote the sport by helping with Violet Ward's book and by joining the League of American Wheelmen. The summers of the 1880's and 1890's must have passed much too quickly for all the sports and swimming, sailing and canoeing, parties and picnics that Alice and her friends wanted to enjoy.

The pleasures of nineteenth-century life on Staten Island carried with them the seeds of their own demise. As more and more New Yorkers crossed the harbor, for the day or for the summer, to enjoy the island (particularly its beer gardens and beaches), promoters began to introduce innovations such as an amusement park, complete with a one-hundred-foot-high electrically illuminated fountain and Buffalo Bill's Wild West Show on tour. Railroads made the quieter areas of the island more accessible. Across the green hills began the slow advance of tree-lined streets and compact houses for middle-class residents, foreshadowing the housing developments of the twentieth century. Partly to accommodate the new residents and their visitors, the first consolidated ferry service to and from Manhattan was instituted in 1890, and a few years later Staten Island became (as the Borough of Richmond) part of New York City. Oldtimers on the island grumbled that their self-contained and peaceful way of life would be spoiled by these actual and symbolic links to the metropolis. They were right. By 1900, as electric trollies replaced horsecars on the streets of the growing towns, light industry began to intrude upon the island's countryside. There were new power plants, and small factories for making paper and fireworks, jewelry boxes and white lead. One of the world's first airplane factories opened on Ocean Terrace to the west of Emerson Hill. Water pollution from sewage and from ships in the harbor began to destroy the oyster beds, which were condemned and abandoned in 1916 after the Department of Health traced some typhoid cases to local shellfish. The island's wealthier residents and summer visitors began moving away to quieter and newer residential areas and resorts. The upheavals of World War I and its aftermath ended Edwardian living, and the advent of Prohibition dealt a blow to the island's prosperity for it closed down the breweries, just one year before Alice Austen was legally entitled to vote for the first time. The cotillions, the coachmen with their handsome horses, and the servants in the large houses, slowly disappeared one by one along with the nineteenth-century lifestyle and the residents who had peopled the world of Alice's youth.

Some aspects of Staten Island life did not change. Because of its position at the entrance to New York's harbor, the island still gives space (as it always has) to the business of the sea and of military defense. Sailors' Snug Harbor, opened in 1833 as a Home for Aged, Decrepit and Worn-out Sailors (in its founder's words), has only this year vacated its Greek-Revival buildings to the east of the old Staten Island Cricket and Tennis Club grounds. Fort Wadsworth, largely rebuilt since the approach to the Verrazano-Narrows Bridge crossed its grounds, still guards the harbor more than a

century after it was named for a Brigadier-General killed in Virginia during the Battle of the Wilderness. A coast artillery post of military importance during the first World War, the fort in the 1940's was a base for 3,500 soldiers, as well as a training area for anti-aircraft units and a supply center for the 15,000 troops who defended the New York area. After World War II, Fort Wadsworth became a site for Nike guided missiles and a military radio and electronics center for the northeastern United States.

The Quarantine Station between the fort and the Austen house is still maintained by the government, although passenger ships no longer enter the harbor daily as they did when Alice photographed them from the bottom of her garden. In the early 1890's, half a million immigrants a year were sailing into New York, as the greatest mass migration in human history got under way. The immigrants were admitted through the newly-built federal station on Ellis Island (opened in January 1892), but before they were allowed to enter the harbor, all ships had to pause for inspection at the Quarantine Station, just south of the Austen house. The station itself consisted of little more than the health officers' houses (Victorian cottages set prettily on lawns that ran down to the water) and a dock for the sidewheelers used to inspect, and if necessary to disinfect, the incoming liners. No hospital buildings had been located on the island since 1858, a memorable year when outraged local residents, tired of ineffective complaints about epidemics spread from the original buildings near Tompkinsville, removed the patients one night and burned the station to the ground. Officials realized that rebuilding on the original site would be a futile gesture. They chose two small islands (called Hoffman and Swinburn) off the island's eastern shore, enlarged them with landfill, and erected on one island hospitals for sailors and immigrants suffering from smallpox, yellow fever, cholera and typhoid, on the other a complex of buildings to house possibly infected crew and passengers in isolation until the danger of a suspected disease had passed. The work of the Quarantine Station so fascinated Alice Austen that she returned with her camera, year after year for more than a decade, to record the equipment, laboratories, buildings and people of Hoffman and Swinburn islands and the shore station.

The immigrants who sailed safely past Staten Island, or who enviously watched the distant bathers on South and Midland beaches from their temporary prison on the hospital islands, had no way of knowing that one day they and their descendants would change the appearance and social life of the green, hilly island at the harbor's entrance. They were, in the early 1890's, newcomers from Italy, Russia, Poland and Austria-Hungary, starting to outnumber the more familiar faces from Britain, Germany and Scandinavia. By the first decade of the twentieth century, they were arriving at a rate of more than one million per year. No one could foresee that the children and grandchildren of these immigrants, working their way out of Manhattan's melting pot to the residential areas of Brooklyn and the suburbs, would by the mid-twentieth century populate Staten Island's new housing developments and outnumber the original farmers, fishermen and storekeepers, descendants of the Victorian nouveaux riches and of Alice Austen's social peers. Would Alice have wept or laughed, as she stood at the end of her garden watching the passing ships in the 1890's, if she had been told that "Clear Comfort" would be sold to a family of Italian tavern-keepers in her lifetime?

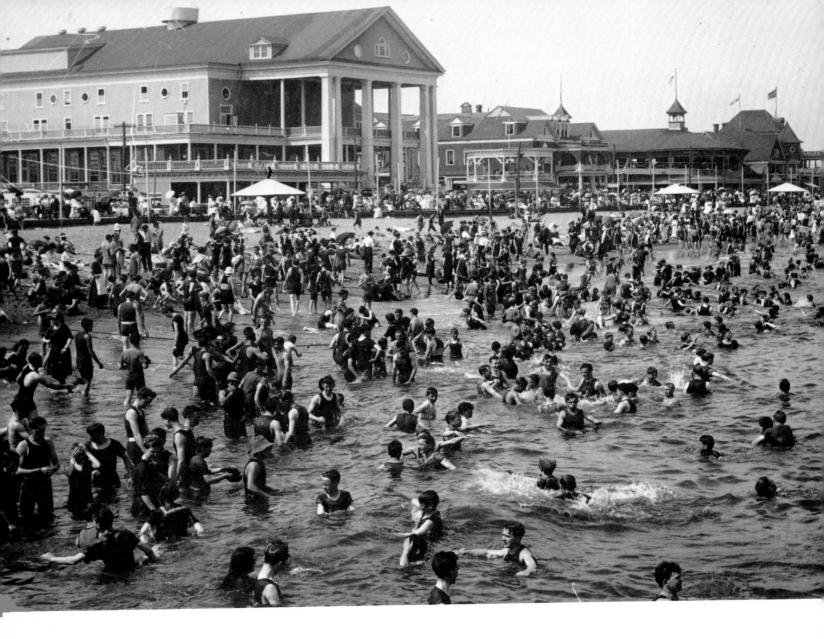

("The thousand and one"). Much more popular than South Beach up the shore, Midland Beach attracted crowds from all areas of the city. They came to enjoy the band concerts, ferris wheel and amusements of the arcade on the boardwalk, as well as the waves and sand.

OPPOSITE: Alice (at rear right) squeezes the end of her cable release and the shutter clicks to capture a South Beach bathing party on September 15, 1886. In the group are Julia Marsh (far left) and Alice's cousin Theodore Townsend (center rear).

Bathers on South Beach watch a catamaran apparently heading for collision with a pole. On the horizon stand the Quarantine hospital buildings of Hoffman Island.

OVERLEAF: The Staten Island Cricket & Tennis Club's courts in Livingston, around 1885. Arranging the players in carefully held poses, Alice has a friend release the shutter, after she herself joins the scene (right of the net, third court from the camera). She wears a dark jacket and smart sailor hat.

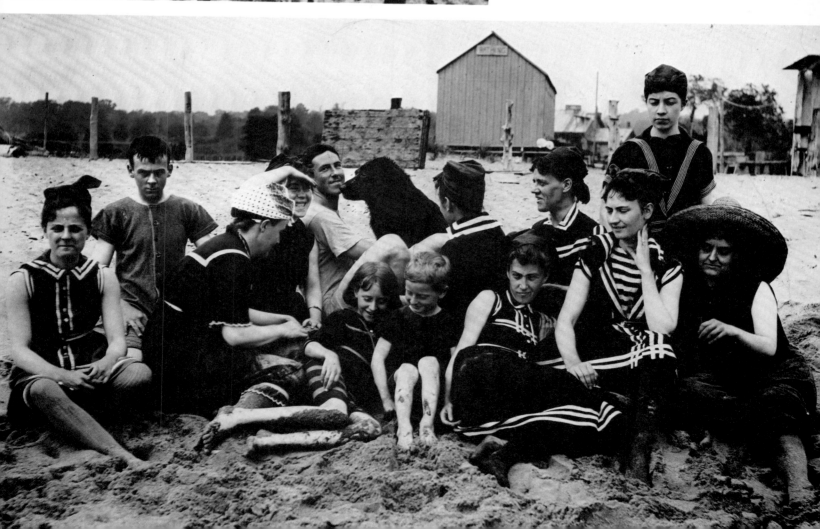

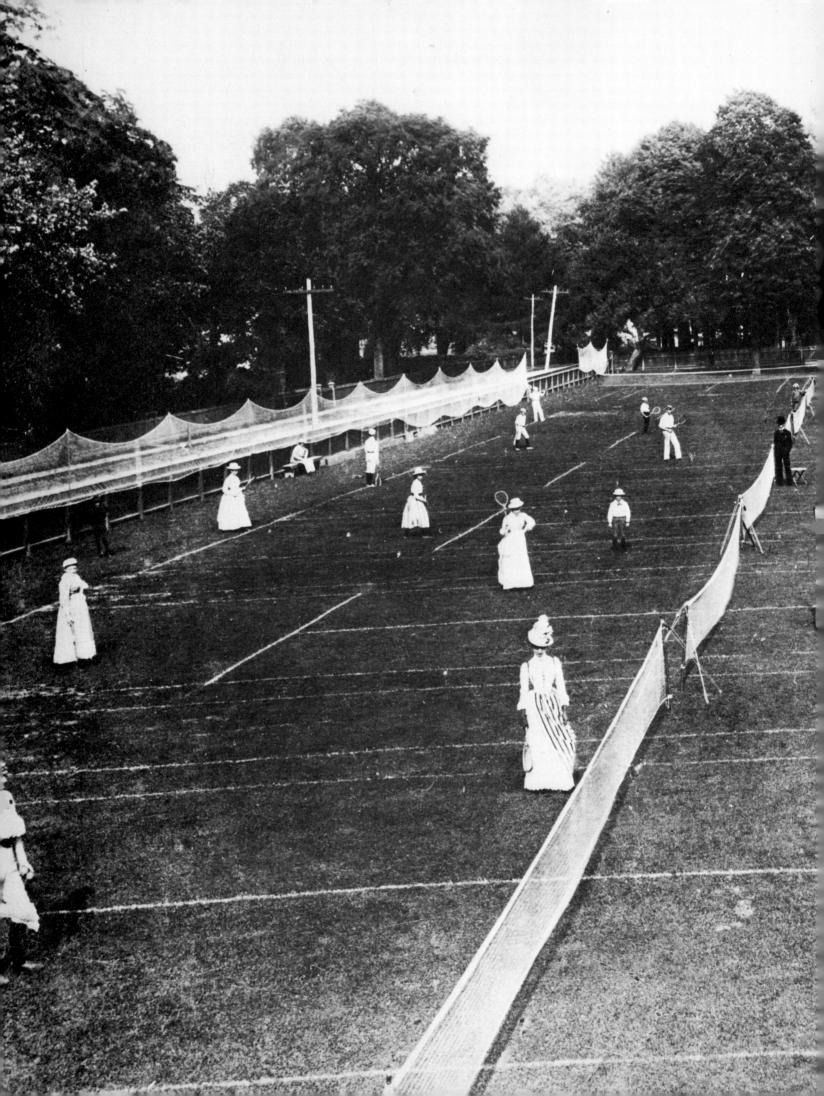

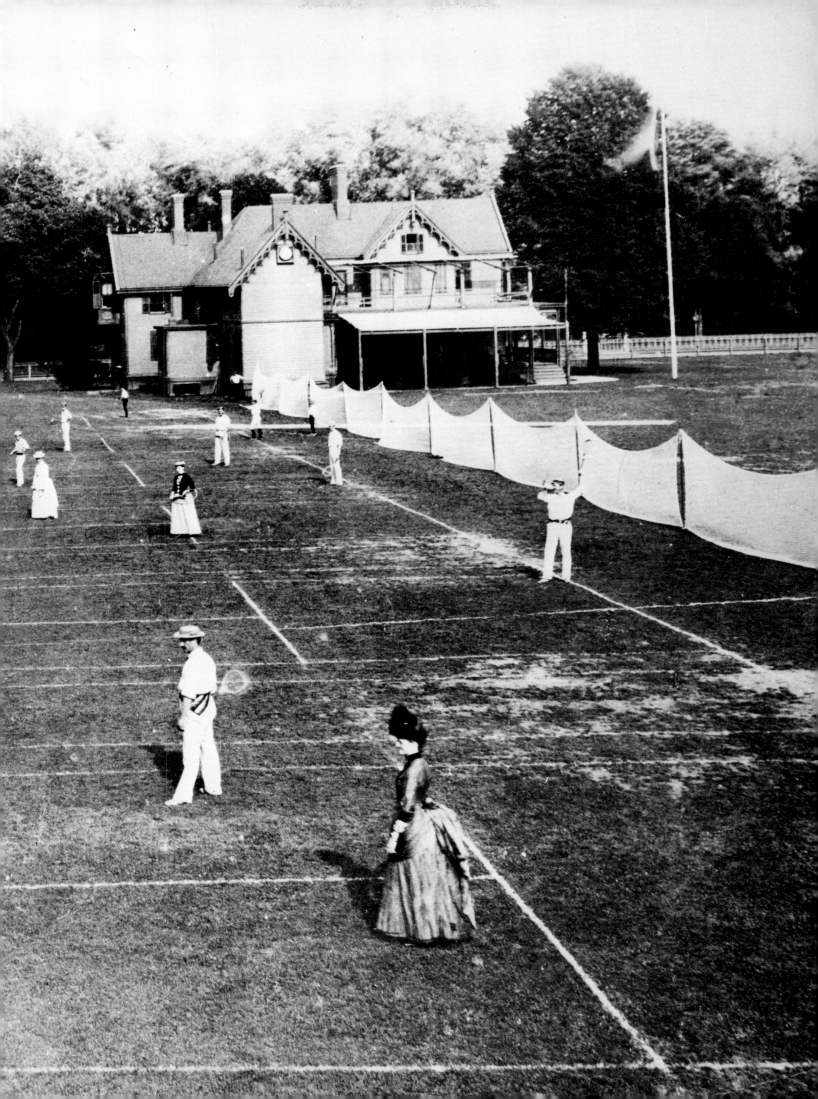

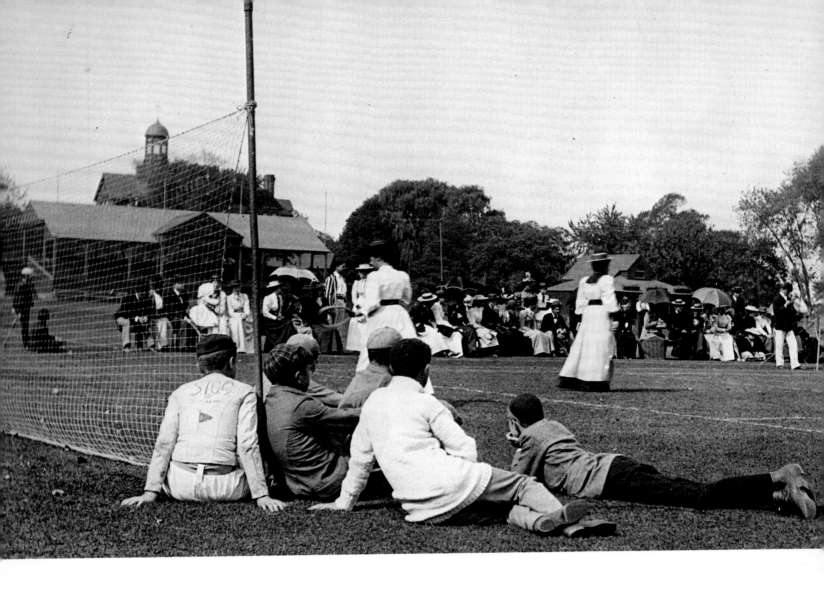

Grace and Ellen Roosevelt, national doubles champions, win another match. (*The finals, boys in foreground, Staten Island Ladies Club. The Misses Roosevelt—won 3 sets to 1—Burdette & Homans. Fine, clear day, hot. 10.30 a.m., Sat., Oct 1st, 1892. Stanley 35, Waterbury lense, 60 ft., Instantaneous quick*)

OPPOSITE: Inside the battery at Fort Wadsworth, cannon make way for more courts. (*Tennis grounds at Fort, officers playing. Fine clear day, sun. 1 p.m., Tuesday, Nov. 6th 1888. Carbutt High Sp. 25 blue label, Perken lense, Stop 32, 2 secs*)

"Never before has such clever tennis been seen among the lady players," reported *The New York Times*, "as that in the matches of the second day of the tournament of the Staten Island Ladies Club." Two contestants in the ladies' doubles concentrate on victory. (*S.I.L.C. Tournament. Miss Cahill & Miss McKinley. Fine sunny day. 3.30 p.m., Wednesday, Sept. 28th, 1892. Stanley, Waterbury lense, 50 ft. One plate went off too soon*)

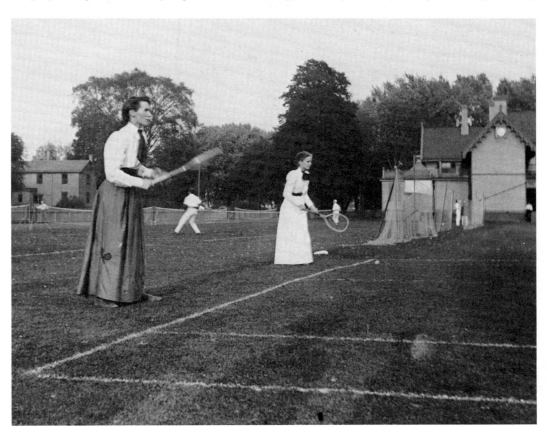

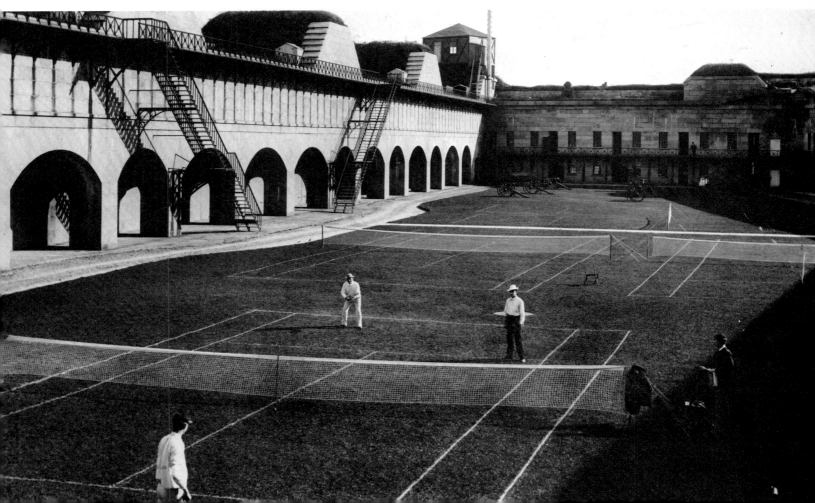

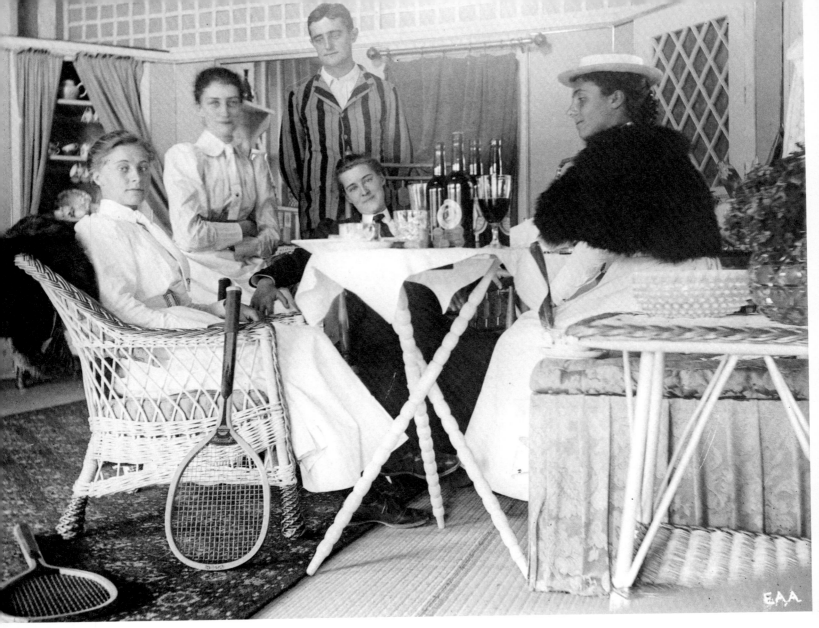

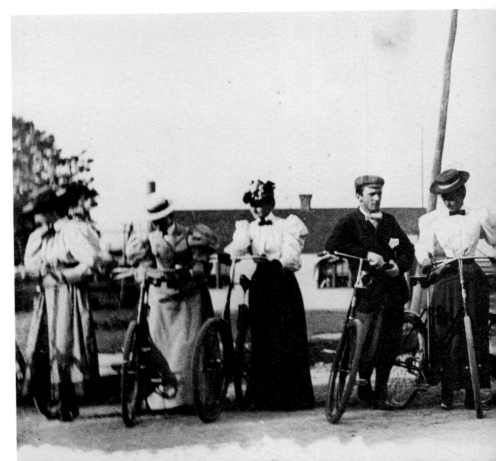

OPPOSITE: After winning the finals, the Roosevelt sisters celebrate with friends. (*The Roosevelts, Nellie Jameson, Gertrude Williams, & Mr. Randolph Walker. Lunch party, without dog. Fine clear day, hot. 2 p.m., Saturday, Oct. 1st, 1892. Stanley 35, Waterbury lense, 12 ft.*)

RIGHT: Trude Eccleston and Alice join Wycliffe Throckmorton (in the polka dot tie) and three uniformed friends, at the end of their game. (*Group of officers, Trude and self at Fort. Fine clear day. 1.20 p.m., Tuesday, Nov. 6th, 1888. Carbutt High 25 blue label, Perken lense, Stop 22, 1½ secs.*)

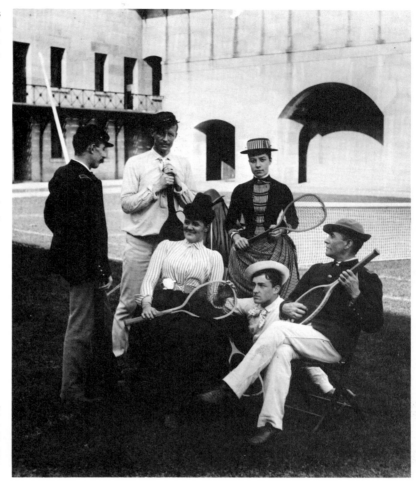

BELOW: Cyclists with new safety bicycles (two wheels of equal size, and pneumatic tires) rattled along Staten Island's unpaved roads as the new sport became a national fad. Violet Ward (center, in black hat) was the most enthusiastic of all the local "wheelmen." (*Staten Island Bicycle Club tea. 5 p.m., Tuesday, June 25, 1895*)

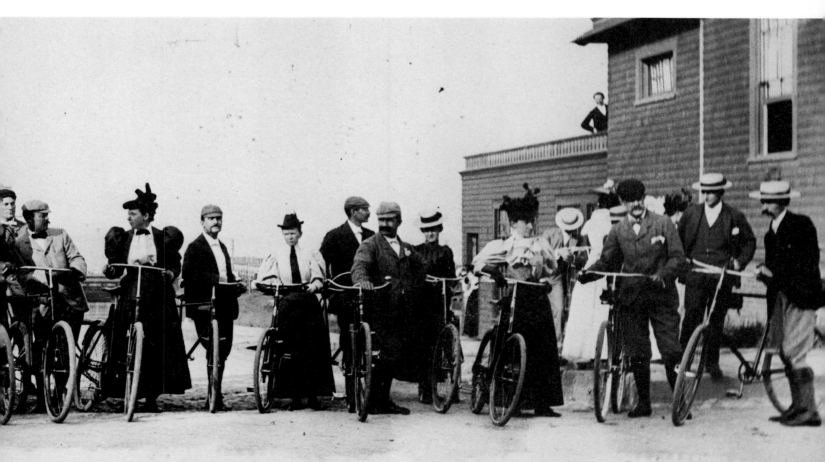

At the Quarantine station just north of Fort Wadsworth, the government paddlewheeler *James W. Wadsworth* comes alongside the steamer *Cyrene*, a 2900-ton British cargo ship from Sunderland. Yellow fever may be on board.

ABOVE: Crew members taken off the *Cyrene* react with mixed emotions to Alice and to the fact that their clothes (and everything else on board) are being disinfected by the *Wadsworth*.

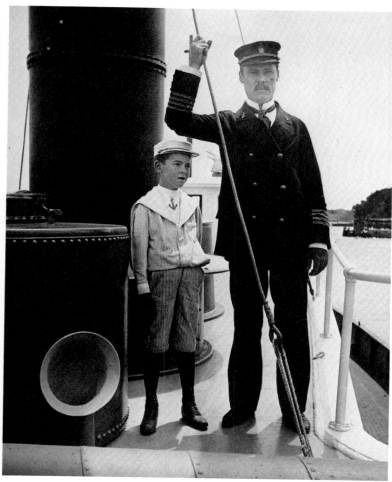

The Public Health Service doctor who asked Alice to record the Quarantine procedures and equipment poses with his son on the *Wadsworth*. (*Quarantine. Disinfecting boat. Dr. Doty & Alvah on deck. Friday, July 17th, 1896. Cramer Crown, Dallmeyer lense*)

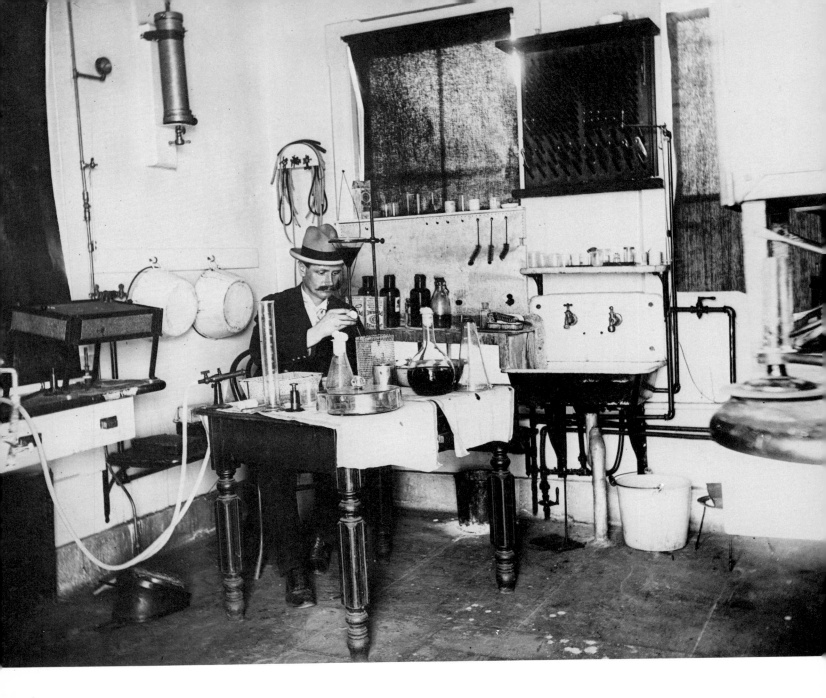

In the upstairs laboratories on Hoffmann Island, a chemist works with a pressurized, steam-heated sterilizer and bacterial cultures in the "media room." (*Quarantine. "Fred" at work. Bright day. 11.10 a.m., Mon., April 29th, 1901. Cramer Crown, Waterbury lense, 10 ft., counted 18*)

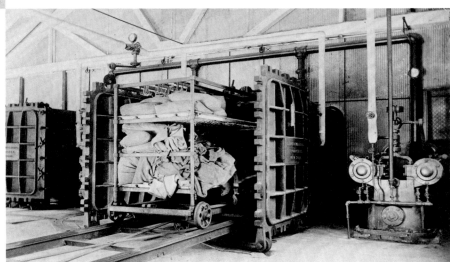

The steam disinfecting chambers on Hoffman Island sterilized clothes and bedding. Bunks in the dormitories for steerage passengers were raised every day so that the floors could be hosed down. And showers were mandatory for the detained immigrants, who were released only after doctors were sure that suspected epidemics would not break out among them.

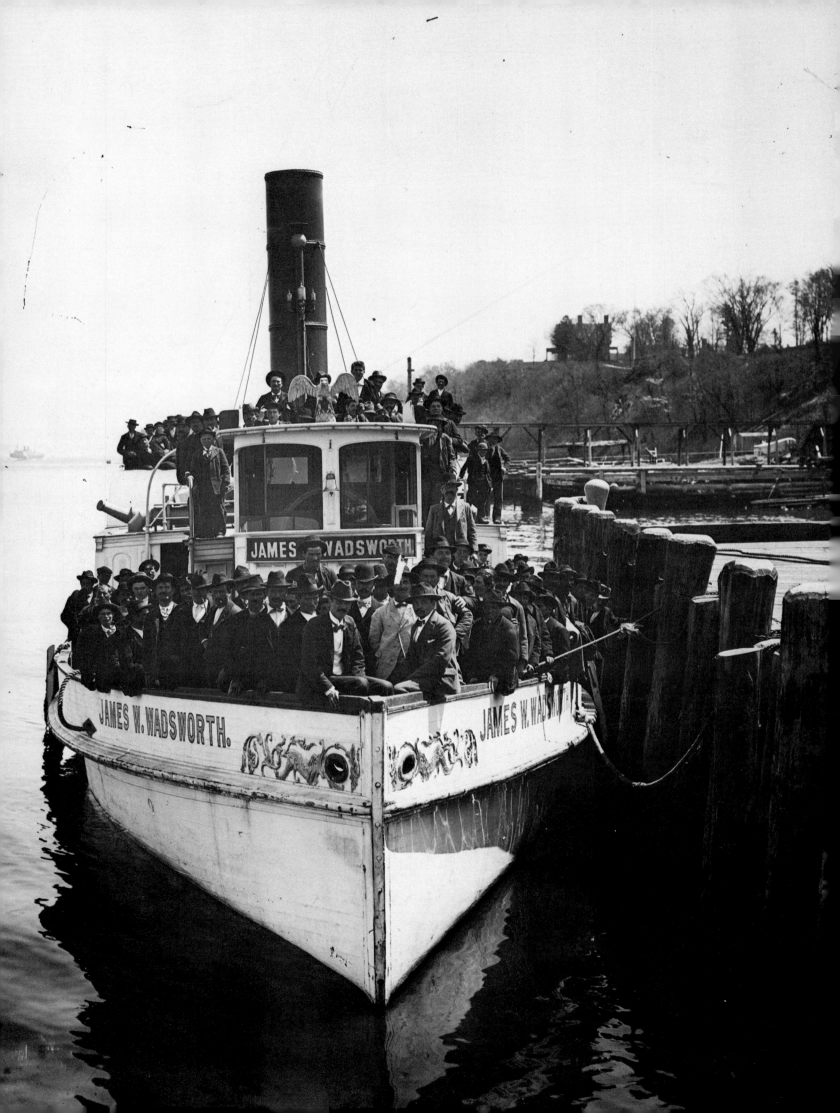

OPPOSITE: Smiling immigrants, released from isolation, resume the last stage of their interrupted journey to America. They are moored at the Quarantine docks on Staten Island, in transit to Manhattan.

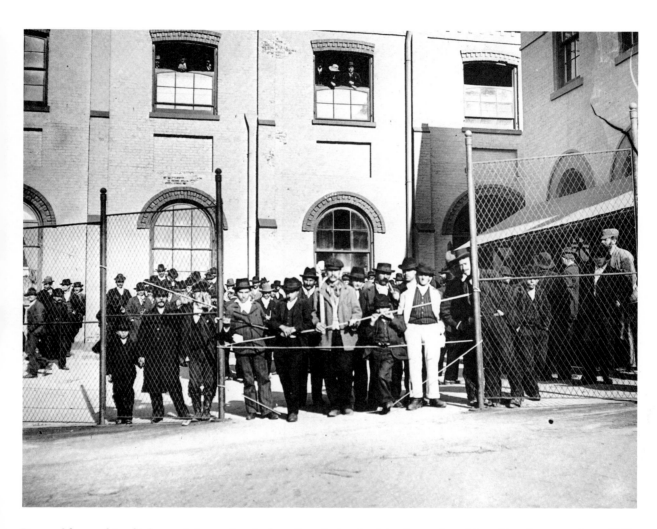

Removed from a ship which reported an outbreak of smallpox during the Atlantic crossing, dejected immigrants wait on Hoffman Island for the period of observation to end.

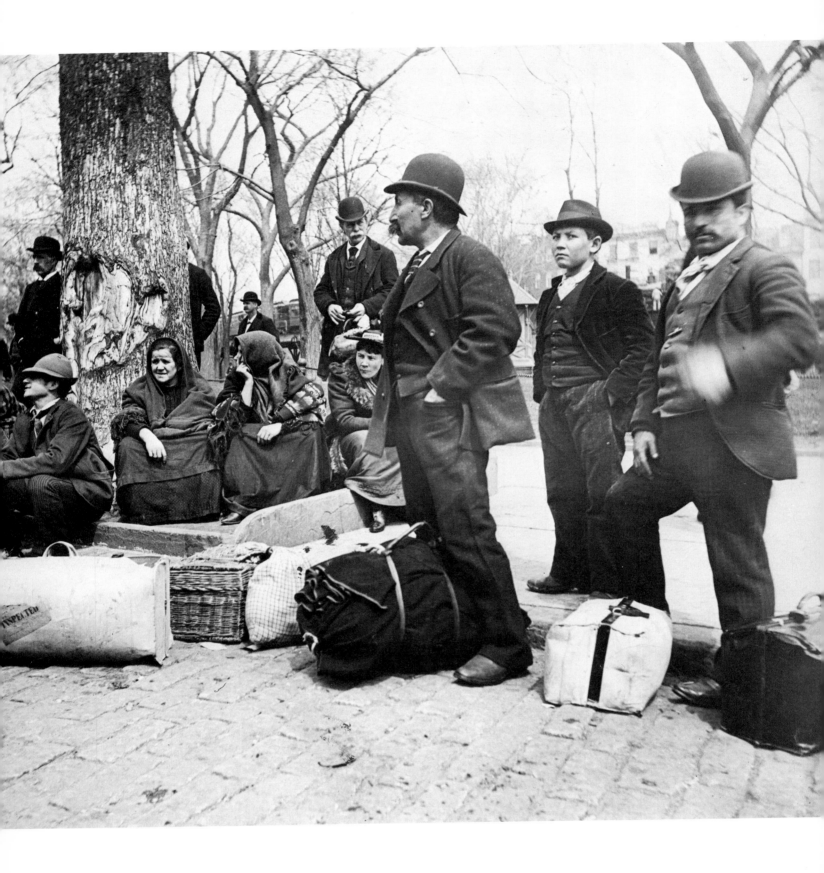

A few minutes after their entry into the new world, bewildered immigrants pause with their baggage near the ferry terminal in Manhattan's Battery Park, perhaps waiting for friends or wondering if they dare to venture on the nearby elevated railroad. (*South Ferry. Emigrants seated near tree. 10.45 a.m., Monday, April 13th, 1896. Cramer C., Waterbury lense*)

Across the Bay in Manhattan

Alice Austen watched the immigrants, as they crowded the deck of a small Quarantine boat or waited disconsolately behind the tall wire fences of the isolation quarters, with a blend of curiosity and sympathy. She knew that she was observing a special moment in the country's social history. And she followed the immigrants—past the newly erected Statue of Liberty Enlightening the World—across the harbor to lower Manhattan's Battery Park, where she photographed them as they paused for their first few minutes in the promised land, dazed and tired, beside their mounds of luggage near the Ellis Island ferry terminal.

The city that welcomed the immigrants was undergoing a social, political and industrial revolution in the 1890's. When Alice Austen was born in 1866, New York had fewer than a million inhabitants, most of them descended from old British or Dutch families or recently arrived from Ireland and Germany. The city's business still centered on its port. It was in the decade after the Civil War that the great change began. The coming of the machine age altered the city's society as it made the industrial fortunes of the Goulds, Vanderbilts and others of the select "400" (New York City boasted more than a thousand millionaires before the turn of the century). And it created a seemingly insatiable demand for tens of thousands of unskilled and semi-skilled workers. Laborers were needed to bury gas mains and to lay cables for the new electric lights and telephones, to erect steel-skeletoned skyscrapers that rose twenty stories or more, to work on the elevated railroads and dig the first tunnels for subways that would replace horse-drawn trolleys as the city's residential areas spread further and further away from the business district. New bridges spanned the East River. Roads had to be graded, paved, repaired

and cleaned. Water mains and sewers were installed as plumbing, slowly, replaced basins and pitchers and privies in the back yard.

As word spread across Europe that America's cities offered work, food and opportunity for all, New York's population soared: by 1900 the city was trying to find room for three and a half million residents. Four out of ten New Yorkers were then foreign-born immigrants, who outnumbered the native Americans in many kinds of work—half the city's draymen, two out of three tradesmen, and four out of every five laborers were immigrants. They tended to cluster in neighborhoods populated by their fellow countrymen and many of them lived in tenement buildings, airless, unsanitary, and so crowded that in one district as many as four thousand people lived on a single block. The arrival of all these newcomers created an increased demand for products and services of all sorts—for food and clothes, transportation and education, street cleaning and the removal of garbage. Immigrant laborers and their families often took the blame for lowering wages, breaking strikes or causing the problems of the city's slums, but they were in a real sense responsible for the city's growth and prosperity. They themselves worked hard for very little (more than ten hours a day for three dollars a week). Wives and young children began work at four o'clock in the morning (doing piecework sewing, acting as messengers) to supplement the family's income, for sixty percent of all men working in the United States in 1900 earned too little to support their families.

Alice Austen carried her camera about the streets of New York, photographing the newcomers and the older residents as they went about their business. Compiling a large portfolio of "street types" (which she had copyrighted at the Library of Congress), she documented street sweepers and snow cleaners, rag pickers and the peddlers who sold anything from oranges to shoe strings and suspenders. She recorded Irish postmen and policemen, Italian bootblacks who gave a spit-and-polish shine for five cents, fishmongers at the Fulton Street market, organ grinders and knife grinders under the El, messengers with shiny Western Union bicycles and uniforms, newsboys and girls so poor that they wore no shoes, and Russian and Polish Jewish women who sold chickens, eggs and vegetables in the open-air market that filled half a dozen streets on the Lower East Side.

She photographed these people quite simply because she found them interesting and somewhat picturesque. Her work has occasionally been compared to that of Jacob Riis and Lewis W. Hine, who photographed immigrants and poor New Yorkers in the city's tenements, sweatshops and streets from the 1880's to the early years of the twentieth century. The comparison does not seem apt. Riis and Hine were social reformers for whom photography was a persuasive tool; Austen was a photographer who njoyed making portraits of unusual people and who does not seem to have been moved by any particular sense of social injustice. Her subjects do not look especially poverty-stricken or downtrodden, nor do they move the viewer to a sense of pity or outrage. They look directly at her camera, for the most part posing with a good-humored grin or self-conscious pride, sometimes with an expression of quizzical curiosity—for they seem to have found their photographer as interesting a spectacle as she found them. The younger women, in particular, smile radiantly to please the attractive photographer in

the beautifully-made clothes, while the boys stiffly hold their breath or burst into laughter in the excitement of having their pictures taken. With the possible exception of the crippled newsboy who was asleep in his wheelchair when Alice Austen passed him, there is no pathos or degradation here. On the contrary, the people in Alice Austen's photographs seem to share (or to reflect?) her sense of human dignity and joy in life, no matter how dreary the material circumstances of their daily lives may be. One small clue reveals the respect with which Alice approached her subjects: several surviving negative envelopes record in her handwriting the names of the policemen and postmen she photographed, together with their badge numbers and the station out of which they worked, and it seems natural to suppose that she sent the man a print when she processed the photograph.

As Alice traveled further uptown in Manhattan, away from the districts in which most of the immigrants lived and worked, the subjects that she chose for her camera included drivers of hansom cabs and of the first automotive taxis, Grace Church, the residences and university around Washington Square, and the busy shopping and commercial areas of 23rd Street. Whenever there was a special event—the Hudson River filled with ships to celebrate Dewey's triumphant return from the Philippines, a parade of soldiers and carriages up Riverside Drive for the dedication of Grant's tomb, or the tickertape celebration of the end of World War I—Alice Austen was there with her camera. There were calmer moments for photography, too, such as afternoons spent boating on the lake in Central Park (designed in 1858 by Staten Islander Frederick Law Olmsted and his associate Calvert Vaux), an 800-acre retreat of winding paths through trees and landscaped meadows, but not so long before that a derelict waste of wretched hovels, garbage piles and pig farms. New York City in the late nineteenth century was expanding and improving and changing under the eyes of its inhabitants, and it was for Alice Austen an endlessly exciting and congenial place in which to take pictures. It was her city, and she loved it all her life.

The sequence of some of the photographs she made in Manhattan reveals her apparently boundless energy. On Friday, December 11, 1891, for example, 25-year-old Alice Austen aimed her camera at the Barge Office at 10:20 a.m., presumably as she arrived on the ferry from Staten Island. Then she traveled uptown to Macy's department store on 14th Street at noon, and by two o'clock that afternoon she reached Broadway and 39th Street to photograph the Metropolitan Opera House. No doubt she did some shopping and attended the opera, as well. The next morning she was at work again, at the start of a five-day visit in New Brunswick, New Jersey, photographing views of Rutgers College and the Second Dutch Church on George Street, and persuading her friends Bessie Strong and Rosalie Bogert to pose for her one more time. Gertrude Tate was not really joking when she mused that it was Alice's athletic stamina, as much as her artistic sense, that had made her an extraordinary photographer. Alice was always on the go. She must have been an exhausting, if entertaining, traveling companion.

Staten Islanders cross the harbor to Manhattan on the newly-consolidated ferries run by the local railroad owner and business entrepreneur, Erastus Wiman. (*Part of our ferry boat deck. Fine day. 10 a.m., Mon., Nov. 17th, 1890. Cramer C., Dallmeyer, 60 ft.*)

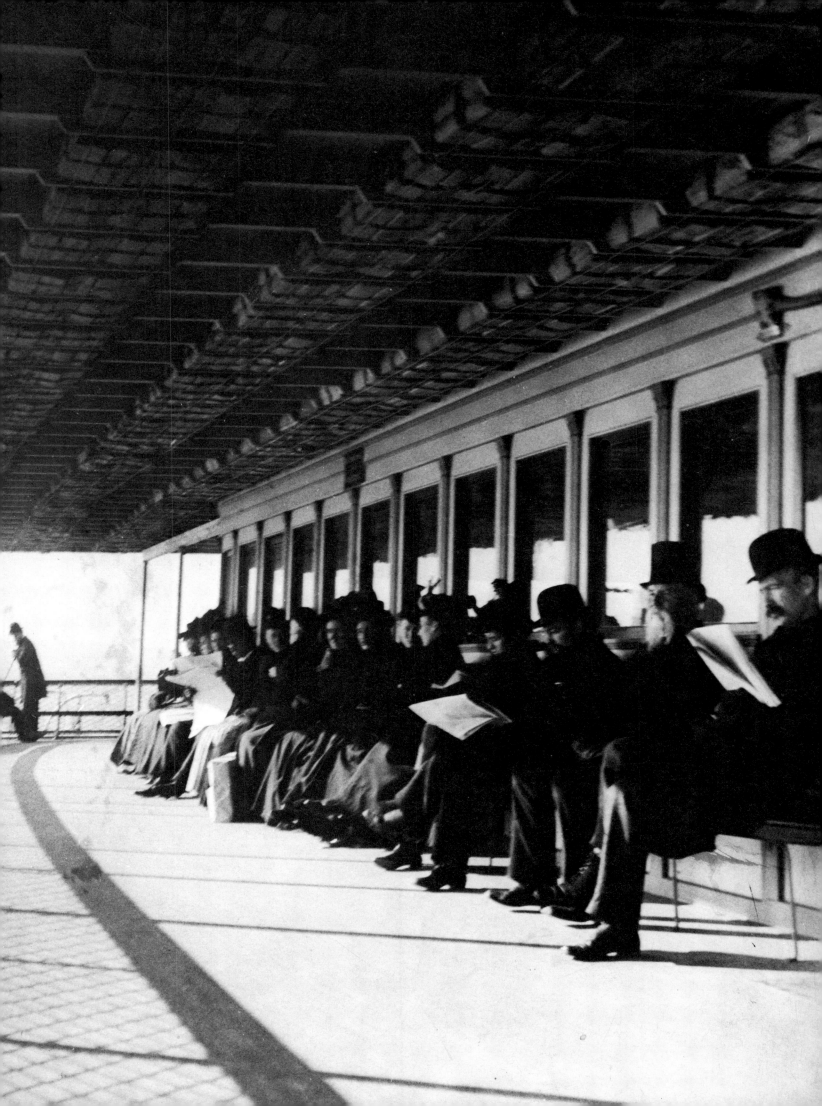

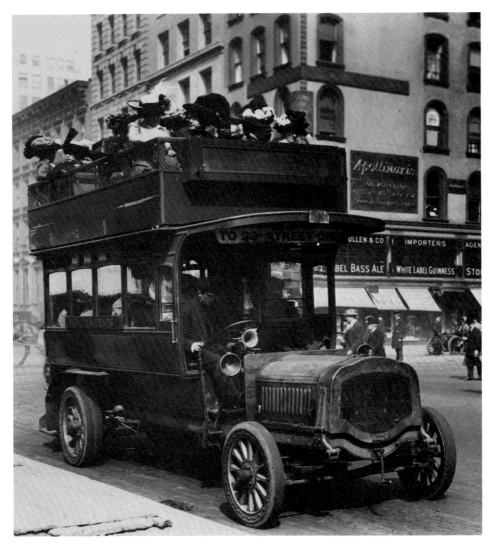

One of Manhattan's first motor buses, crowded with shoppers riding down to 22nd Street. (*Fifth Avenue stage auto. Corner 42 & Fifth Avenue. Sunny, hazy, 2.25 p.m. Eastman Kodak Premo Film Pack, Dallmeyer, Stop 16*)

A hansom cab driver waits at Union Square and 16th Street in 1896. Possibly he is hoping for passengers from Brentano's or Tiffany's stores behind him.

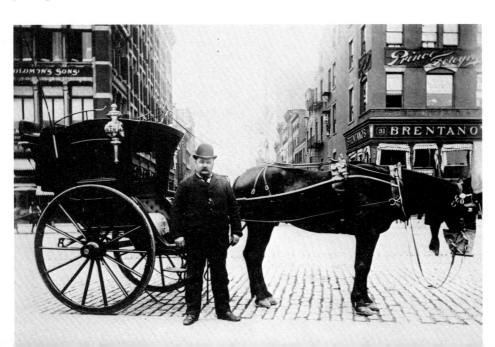

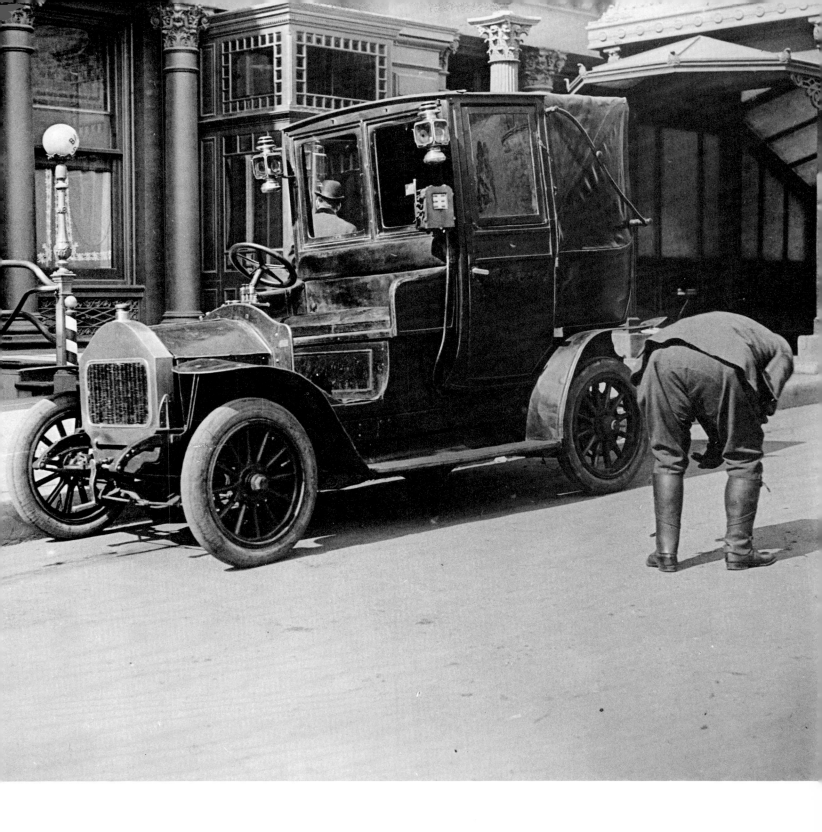

The driver of one of New York's first automotive taxi cabs is caught unawares by Alice as he searches uncertainly for mechanical trouble, in front of Lüchow's restaurant on 14th Street.

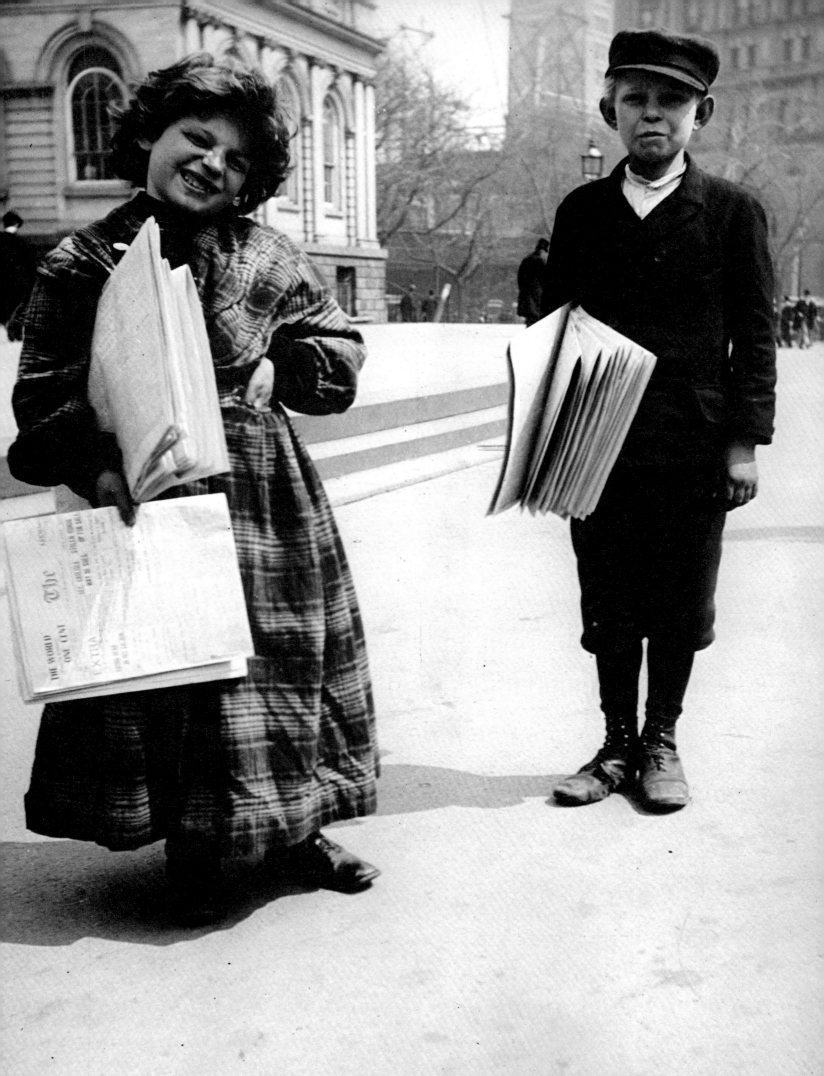

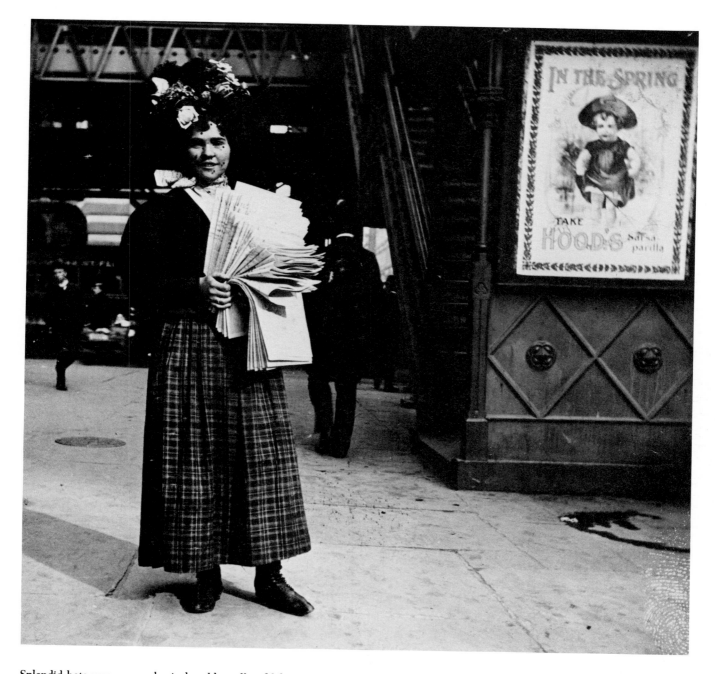

Splendid hats were worn also in humble walks of life, even on the job at the Sixth Avenue El station. (*Newsgirl, 23rd Street*)

These children were selling the "Extra" edition, on the steps of City Hall, until Alice Austen diverted them.

OVERLEAF: As Alice carried her camera through the streets of the Lower East Side, she received brilliant smiles, curious stares, and impassive shrugs from immigrants to whom most Yankees seemed a little odd. Many of the pushcart vendors and shoppers were simply too busy to pay her much attention. (*Hester Street. Egg stand group. Fine day, bright. 10.05 a.m., Thursday, April 18th, 1895. Cramer C., Waterbury lense, Instantaneous fast*)

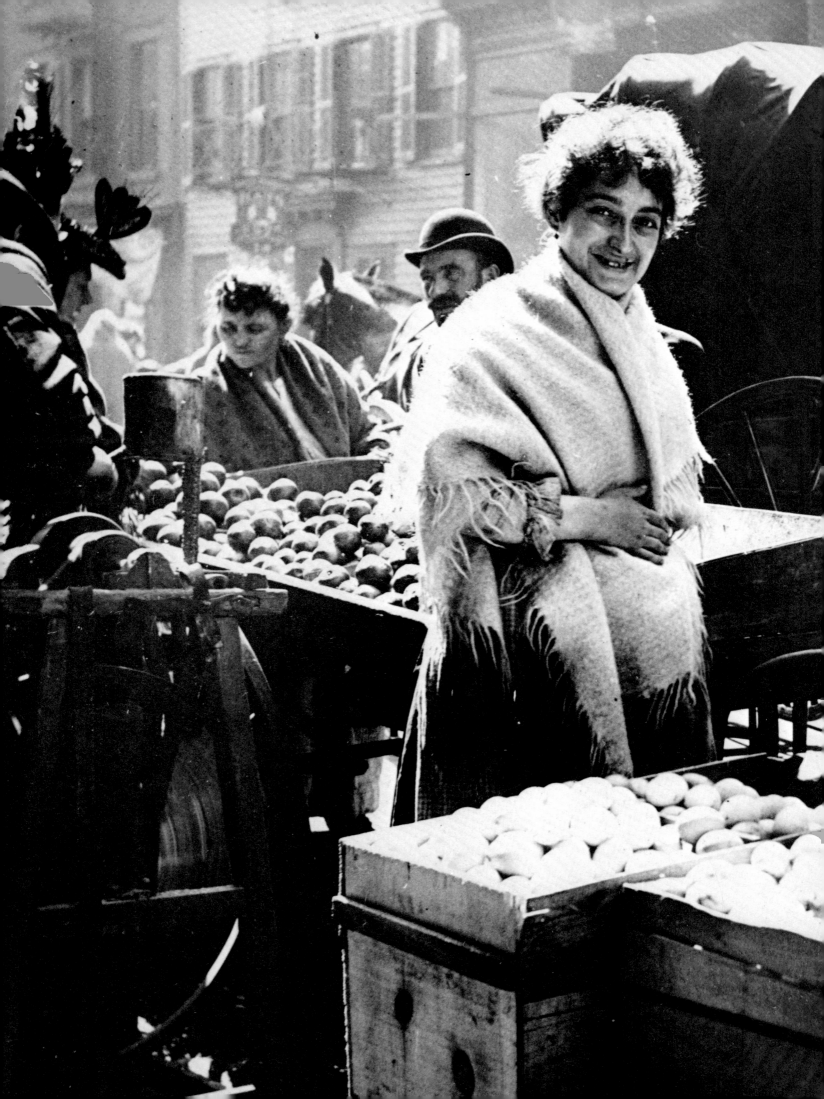

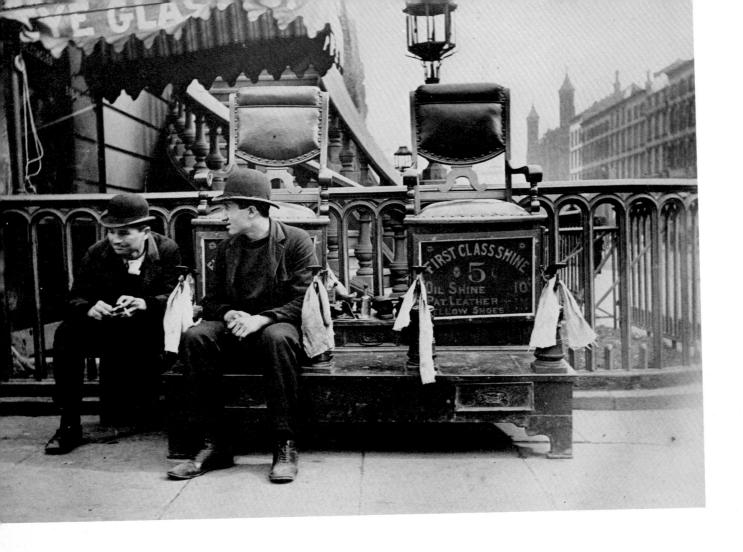

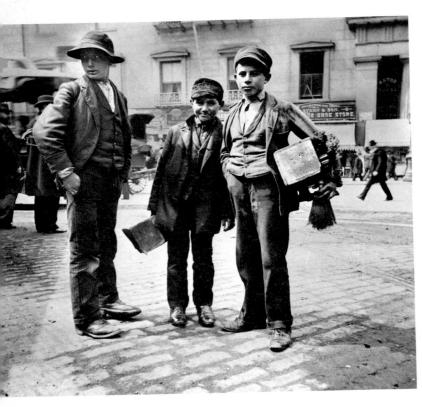

Shoeshine boys search for customers, and find a photographer instead. (*Three bootblacks. Hot, fair, sun out. South side of N.Y. Post Office. 12.35 p.m., Monday, April 13th, 1896. N.Y. Cramer C., Waterbury lense, 12 ft., Instantaneous fast*)

OPPOSITE: Uptown on 42nd Street, two idle bootblacks seem not to have noticed the lady with the camera. (*Shoe blacks and stand, 4th Ave. Cloudy. 2.35 p.m., Monday, March 5th, 1894. N.Y. set. Stanley 25, Dallmeyer, 40 ft. Instantaneous*)

An old man tries to earn a living as an organ grinder, at 58th Street and Lexington Avenue.

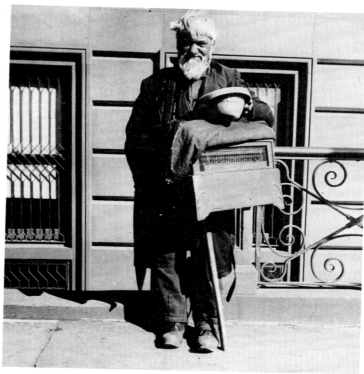

BELOW: On a street of Russian- and Polish-Jewish shops, a knife grinder keeps his eye on Alice without missing a turn of his stone.

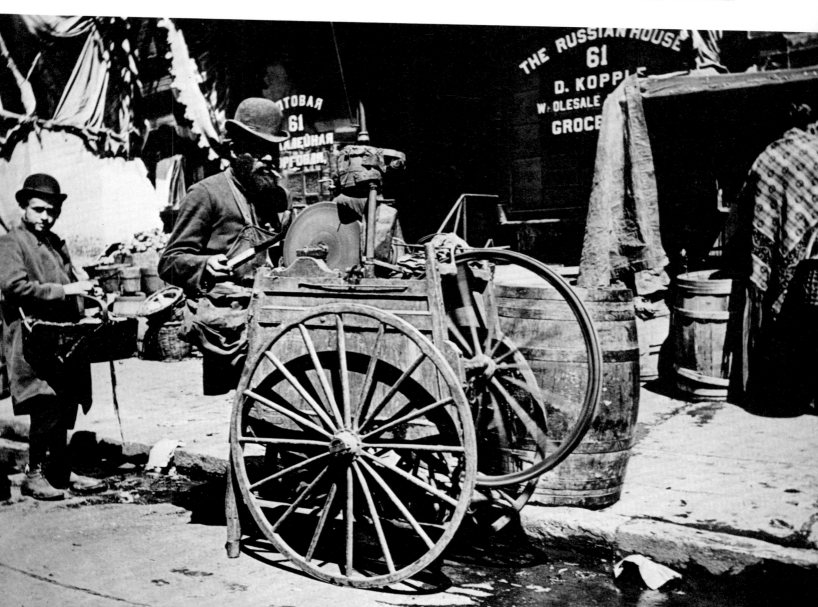

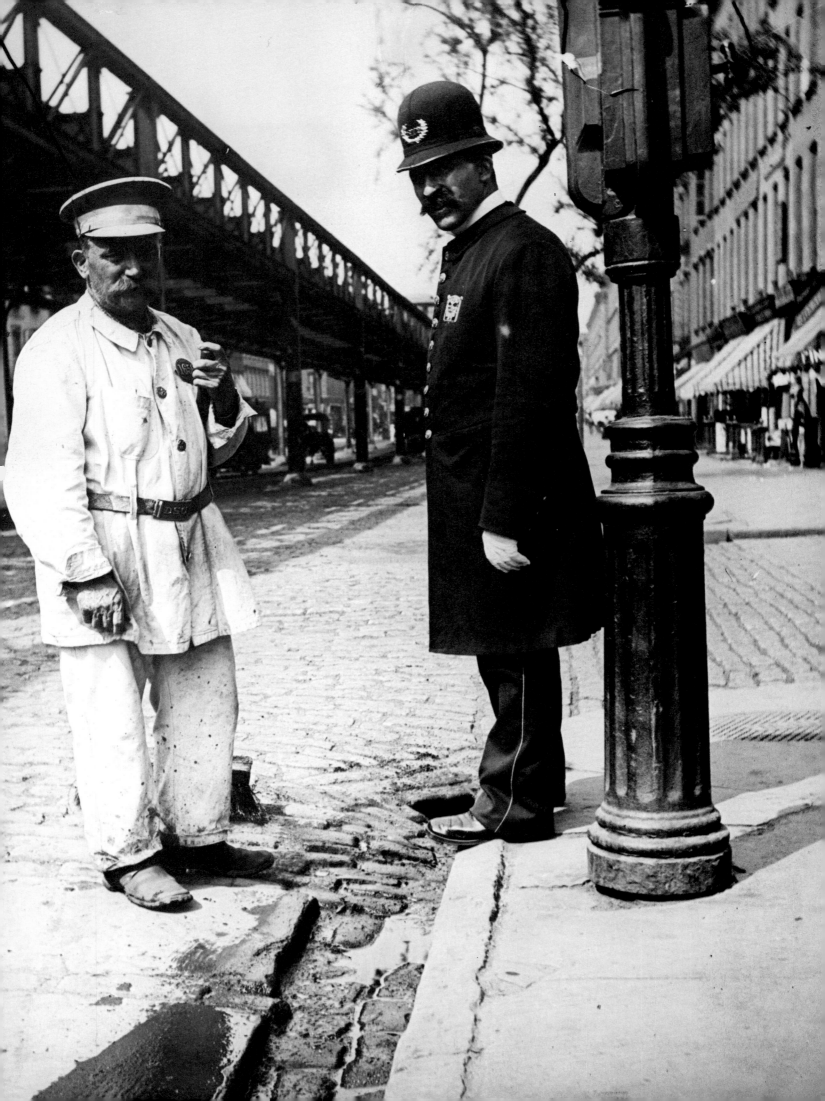

Rag pickers (included in Alice Austen's published series of "Street Types") rest at 23rd Street and Third Avenue, 1896.

Patrolmen protected the city's two million residents, and White Wings cleaned the streets. (*Policeman & Street Sweeper. 6th Ave & 46th St. Fine, sunny day. 2.20 p.m., Sat., May 9th, 1896. N.Y. Cramer C., Waterbury lense, 12 ft., Instantaneous fast*)

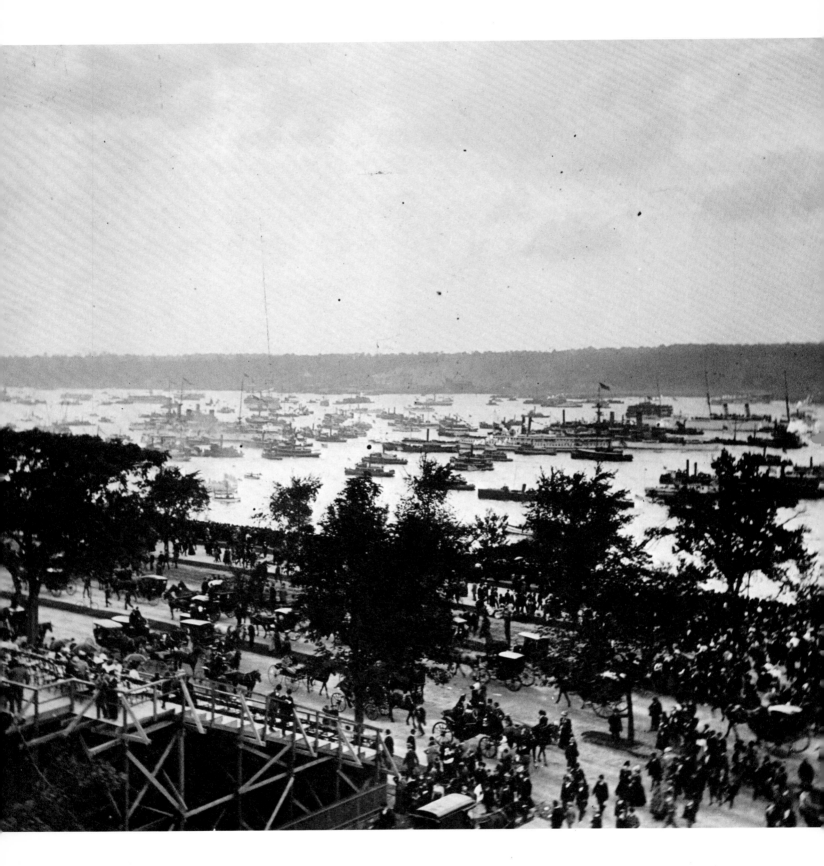

A naval parade on September 29, 1899, celebrates the return of the Hero of Manila, Admiral George Dewey, at the end of the Spanish-American War. The flagship *Olympia* receives a 17-gun salute and steams back down the Hudson River, surrounded by warships, as dozens of tugs and private yachts blow whistles, sirens and foghorns. One million spectators line both shores, many of them (like Alice) watching the spectacle from the vantage point of Riverside Drive.

Frederick Law Olmsted's Central Park was a newly-landscaped oasis in the city. (*Swan boat & lake bank. Central Park. Fine, clear day, wind. 2.30 p.m., Friday, Oct. 16th, 1891. A&R 40, Waterbury lense, 50 ft., Instantaneous*)

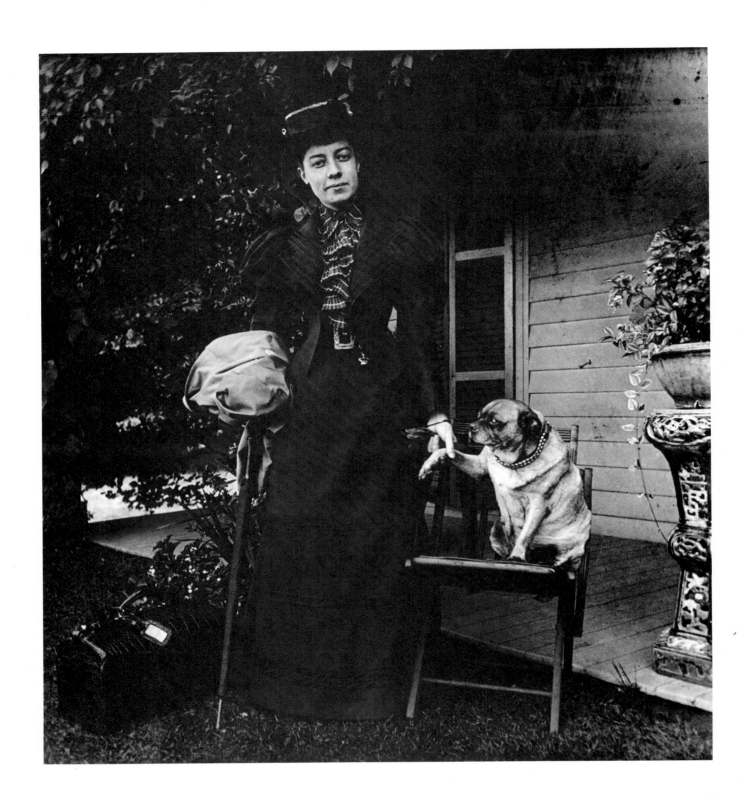

Setting off for the World's Columbian Exposition, 27-year-old Alice Austen says goodbye to her pug at "Clear Comfort." (*Self starting for Chicago. Punch also. Fine day, in shade. 3.30 p.m., Saturday, July 1st, 1893. Stanley 35, Waterbury lense, 10 ft., Instantaneous medium*)

CHAPTER FOUR:

Travels

Alice Austen was a tireless traveler, an enthusiastic sightseer. Her surviving photographs are mainly of scenes in the northeastern United States, but she is known to have traveled north to the Province of Quebec, west to Ohio and Illinois, and as far south as Maryland and Florida. Everywhere she went she took her camera with her, meticulously documenting the places and objects of interest— Nathaniel Hawthorne's birthplace in Salem and Cotton Mather's grave in Boston, the monuments at Bennington and Bunker Hill, the Liberty Bell, "our chain" at West Point, a portrait of George Washington in the Annapolis State House and the old Cambridge elm (now gone) under which he mustered his first Continental Army. She didn't want to miss a thing nor waste one moment of the day. Although she was normally a bit of a night owl, when traveling she was capable of getting up at dawn, photographing "sunrise from my window" just as easily as she recorded "sunset from Miss Rumsey's". And she was not just a fair-weather traveler: she would eagerly embark in a small boat bound for Annapolis in late October, or stride along the half-deserted beaches and boardwalks of Atlantic City on a windy day in early March.

Her photographs suggest that she loved the simple activity of going somewhere, for she recorded departures from home, crossings on ferries, cars and buggies on the road, and arrivals at hotels. All means of transportation drew her eye—the people in her pictures are riding in donkey carts, buckboards and phaetons, horse-drawn omnibuses and electric trolleys, automobiles, taxis, and (in the Alps) even on mules. She was particularly interested in boats, and she photographed them all—rustic rowboats and punts, steam yachts, sailboats off Marblehead, skiffs competing in the Yale-Harvard

races at New London, Coast Guard life-saving boats, paddle-wheel ferries, excursion steamers on Lake George, and even the decorative swan-boats in the parks of Manhattan and Boston. One boat in particular won her affection: this was the two-masted ketch *Wabun*, built by Nellie Austen's brother, Ralph Munroe, who treated Nellie and Alice to a nine-day excursion as he set off through the canals crossing New Jersey, down the Delaware River and into Chesapeake Bay, on the maiden voyage to Florida in October 1892.

The people of Alice's world went on trips to stay in one another's houses for leisurely visits of a week or more. Alice was for years a frequent house guest of Bessie Strong in New Brunswick, New Jersey, and there she also went to stay with her uncle Peter and his family during the years when he was teaching at Rutgers. She traveled with Julia Bredt to a Philadelphia house party that lasted for at least nine days, and with her mother to more sedate family gatherings in the Van Rensselaer mansion in Fishkill. In Cambridge she stayed with her old friend Lou Richards, formerly Miss Alexander of the family whose Dongan Hills estate was acquired by the Richmond County Country Club. And with uncle Peter's wife, Nellie Munroe Austen, she spent pleasant days visiting the old people of the Munroe family in Concord, Massachusetts—in those years a prototypical New England town which had not changed since the days when Emerson and Thoreau lived there.

In summers, everyone migrated—to the lakes and mountains of the Catskills and the Finger Lakes region, or to the seaside resorts like Bay Head, New Jersey (where Peter and Nellie had a beach cottage, and the sailing was good). During these holidays Alice photographed wooded hillsides and ox-teams crossing covered bridges, tranquil churches and old mills still in operation, clear lakes and isolated waterfalls. She has left us a picture of an unpolluted, uncrowded, unhurried and long vanished America. The very place names she pencilled on her negative envelopes—Rainbow Falls and Still Water Gorge, Fairy Cascade, Echo Falls, Twilight Rest and Flirtation Walk—evoke the charm of those golden summers in the 1890's.

Alice was by no means a romantic nature lover. Most of her rural pictures have people in them—her friends, or people as different and varied as charcoal burners in the Catskill forests, gypsies camping by the road in Vermont, or old soldiers lined up in front of their home in Bennington. She enjoyed recording Americans at work—black oyster-shuckers and busy naval cadets in Annapolis, Maryland, fishermen unloading their catch in Gloucester, Massachusetts. And wherever she traveled she photographed the activities in which people enjoyed themselves—university commencements and boat races, amusement parks by the sea, country fairs in Vermont and, of course, the great world's fairs in Chicago and Buffalo.

The World's Columbian Exposition, which Alice visited in Chicago in the summer of 1893, seemed destined to become the most-photographed wonder of the world to date. Many of the 27 million visitors (an astonishing number, equivalent to almost half the population of the United States at that time) carried a new Kodak. Alice took her four-by-five-inch camera and recorded such marvels as a Liberty Bell made of oranges from San Francisco, the world's first Ferris wheel, totem poles from Alaska and the

commemorative statue of Columbus (in whose honor the fair was held). Her photojournalistic instincts were alert, and she managed to get one picture of a fire breaking out in the tower of a cold storage building. She photographed as many as possible of the 150 gleaming buildings of the White City, and the lagoons and fountains landscaped by the former Staten Islander, Frederick Law Olmsted. The chief marvel of the 1893 fair was electricity: an elevated electric train circled the fair grounds (no smoke, no cinders), and a tower of light made of one thousand electric light bulbs dazzled spectators every night. At the next fair, Buffalo's Pan-American Exposition of 1901, there were so many electric lights that they offered new possibilities to the experimenting photographer, and Alice produced more than a dozen successful night shots of the illuminated buildings. She was also particularly interested in the international pavilions, where she photographed oriental rickshaws and a Japanese tea house, a water buffalo and ox carts, trained bears, a bullfight and an elephant in a procession, as well as Arabs with their camels.

These fairs were designed, in part, to introduce Americans to the marvels and the curiosities of the world. But Alice Austen did not view the exhibits with an uninitiated eye. She was already well acquainted with much of the world beyond the United States—from pictures, books and her own travels abroad. It was not possible to grow up in "Clear Comfort" without learning a great deal about Europe and the Orient, for a start. Her grandfather travelled to Europe in the years immediately after photography was invented in France, and he developed a passion for collecting photographic views— sepia-toned prints on delicately thin paper—of the cities he visited. One of his great pleasures was browsing through photography shops in Paris, and he confessed in a letter home to his wife, "photographs and stereoscopes . . . are the only things I am at all extravagant in." Photographs could not, in the nineteenth century, be reproduced in books (unless individual prints were pasted onto the pages, one by one). But the shelves in the bedroom young Alice shared with her mother were lined with books containing vivid descriptions of foreign places. There were Baedeker guides to Greece and Holland, Spain, Venice and Florence, as well as at least fifteen of Augustus J. C. Hare's travel books on England, France, Scandinavia, Italy, Holland and Russia. When Uncle Oswald was home from the sea, he told Alice stories about Denmark, the Orient, and all the ports he had visited. Uncle Peter talked about his travels as a student in Germany and Switzerland.

By the time Alice went for her first trip to Europe (possibly in the autumn of 1892), many of the continent's small villages were, by name, as familiar to her as the communities of Staten Island. She traveled around Europe—at first with her mother, then with Gertrude Tate—for many of the summers between the early 1890's and the outbreak of the Great War, and returned again between the end of the fighting and the Depression. She may have spent more than twenty summers abroad. As an old woman in her eighties, she remembered with amusement that she and Gertrude were always traveling off the beaten track, going to see some tiny town in Austria, Norway or Switzerland which no other American tourists had ever heard of, but which she remembered from her childhood.

When they landed in France, Alice and Gertrude went on a shopping trip in Paris to order gowns by Worth and elbow-length white kid gloves for Gertrude's dancing classes. They would collect these items on their return journey. Then they set off for the chateaux of the Loire Valley, for the seaside resorts of Normandy, the interesting spectacle of the faithful being cured at Lourdes, or the historic cities of Bordeaux or Toulouse. Alice photographed churches and market places, houses and religious processions. There were windmills for her camera in Holland, sheep beside the canal in Bruges, and bullfights in Madrid, Seville and Granada. In Bavaria in 1910, they saw the Oberammergau passion play. During their travels from lake to castle, mountain to hotel, Alice fired off a succession of daily postcards to Aunt Minn at home: "Seeing the castles of the King of Bavaria, Ludwig II who drowned himself—Superb situations—Curious, everything decorated with white swans. Magnificent weather—With love EAA." "Had coffee here after seeing the waterfall, mountains fine. Cows coming home with their bells ringing. Also horses . . . EAA." "Leaving in the morning for Vienna. . . ." "Left Munich this a.m. Have stopped here to see this castle of Ludwig II. Wonderful golden rooms especially Hall of mirrors & room of Meissen china. Rushing for boat 3:30 p.m. With love EAA." Summer by summer, Alice and Gertrude toured the countries of Europe. It is a tragedy that so many of Alice's photographs of these holidays are missing. In Italy they had audiences with the Pope, they told their young friends in Staten Island. They went to Sweden, Norway, and once far enough north to see the phenomenon of the midnight sun. Possibly they even got to Iceland one year, for among a small collection of Alice's travel souvenirs surviving in the hands of a friend is a small spoon inscribed "Reykjavik."

Given enough time, and a steady supply of money, Alice Austen and her friend would have had enough energy to tour the whole world.

A flat tire delays the progress of an auto ride with friends to Centerport, Long Island. April 23, 1910.

Squeezed into a surrey with trunks full of photographic equipment, Gertrude Tate waits for Alice to join her. They have just crossed the Delaware River at Dingman's Ferry, Pennsylvania.

A Packard touring car delivers guests to the fashionable, but conservative, Ocean House in Watch Hill, Rhode Island.

OPPOSITE: On a summer morning in Concord, Massachusetts, Nellie Austen and her uncle Alfred Munroe float past the rocks of the Assabet. (*Mr. Munroe & Nellie in boat on Assabet River. Fine day, shady. 10 a.m., Monday, June 13th 1892. Dallmeyer lense, 50 ft.*)

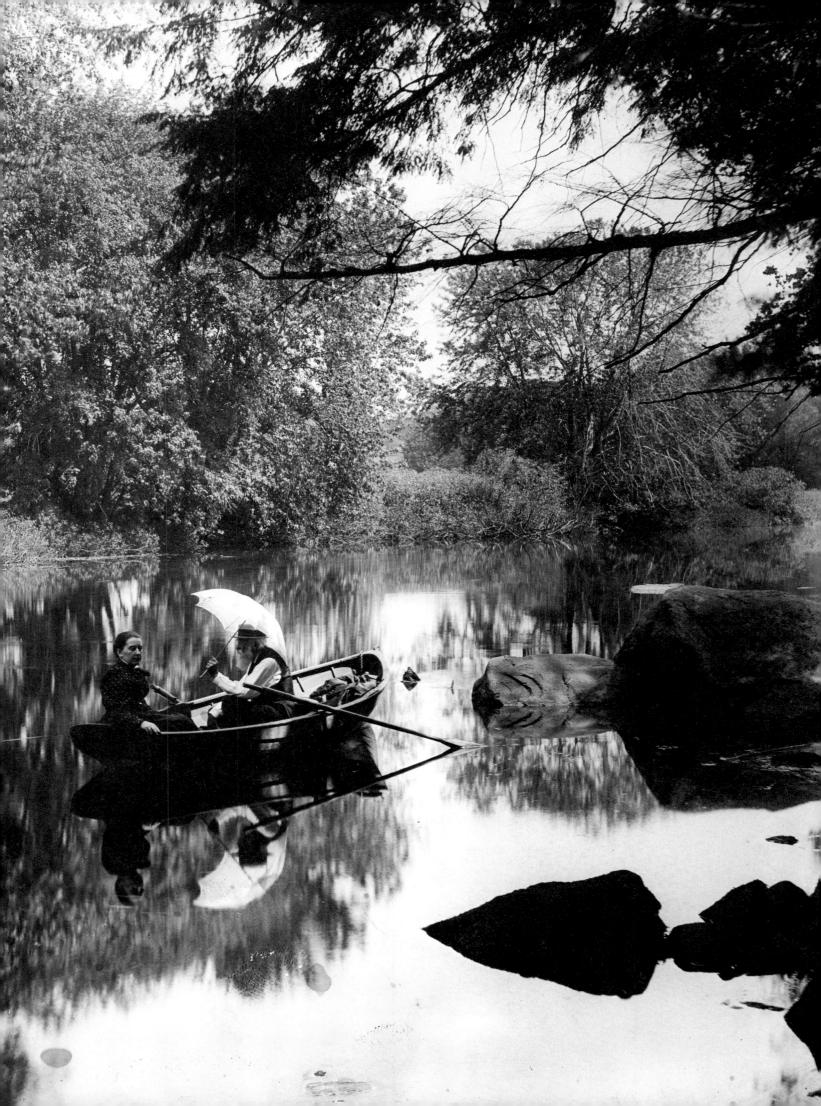

Arriving by train to visit friends in Philadelphia, Alice records horse-drawn traffic at the city's center. (*Public buildings, Pennsylvania Depot & omnibus. Cloudy. 3 p.m., Saturday, March 25th, 1893. Waterbury lense, Instantaneous quick*)

OVERLEAF: Gertrude Tate ascends an Alpine mountain on horseback, during one of her many summer holidays with Alice in Europe.

An open trolley at the corner of Beacon and Charles Streets leaves the Boston Common, heading for Harvard Square, in June 1892.

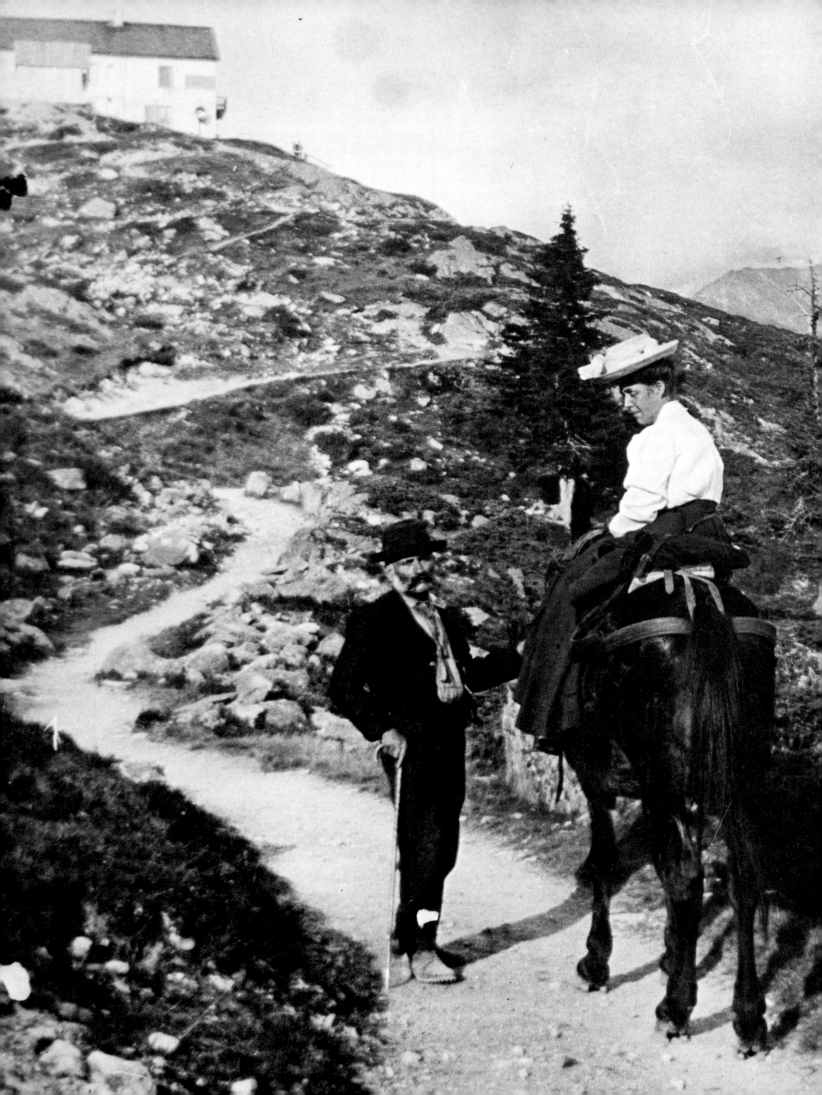

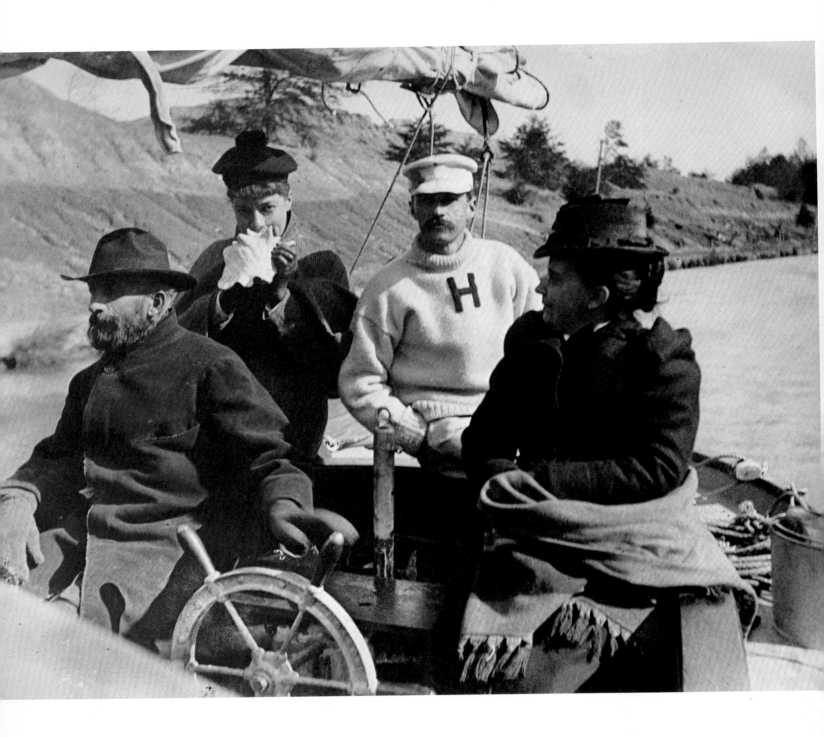

Alice blows on a conch shell as their yacht is emerging from the 19-mile Chesapeake & Delaware Canal into Chesapeake Bay. It is the seventh day of a cruise from New Brunswick to Annapolis. Traveling companions are (left) Ralph Munroe of Florida, designer and owner of the ketch *Wabun*, Ralph's sister Nellie Austen, and two crew members (one of whom mans her camera). (*Canal trip. Our party in stern of Wabun. Fine day. 11.30 a.m., Oct. 24th, 1892. Stanley 35, Waterbury lense, 12 ft.*)

Returning to Annapolis, two years after the cruise, Alice photographs the Naval Academy. (*Naval cadets in boats, oars up. Fine sunny day. 3.15 p.m., Tuesday, Sept. 25th, 1894. Stanley 50, Waterbury lense, Instantaneous fast*)

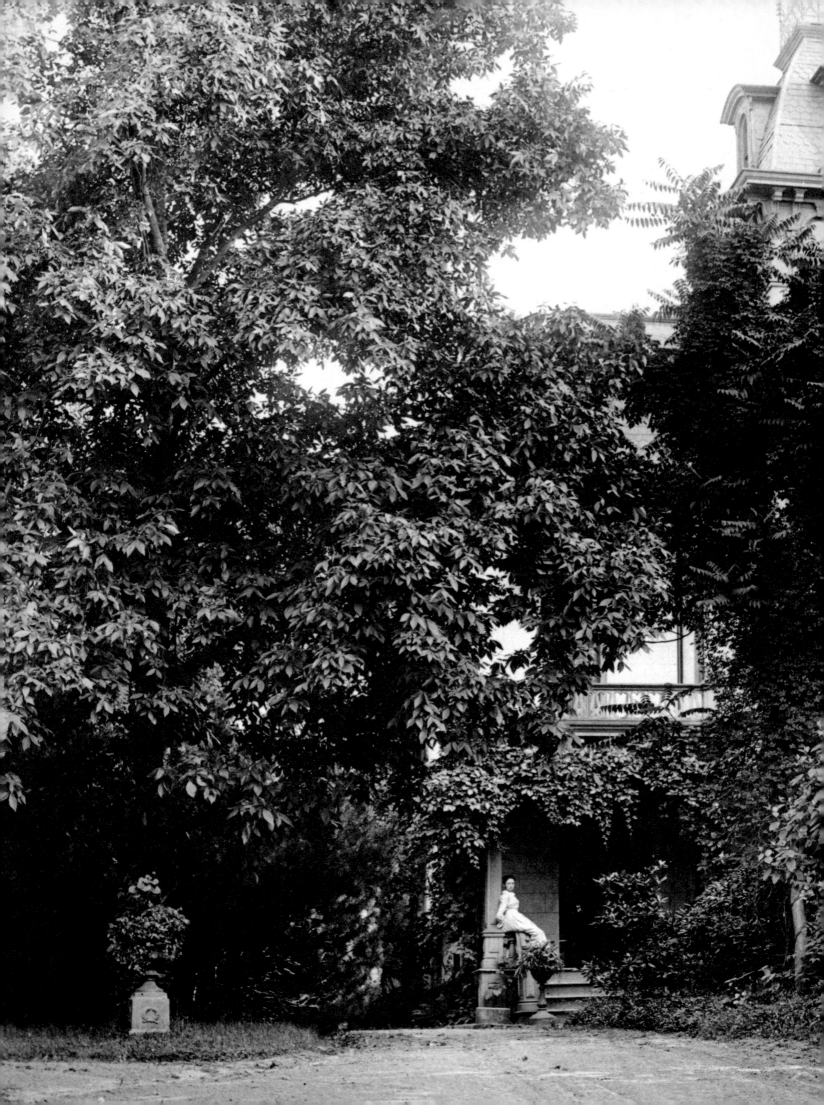

In New Brunswick, New Jersey, Bessie Strong sits on the porch of the 22-room mansion built by her father—a judge and amateur horticulturist. (*Mrs. Strong's house from gate. Fine clear day. 5.35 p.m., Friday, June 20, 1890. Seed 26, Stop 32, 3½ secs.*)

At a week-long house party in Bethlehem, Pennsylvania, Alice and Julia Bredt lark in front of the camera with their friends, the Messrs. Rawl, Ordway, Blunt, Gibson, Maurice and Wildrick.

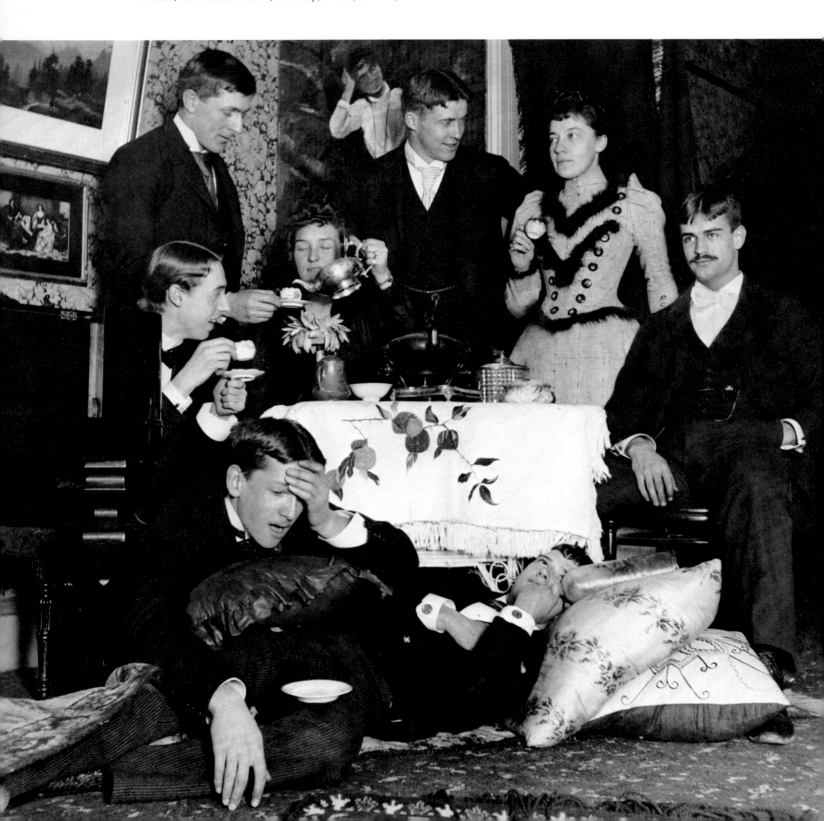

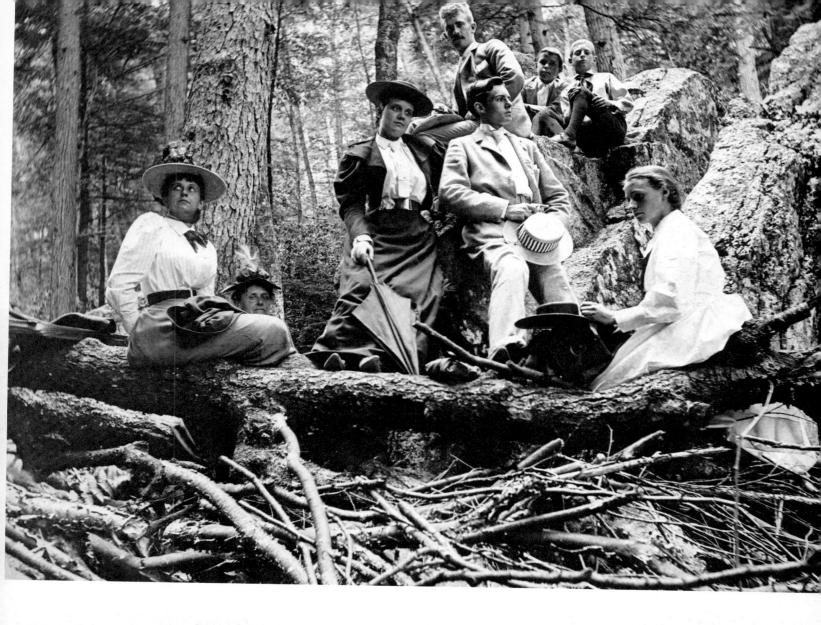

Picnickers in Pennsylvania hold still for a long exposure. Alice's Waterbury camera rests on the fallen tree, under Louise's hat. (*Mauch Chunk. Group at big split rock. Mrs. Hubbell, Mrs. Scofield, Louise, C. Wildrick, Trude Ec., Walter Stewart, George, Mr. Blanchard. Fine day; clear dark light. 4.30 p.m., Thursday, Aug. 3rd, 1893. Stanley 35, Waterbury lense, 5 secs., 60 ft.*)

Visiting a friend at Harvard Law School, Alice stayed to watch the graduation ceremonies. (*Procession of students &*
alumni in Yard, Harvard, on its way to lunch. Fine day. 2.30 p.m., Wed., June 29th, 1892. Cambridge, Mass. Stanley 35,
Waterbury lense, Instantaneous, 60 ft.)

She felt equally free to visit places considered unseemly for a lady. (*Annapolis. Darkies opening oysters. Fine day. Skylight, dark. 10 a.m., Tuesday, Sept. 25th, 1894. Stanley 50, Waterbury lense, 10 secs. 50 ft.*)

OPPOSITE: Half hidden in the trees, the Minute Man statue stands beyond the old bridge at Concord, Massachusetts, on a fine clear day in June, 1892.

Funeral carriages encircling the White House caught Alice's eye as she arrived in Washington after the canal trip. (*Mrs. Harrison's funeral at White House. Carriages in circle. Fair day. 10.30 a.m., Thursday, Oct. 26th, 1892. Stanley 35, Waterbury lense, Instantaneous, 60 ft.*)

Boston as seen from the roof top of Alice's hotel. (*View down Beacon St. from top of Hotel Bellevue. Fine day, no sun. 5.10 p.m., Thursday, June 30th, 1892. Stanley 35, Waterbury lense, 60 ft., Instantaneous*)

ABOVE AND BELOW: The fountains, sculptures and gleaming white buildings of the World's Columbian Exposition in Chicago covered more than 600 acres. Alice spent two weeks there, recording obelisks and peristyles, the Art Palace and Machinery Hall, statues of Columbus, Indians, and abstract spirits. She copyrighted some 25 of her pictures.

Electric illuminations dazzled visitors to the Pan-American Exposition in Buffalo in 1901, and Alice used the lighting to experiment successfully with nighttime photography.

On a 1909 summer tour of France and Spain, Alice and Gertrude came across Basque dancers and musicians celebrating the feast day of Saint Ignatius.

OPPOSITE: An old windmill in Dordrecht, in the southwest Netherlands, so pleased Alice that she copyrighted the photograph in 1909 and presented prints to friends.

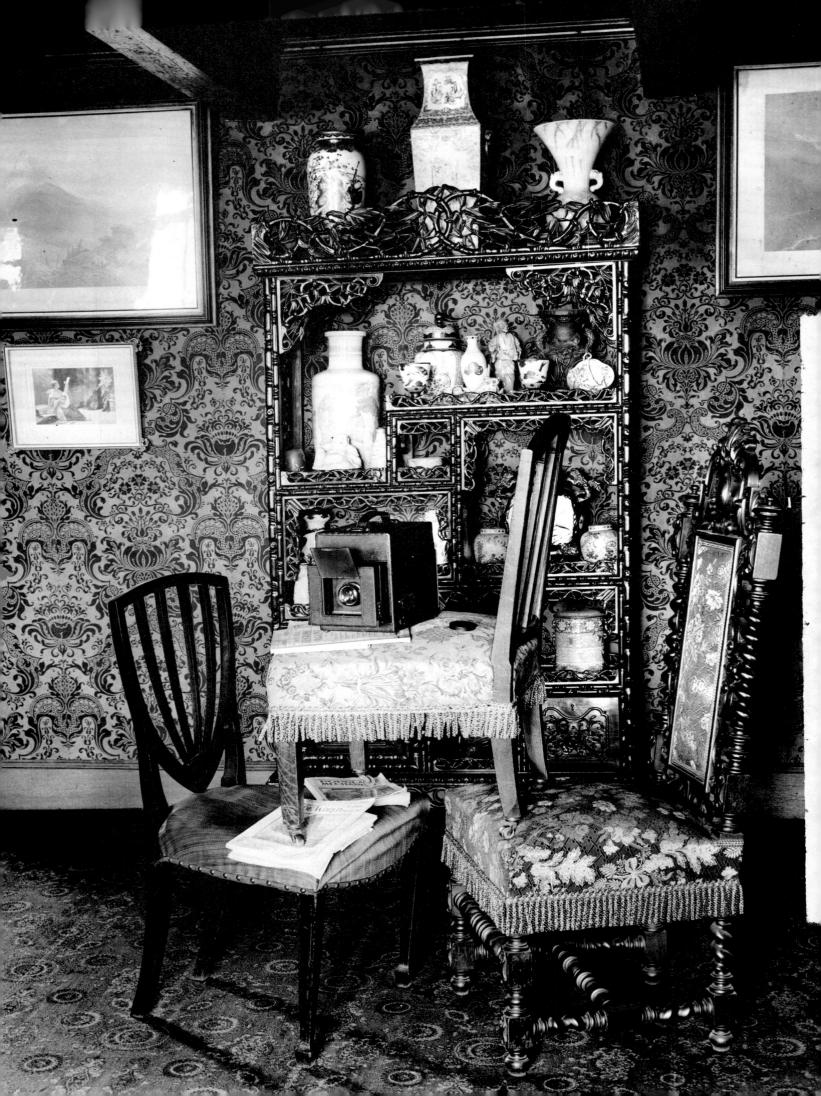

CHAPTER FIVE:

Alice's Equipment and Style

Nearly fifty pounds of cumbersome photographic equipment traveled with Alice Austen when she went on a journey. It filled a large and carefully-guarded steamer trunk, whether she was sailing to Europe to spend the summer, or wandering around New England by railroad and horse-drawn buggy.

The cameras of Alice's youth were large, made of polished mahogany with shiny brass fittings and pleated leather bellows. Cheaper wood, when used, was covered with morocco leather, for the sake of appearance. The most practical camera for traveling was one that took four-by-five inch photographs. But on lengthy or exciting excursions, when any subject from a landscape to lawn tennis, a parade or a party, might present itself to her eye, Alice liked to take along at least two cameras capable of producing images of different proportions, since these were the days before the enlarging of negatives had become practical. Glass plates coated with a chemical emulsion, once exposed and developed, became the negatives. The finished photographs were all contact prints of the same size as the plate, made by the simple expedient of laying a sheet of photographic paper under the glass negative (in a wooden holder) and exposing it to sunlight. If a large photographic print was wanted, one of the big cameras had to come along on the journey.

All the cameras, of whatever size, also required boxes of accessories, the heaviest of which were the glass plates (those of the eight-by-ten-inch dimension weighed half a pound each). Alice owned a good selection of lenses (each with its own special merits, but all of them, by our standards, frustratingly slow). Into the luggage had to go the inevitable wooden tripod, needed to hold her camera motionless. Cameras could not be

One of Alice's half-dozen cameras, possibly a Graflex made by the former Folmer & Schwing company, in the Austens' parlor, early 1900's. *Popular Mechanics* (under the rear chair leg) was a magazine Alice read with interest.

held by hand since photographs taken in the shade, even on a fine day, required an exposure time of three full seconds, while indoor photography was often timed in minutes. At night, even when gas lamps burned in a parlor or a bedroom, Alice had to increase the illumination by igniting magnesium flash powder—a smoky and sometimes dangerous process. (Miss Austen declared she never burned herself, though she admitted to setting fire to some papers on one occasion.) So the cartridges of magnesium powder had to be packed, as did yet another special accessory that Alice particularly enjoyed using, the long rubber cable with a pneumatic bulb at its end, by which she could operate the shutter from a distance and include herself in many of her group portraits.

Alice, luckily, was a tall and strong woman, perfectly capable of carrying her own heavy cameras, tripod and boxes of plates when there was no young gentleman in sight to be commandeered or cajoled into moving the equipment for her. Cumbersome as her apparatus seems to us today, she was well aware of its convenience compared to the paraphernalia carried around by photographers in the 1850's and 1860's.

There was one big difference between Alice Austen's time and those earlier years. The older glass plates, from the moment that they were coated with a light-sensitive layer of collodion and silver nitrate, had had to be kept moist. Each plate was coated with these chemicals just before it was used, and then developed immediately after exposure. Some seven steps were involved in the handling of these so-called "wet" plates, and a mistake at any one stage ruined the picture. The poor photographer was imprisoned in the darkroom for hours, and, if he wished to travel away from home, he was required to take his darkroom with him—usually in the form of a canvas tent. Professional photographers on long journeys, such as William Henry Jackson who recorded the landscapes of the American West, or Mathew Brady who followed the battles of the Civil War, equipped horse-drawn wagons as both their traveling darkrooms and their sleeping quarters. Together with a tent, the moveable equipment in the era of the wet plate included, necessarily, many bottles of chemicals and a sizeable table on which to work. The total weight of all these supplies, needed by even an amateur, could easily exceed 120 pounds. To reach scenic views inaccessible by horse and carriage, some enthusiasts strapped their gear onto their backs (or onto the backs of hired porters), while others pushed or pulled their loads in wheelbarrows or handcarts. Few ladies, understandably, became interested in landscape or architectural photography in those mid-Victorian years.

Just in time for ten-year-old Alice Austen and her uncles to benefit from it, a new era in photography began in the mid-1870's, with the introduction of the first practical dry plates. For twenty years, inventors had struggled to devise some way to keep plates sensitive to light after their coating had dried. The first experiments were unsuccessful because the dry plates were so insensitive that they required six times the exposure of wet plates. Then, in 1871, a British physician substituted a gelatin emulsion for the old collodion coating, and dry plates became fast enough (especially with technical improvements which came in 1873 and 1878) to be practical. The greatest change was that photographers, now able to wait for days or weeks before developing negatives, no longer

had to prepare their own plates for use. Precoated by the manufacturer, dry plates were being produced in substantial numbers in Britain by 1876 and soon became an important export to the United States and continental Europe. The techniques of photography were now considered to be so simplified that manufacturers boasted that "a person of average intelligence could master it in three lessons."

Alice Austen, a person of more than average intelligence even as a child, probably grasped the principles after one or two experiments. She was a quick learner and a persevering worker. It was not long before Oswald Müller was receiving helpful hints back from his former pupil. But Alice's new pastime was, nevertheless, not at all easy, by the standards of our present push-button technology. Extraordinary patience as well as skill were needed by the photographer of the 1880's and 1890's. One glass plate at a time, carefully inserted into a holder and placed in the back of the camera after the lens had been focused, had to be correctly exposed, unloaded, and later developed and printed by the photographer. Proper exposures depended on successfully guessing at the degree of brightness of the light on the subject (no light meters, then). Alice soon learned that it was easier to shoot in slight shade or in overcast weather, rather than in brilliant sunshine. She strained against the technical limitations of her equipment, trying to freeze the moment of action of a tennis player, a trotting horse, a bicycle rider or a little boy leaping over an obstacle in her garden—sometimes succeeding surprisingly well, but often producing a frustrating blur when the movement was too rapid for her camera.

"Greenhorn luck, just greenhorn luck," is how Miss Austen described the success of her early photographic efforts, when she was interviewed in 1951. It is difficult to believe that, even at age eighty-five, she could have forgotten the hours of painstaking effort she put into her hobby.

As a young woman, Alice was willing to spend an hour composing one picture, making adjustments and calculations until absolutely everything (including the facial expressions of her subjects) was perfect. She spent hours on end in her closet-like darkroom, developing plates and "toning" and "fixing" her prints. Because there was no running water in the house when she was young, she carried them all downstairs and out into the garden, to be rinsed in a basin under the hand-operated pump, winter and summer. Sometimes she changed the rinse water twenty-five times, she recalled. On the envelopes in which she stored her negatives, she diligently penciled the brand name of the plate and of the lens she had used, the exposure time, the aperture and focal distance, light conditions, the subject, and the exact time at which she had taken it (the date, hour, and even the precise minute). Poring over these envelopes later, she learned to correct her errors ("Mistake!" she scribbled crossly, over one drastic miscalculation—a distant warship on which she focused at ten feet). Working steadily, year by year, from about 1880 to 1930, she may have made as many as 8,000 photographs, though only about half this number are known to have survived the tragedy of her later years. As she grew older, she made many photographs on roll-film which was marketed as early as 1889, and became increasingly inexpensive and popular as the twentieth century progressed. She experimented with the Lumière Autochrome color

ABOVE: A haze of smoke hangs in the northeast corner of Alice's bedroom, apparently caused by the magnesium flash powder she ignited to take the previous picture. She was working her way around the room, recording each wall and corner.

A European collapsible camera, of a type popular for press use, was tied by Alice to a tree in the back yard. She did not record why.

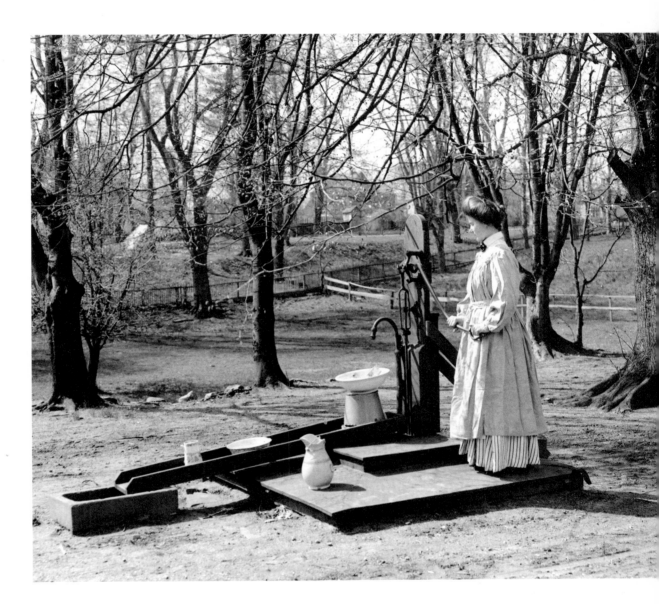

Demonstrating the way in which prints had to be rinsed ("Clear Comfort" had no running water for many years), a maid stands in for Miss Austen. "The water was cold as ice," the photographer reminisced years later.

Fighting with slow lenses, relatively clumsy shutters and films that required lots of light, Alice struggled to capture the excitement of people and vehicles in fast motion. (*Our place. View with Jimmy jumping box. Fine clear day. 10.45 a.m., Friday, April 9th, 1897. Stanley 50, Focus 100 ft., Spring 3 notch 4, Stop 11*)

OPPOSITE: (*Cousin Emmie's pony trotting. Fishkill. July 19, 1890. Fastest shutter*)

Violet Ward concentrates on free-wheeling her bicycle as slowly as possible down the sloping lawn, but she is still moving a shade too quickly for Alice's camera.

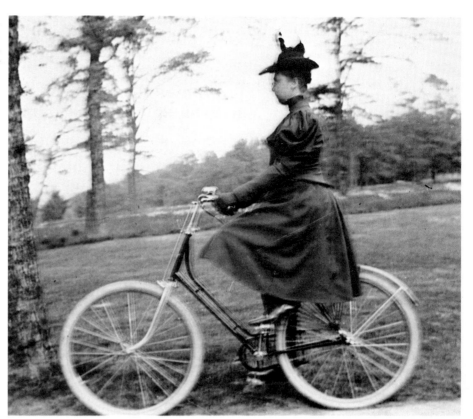

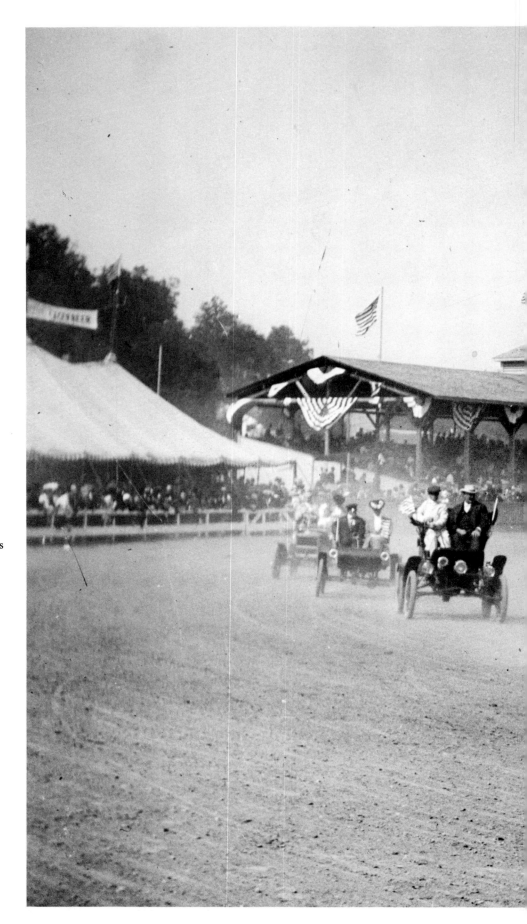

Cars race around the track in auto speed trials at Dongan Hills fair grounds, around 1903.

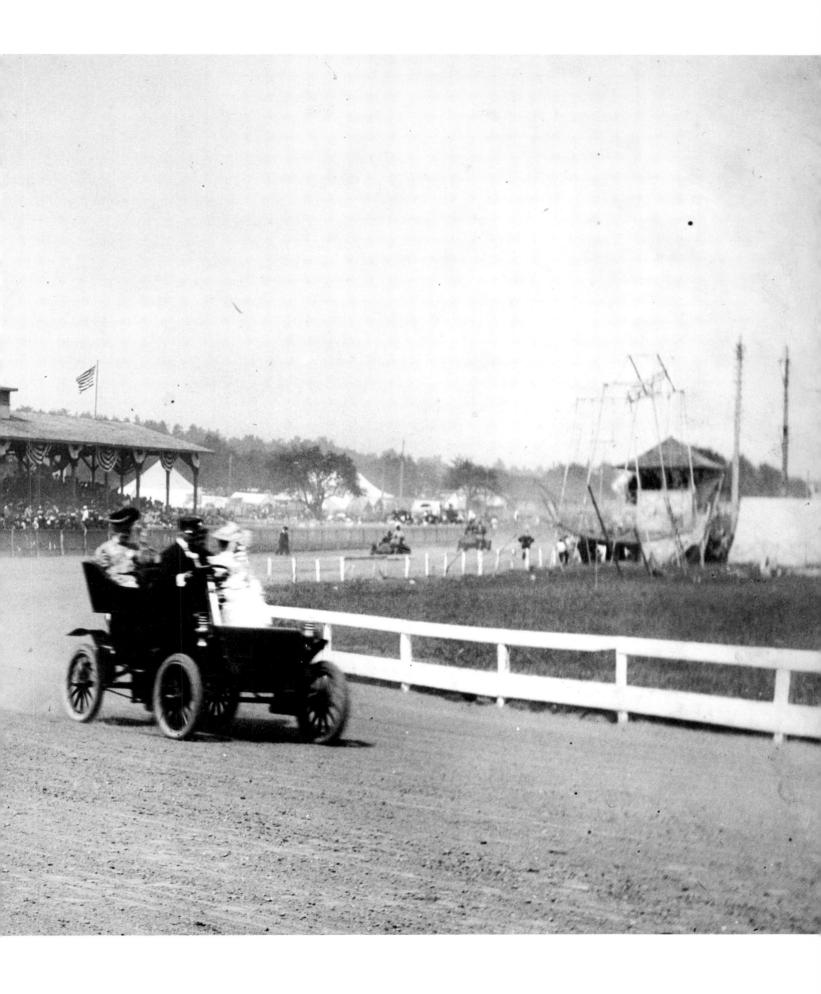

process and even with a motion picture camera. But she never quite managed to master the newer materials and techniques, to her frustration, and some of her surviving film negatives are poor in quality compared to the exquisite clarity and composition of the glass plates she exposed mainly before 1910.

She never, however, stopped trying to learn. One of her great pleasures, when she was in her seventies, was to talk to a young naval officer about the latest techniques in military and aerial photography, to inquire about the improved possibilities of color film, and to be taken behind the scenes in the Paramount movie theater to examine the very newest projection equipment. "She instantly made friends with the projectionists on duty by her perceptive remarks and questions," her younger friend remembers, "and they treated her like a colleague and demonstrated everything. They talked pictures, with delight on both sides." When a visitor brought a new 35mm camera to the house on Staten Island, Miss Austen turned it over and over in her hands, examining every part of it. Even when arthritis had started to stiffen her fingers, she would bring out her favorite old camera and use it as best she could. "It was painful to see her suffer so much annoyance," a friend recalls, "when she had to take such care, in place of her beautifully practised ease of former years."

A few months before she died, a reporter asked 85-year-old Miss Austen when she had given up photography. "I *haven't* quit," she chuckled—with some truth, too, for a few weeks earlier she had taken a camera from the hands of the visiting photo-journalist, Alfred Eisenstaedt, from *Life*, and snapped a picture of him.

The cameras used by Alice Austen during her fifty years of work as a genuinely active photographer have, with the exception of two, been lost. She is believed to have owned at least half a dozen. As an elderly woman with occasionally failing memory, she recalled her very first camera as being a Waterbury model holding four-by-five-inch plates; but, since the Waterbury was not introduced until 1888 by the Scovill Company, she may have been remembering an earlier product of the same manufacturer, which did have cameras on the market as early as 1875. Since she so much favored the Waterbury (which was made in the four-by-five, five-by-eight, and 6½-by-8½-inch sizes), it seems likely that she did later buy one.

As her requirements became more exacting, she had at least two cameras custom-made to her specifications. The first of these she ordered from the Folmer & Schwing Manufacturing Company, then a photo supply store at 271 Canal Street in Manhattan, later famous as the maker of high-speed Graflex cameras for press photographers. Alice's Folmer & Schwing was a view camera of 8x10-inch size, covered in black leather, which she liked to use with a Ross Goerz lens imported from England. (This camera and lens are preserved at the Staten Island Historical Society). Some time after 1913, she asked Willoughby's shop on Manhattan's West 32nd Street to make her a smaller camera, for 6½"x8½" plates; its special feature was a rear compartment able to store six glass plates at a time—an innovation which was convenient when traveling, but which made the camera unusually heavy. The half dozen lenses Alice used, in addition to the Ross Goerz, included a Goerz from Germany and a Dallmeyer, another English lens she brought home from one of her holidays. She owned a Waterbury, a Zeiss, and an

unspecified "wide angle lense" (she always spelled it with an e), but her favorite was a Perken, a less well-known lens, but of good quality. The dry plates she tried, as noted on her envelopes, ranged through A&R, Carbutt, Central and Cramer, to Eagle, Eastman, Harvard, Seed, Standard and Stanley, many of these manufactured in St. Louis or Rochester. She was always looking with interest at new materials and equipment, scanning photographic catalogs and scribbling notes in the margins about one or another improved product.

"You push the button, we do the rest," was the tempting and catchy advertising slogan used by George Eastman, when in 1888 he introduced the Kodak, a small hand-held camera designed to use roll-film instead of single glass plates. This is the camera that made the hobby of photography accessible to everyone. The user simply exposed the film (which was long enough for 100 pictures), then mailed the camera, with the film inside, and $10 back to Rochester for the negatives to be developed, prints made, and a new film loaded. The smallest, lightest, simplest camera anyone had seen, the Kodak attracted thousand of customers, initiated the snapshot age of photography, and founded the photo-finishing industry. By 1890, eight styles and sizes of Kodaks were available. And in 1895, Alice Austen succumbed and spent $5 on one of the new Pocket Kodaks (predecessor of the Brownie). Less than four inches long, made of light-weight wood covered in red morocco, her Pocket Kodak could take twelve exposures, each negative only 1½"x2". This tiny camera (with its former owner's name penciled on the inner wood—"E. A. Austen, Clifton, Staten Island, N.Y.") is only the second of Miss Austen's cameras to be located. It survives today, in private hands, only because Alice gave it away, with typical generosity, to a young woman who she thought might enjoy experimenting with it.

Something of the child in Alice Austen never grew up, and throughout her life she seems to have regarded a camera as a marvelous plaything. She used her camera in a very personal way—to record interesting travels and moments of humor shared by old friends—and not as the instrument of a new form of art. Her unselfconscious attitude toward photography reveals itself in the simple fact that she bought a Pocket Kodak, a toy-like camera that was not nearly versatile enough (because of its fixed focus and fixed aperture) to make pictures of her normal quality. (Not until 1925 did a camera small enough to hang on a shoulder strap or push into a pocket, but designed for professional use, become a reality). The pictures that Alice Austen made charm us because they are, like their maker, unpretentious.

The originality of Alice Austen's work becomes strikingly clear when it is compared to that of other photographers of the late nineteenth and early twentieth centuries. Women photographers, in particular, succumbed to the fashion of making photographs to illustrate romantic tales of childhood and of colonial village life or popular works such as *The Rubaiyat of Omar Khayyam*. Daily American life, if pictured at all, was sentimentalized beyond recognition. In the spirit of turn-of-the-century romanticism, photographers produced pictures of an uncomplicated, unreal world in which all landscapes were pretty or quaint ("The Fairy Brook" or "Ye Old Willow") and in which every child, following the tradition established by Julia Margaret Cameron of Victorian England,

was a cherub or "Mother's Darling." The children picked posies of wildflowers in sublime landscapes while their mothers struck classical poses in diaphanous flowing garments of some eclectic style. "The picturesque" was the ideal, and when photographers made portraits they were instructed to aim for "a rich effect of light with sweeping lines of drapery and distinction of pose." Some unusual poses were recorded by one of Alice Austen's contemporaries, Annie Brigman (1869-1950) of California, who photographed herself, naked among trees and rocks, as a naiad or dryad communing with Nature. Gertrude Käsebier (1852-1934), a fashionable portrait photographer in New York from 1898 to the 1920's, tried to capture the Eternal Feminine essence in stylized photos of women and children, which were praised as "portrayals of the tender grace of Motherhood, . . . imaginative creations full of deep and sincere feeling." Mrs. Käsebier was typical of her time in the way she used a soft focus to obscure the flaws and mundane details of her subjects, and in the way she emphasized light and shadow in imitation of Impressionist painters, trying to evoke an emotional response from her viewers. Like most photographers of her period, she did her best to prove that photography was a form of art by trying to disguise the fact that her pictures were made by mechanical means (the precise fact that Alice Austen enjoyed about photography). Alice's work was out of tune with the fashionable dictates of her time. When *The Ladies' Home Journal* in 1901 published a series of articles on the foremost women photographers of America, her name, understandably enough, was not mentioned among them. Typical of the praised artists was one Miss Emma Justine Farnsworth (long since vanished from the annals of photographic history), "who, as a worshiper of the beautiful, lives in an atmosphere of art and poetry. . . ."

Alice Austen lived in the real world and photographed people and places as they actually appeared, focusing her lens so sharply that every small detail of leaf or woodwork, facial expression or lettering on a sign, was recorded. She approached her subjects straightforwardly, without any attempt at the "refinement, grace and decorative sense" encouraged in the photographic journals of her most productive years. Instead of idylls of motherhood, she photographed the harried-looking Mrs. Cocroft with her ten small daughters, and Gertrude Eccleston helping her married sister cope with babies and luggage on moving day. Alice Austen's photographs show us real children, who look as though they enjoyed posing for their sympathetic older friend and neighbor, even though it was an effort not to blink or wobble during long exposures. She may have let the Cocroft children arrange themselves, to some extent, like birds in the branches of her sumac, because she understood all too well that little girls seldom had a legitimate excuse for climbing a tree. It would never have crossed her mind to subject children to the awful ordeal of posing in period costumes or in disguise as cherubs. She appreciated them as they were—happily energetic (like Jimmy jumping), inquisitive and busy (like the Cornell boys exploring their new car), often laughing and mischievous, sometimes slightly grubby (when collecting firewood or selling newspapers), and always natural. The adults she recorded are emphatically located in the actual world, too. Pictorialists may have portrayed nymph-like young women floating (apparently weightless) in unruffled ponds and dancing on tiptoe effortlessly through flower-filled fields: Alice Austen

Mrs. Cocroft did housework for Grandmother Austen, while her husband was in the service at Fort Wadsworth. Their eleventh offspring is in christening robes. (*The Cocroft children in the trees. Fine warm day. 1.30 p.m., Tues., Nov. 2, 1886. Cramer, Stop 2, Instantaneous*)

OVERLEAF, LEFT: Two respectable residents of Bennington, Vermont, egged on by Alice and Julia Martin, expose a shocking amount of black-stockinged ankle, calf and knee. "She was a devil of a girl, if ever there was one," old Miss Austen chuckled when she remembered Mrs. Snively. "Oh, she was a corker!" (*Miss Sanford & Mrs. Snively. Fine day. 5.35 p.m., Friday, Aug. 29th, 1890. A&R 40, Dallmeyer lense, 10 ft.*)

OVERLEAF, RIGHT: In an era when women were arrested for smoking in public, 25-year-old Alice and the Episcopalian minister's daughter simulate sinfulness. The scene is Miss Eccleston's bedroom in the rectory. (*Trude & I masked, short skirts. 11 p.m., Thursday, Aug. 6th 1891. Gas on, flash. Stanley 35, Waterbury lense, 11 ft.*)

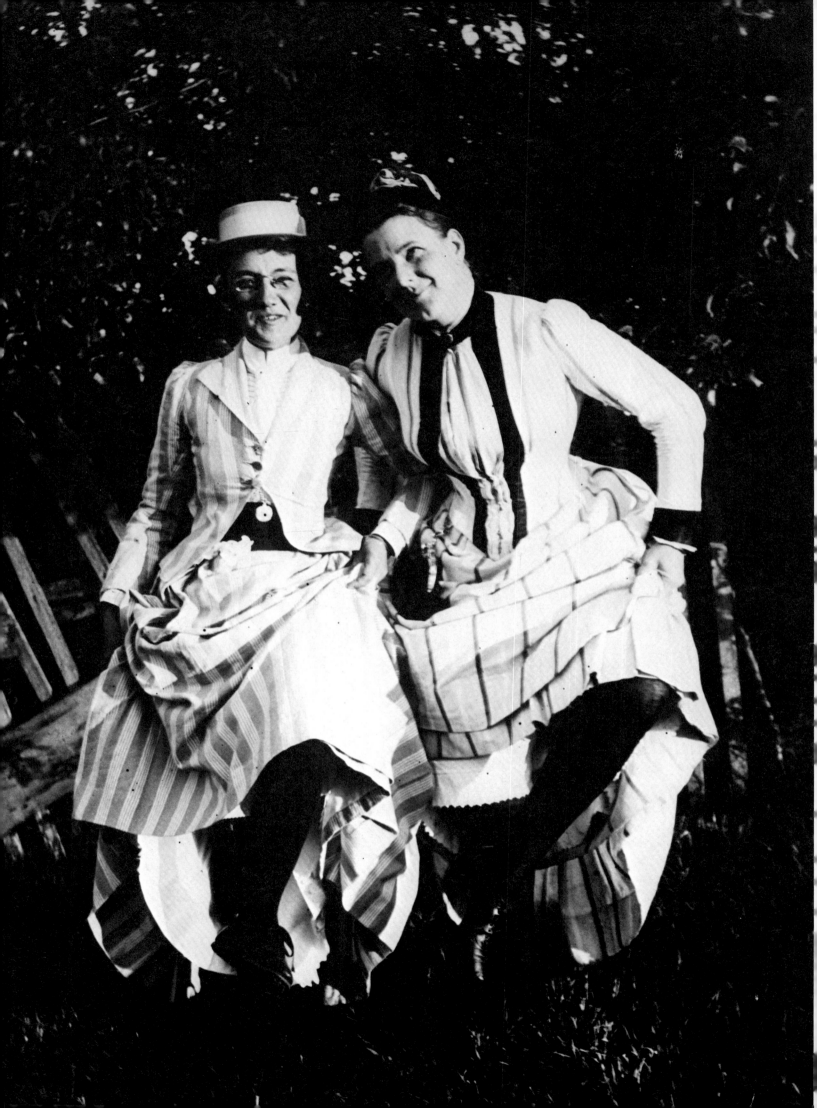

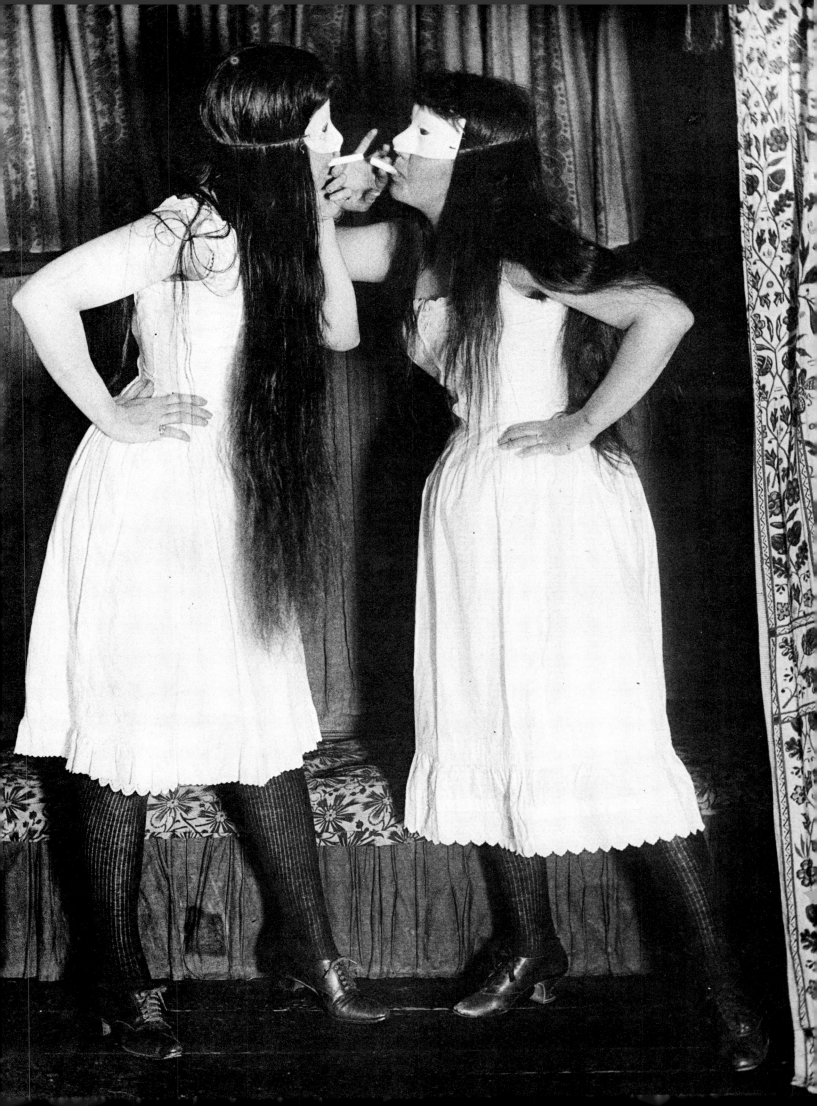

The unsentimental realism of Alice Austen's photos of mothers and children was unusual for her day. Here, Uncle Peter's children (William Munroe, Elizabeth Patty and little Oswald) enjoy the fun of posing with their mother and governess. (*Nellie, Miss Butler & children laughing. Cloudy, rainy day. New Brunswick. 2.10 p.m., Monday, March 7th, 1892. A&R 40, Waterbury lense, 10 ft., Inst.*)

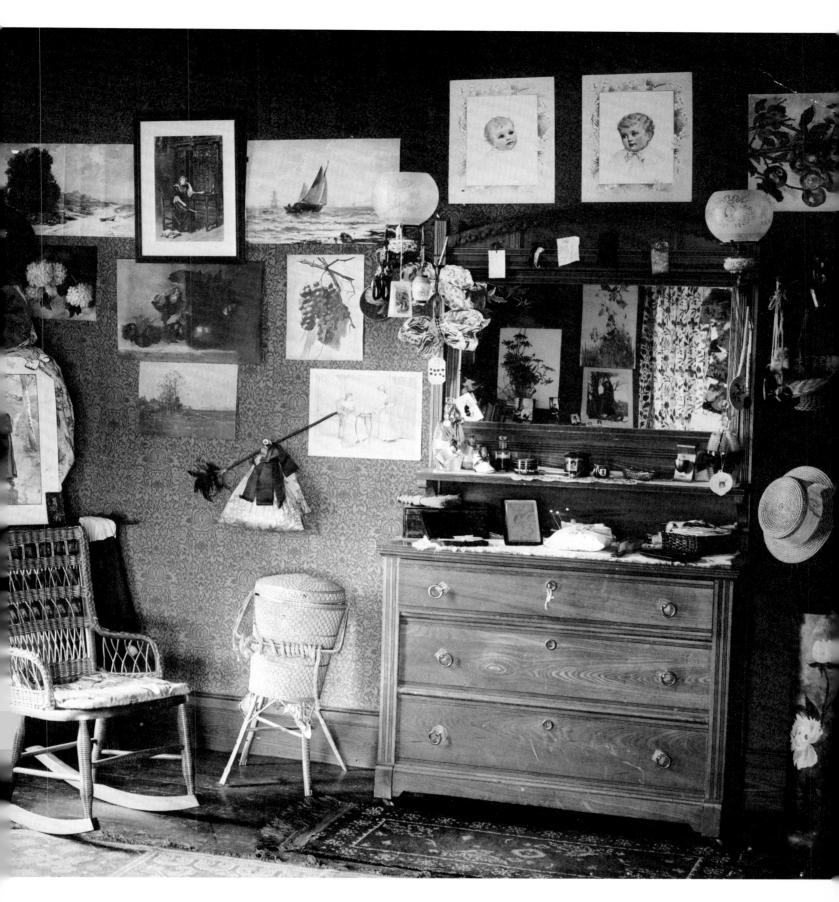

A picture that no masculine photographer would have taken. Only Trude Eccleston's girl friends and perhaps her brothers ever saw her bedroom. Pretty watercolors on the wall, a wicker sewing basket and treasures on the dressing table were the accouterments of Victorian girlhood. October 16, 1889.

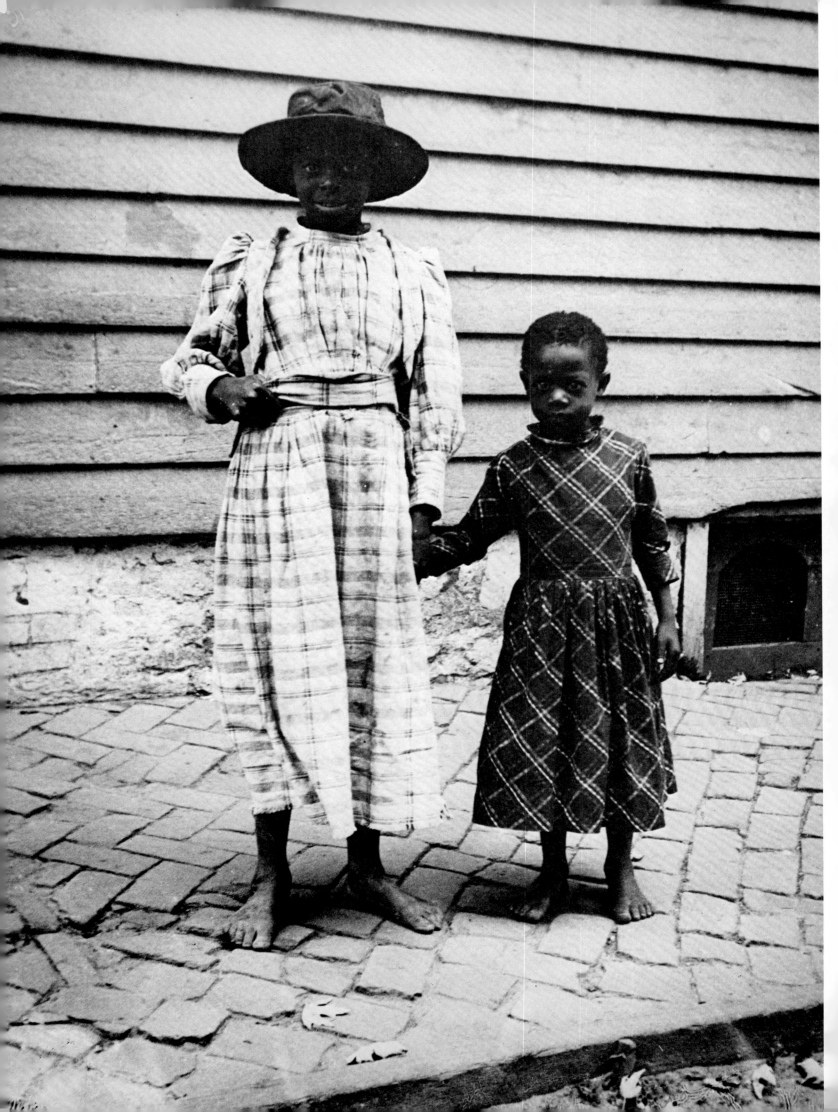

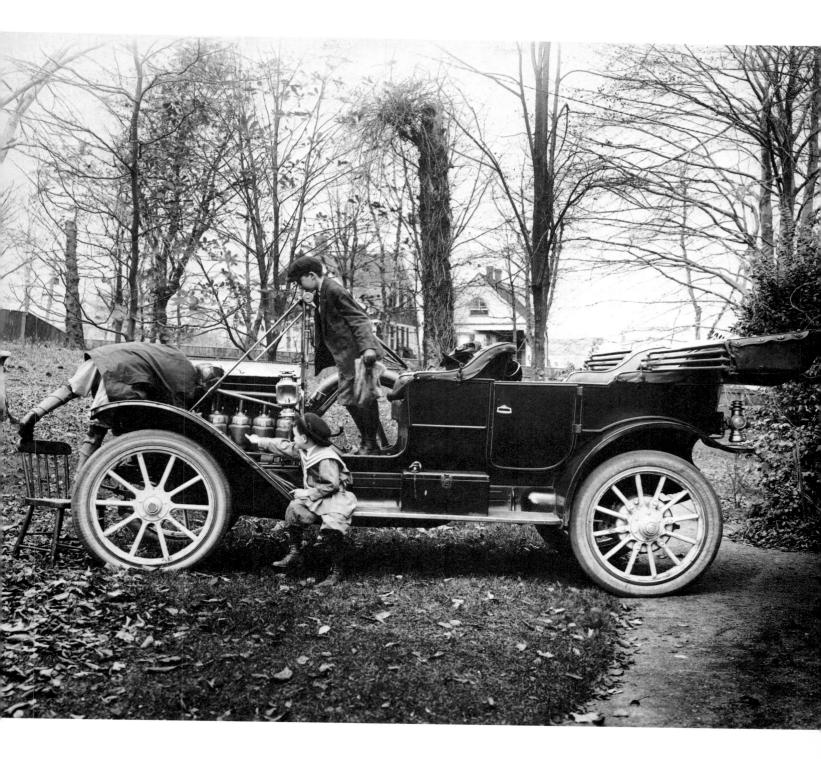

The Cornell boys, Donald, Gordon and Bobby, examine the mechanics of their family's magnificent new automobile. Children behaved naturally in front of Alice Austen's camera.

OPPOSITE: Two children in their Sunday dresses, photographed near the Methodist Church in Delaware City, react to the unusual lady off the *Wabun*. (*Two little darkies. Cloudy, sun in & out. 12.40 p.m., Sunday, Oct. 23rd, 1892. First, slow*)

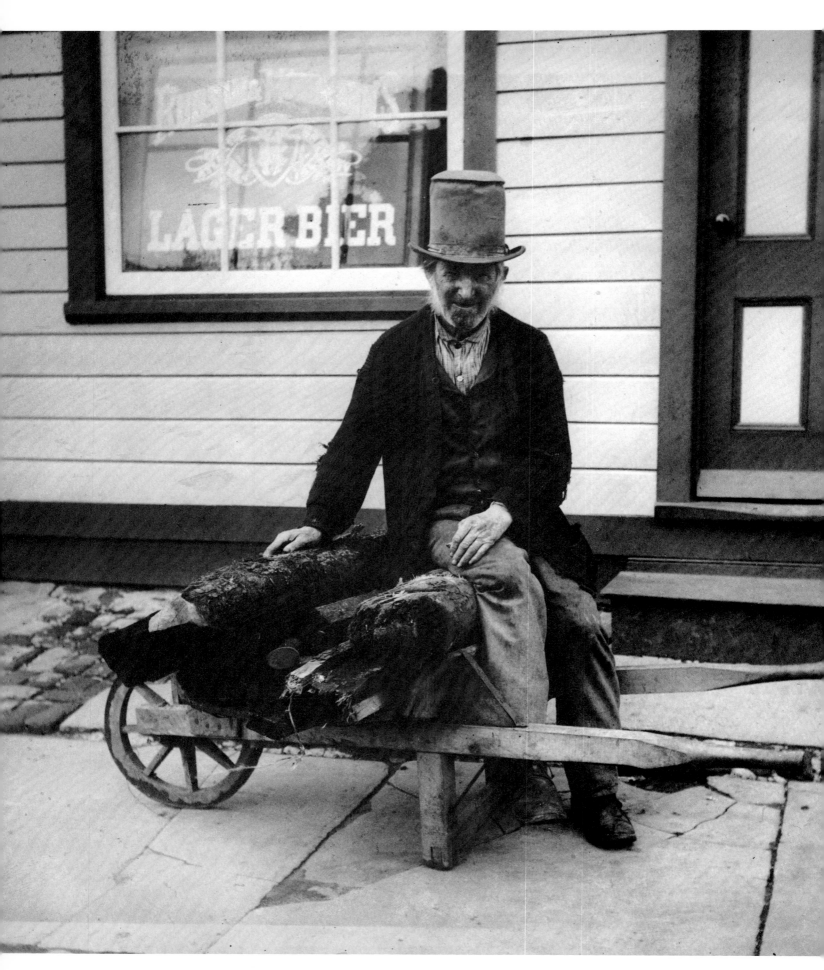

Ordinary people in unaffected poses always appealed to Alice. (*Old man & wheelbarrow, St. Mary's Avenue. Fine clear day. 3.06 p.m., Thursday, Oct. 2nd, 1890. A&R 40, Dallmeyer lense, 10 ft., Inst.*)

Children on the road below Mount Anthony, near Bennington, Vermont, watch as Alice and Julia Martin pass by in their donkey cart. August 14, 1890.

recorded her friends in the flannel skirts and woolen stockings of clumsy bathing suits calculated to impede the movements of the strongest swimmers, and she showed them doing gymnastic exercises to develop the strength their daily activities required. Alice Austen's women ride bicycles and horses, work in the streets and marketplaces, and are as vigorous and real as Alice herself.

The fact that Alice was a woman, often photographing women, adds a special dimension to her work. No masculine camera would have invaded the private sanctum of the young Victorian lady, preserving the bedrooms of Trude Eccleston, Julia Marsh, Bessie Strong and of Alice herself, showing us all the souvenirs and home-made decorations that are so charming to our eyes because of the innocence and vulnerability they reveal. Only a woman's camera would record the unselfconscious affection of young women for one another, and their mockery of the conventional strictures of their society: Mrs. Snively and Miss Sanford would never have kicked up their skirts to reveal knees and ankles if a man had been watching, nor would Alice and her friends have posed as cigarette-smoking depraved women or, worse still, dashing young men about town. Alice Austen did not waste any time pondering the essence of femininity. She photographed actual women—as young, funny and energetic as her own friends, as plain and poor as the street vendors of the Lower East Side, single like the Ward sisters or married like the Ecclestons, and as old as Cousin Emily in Fishkill.

The fact that she was a woman also means that it was a considerable achievement to have produced a body of work as large and as excellent as hers. Alice Austen did not have to worry about money when she was young, but she still had to surmount the less tangible deterrent of social custom. The barriers to be overcome by the serious woman photographer—much more formidable a century ago than today—are described in *The Woman's Eye* by Anne Tucker: "Not only must she find the time and energy to create, and establish her right to do so, but she must know what she wants to express and how best to express it. To achieve this, any artist has to explore and take risks, but so often a woman is handicapped by her public image as a woman. . . . Exploration, whether of jungles or minds, is considered unfeminine and dangerous. . . . Beyond the realm of fashion, women are not encouraged to be original, but to look for approval." Alice Austen received all the approval she needed from her family and close friends. Victorian society was not strong enough to restrict her growth or undermine her courage. She did, simply, exactly what she wanted to do, and didn't give a tinker's damn if she exposed her ankles while climbing a fencepost in pursuit of the picture she wanted. She behaved with the kind of self-assurance that was the more natural prerogative of the men of her society. As a result, her photographs are in one sense not particularly feminine: many of them are funny ("men are supposed to be witty, women humorless," writes Anne Tucker), and few of them have the softness, delicacy or compassion traditionally sought in pictures made by women.

Although she valued her own work, Alice Austen almost certainly did not regard herself as an artist. Probably she thought of herself simply as one of the hundreds of enthusiastic amateurs of her day, as a member of the Newark and Jersey City camera clubs, and an occasional contributor of pictures to journals of amateur photography such

as *Camera Mosaics* and the *Photo American Review*. And yet she had the self-confidence to see that her photographs were unusually good. "I would guess that she didn't think of her work as something to get all excited about," a life-long friend of hers has commented, "but I am sure that she knew if it was good or bad. She was too well educated, too experienced with art in all its forms, in her own country and abroad, to avoid knowing what a picture was." The fact that her photographs might have been a source of income did not concern her when young and apparently never occurred to her in the later years when she so desperately needed money; but she may, in fact, have sold a good number of photographs. From the time when she was twenty-seven (when she recorded the 1893 world's fair in Chicago) until she was nearing fifty, photographing the homes and gardens of Staten Island, she sent some 150 prints to the Library of Congress in Washington to be copyrighted. Several of these copyrighted photographs (including a view of her own house) were printed as postcards. One series of pictures dating from 1896 (the 50 "street types" of New York City) was published as a small portfolio of photogravures by the Albertype Company of New York, the prints individually mounted on boards and packaged in a folder tied with a silk ribbon. Some of her European landscapes of grazing sheep and windmills ("Peace in Old Holland") and scenic views of fruit trees and flowers on Staten Island ("In Full Bloom"), copyrighted in the years just before World War I, may, like the portfolio, have been intended for sale.

She undertook photographic projects of a quasi-commercial nature to oblige friends. At the request of Daisy Elliott, a professional teacher of gymnastics, she made pictures of Miss Elliott's studio with its pupils dressed in smart uniform bloomers and its impressive array of calisthenic equipment. When her friend Violet Ward was writing a book on bicycling, Alice photographed Daisy as a model demonstrating the correct (and dangerously unstable incorrect) positions in which to turn corners, coast, dismount and turn the vehicle upside down for repairs. When the book, *Bicycling for Young Ladies* by Miss Maria E. Ward, was published in 1896, the illustrations appeared as engravings (with the stout pole that propped up the bicycle, as well as some of Daisy's glummer facial expressions, omitted by the engraver), because the halftone printing process, enabling the reproduction of photographs on the printed page, had not yet come into general use.

It is tempting to speculate that if Alice Austen had been born a few years later, or if she had had to face the problem of earning a living earlier in her life, she might have made a name for herself as one of the country's first newspaper photographers or photojournalists. The photographer whose work most closely resembles hers is Frances Benjamin Johnston (1864-1952), who in the 1890's in Washington, D.C. began a career as a photojournalist (after writing to George Eastman: "Please send me a camera which will take good pictures for newspapers"), and later made portraits and photos for public relations purposes (most notably for the Hampton Institute). She exhibited her more "artistic" prints at exhibitions of the New York Camera Club, but she was, like Alice Austen, basically a documentary photographer with an eye for detail and natural composition. There are striking similarities between the two women: Miss Johnston, like Miss Austen, never married, was well connected and much traveled, unconven-

tional according to the norms of her society, a strong and independent woman. Like Alice, she photographed the Chicago fair and Dewey's fleet, as well as the streets of her own city, and in her later years—at the end of a career that lasted into the 1930's—she made many photographs of old Southern houses and gardens. Another photographer to whom Alice Austen might be compared is Jessie Tarbox Beals (1871-1942), who began taking photographs when she was an eighteen-year-old school teacher in Massachusetts, and soon discovered that she could earn more money by making pictures than teaching children. She took many portraits of famous people (Theodore Roosevelt and Mark Twain among them) and enjoyed an unusual career as a news photographer for *The Buffalo Courier*.

Alice Austen's photographs reveal a natural instinct for photojournalism (some forty years before the word was coined). She never missed major events like Dewey's return from the Philippines or the end of World War I, or incidents of local interest, such as a ship run aground in the Narrows. She certainly had the tenacity and physical stamina to have made a good news photographer: when fire destroyed fourteen houses in Hoboken in 1897, Alice spent more than an hour and a half scrambling over the dangerous rubble to record the gutted ruins from every angle. Her reluctance to abandon a photographic subject until she had covered it thoroughly can be seen in the exhaustive series of pictures she made of the quarantine facilities on Staten Island and nearby Hoffmann and Swinburn Islands. The earliest of these photographs—taken almost as a professional assignment, at the request of Dr. Doty of the U.S. Public Health Service—were exhibited in Buffalo at the Pan American Exposition of 1901. But Alice's personal interest in the ships and the medical procedures, her fascination with the details of the fumigating machinery and the laboratory equipment, kept drawing her back, year after year, to the shore station and the two isolated hospital islands where immigrants suffering from contagious diseases were detained and treated; not until 1910 did she complete this series.

Using the term in its widest sense, then, Alice Austen was a photographic reporter, almost consciously a social historian. As an old woman in 1951, she confided to Oliver Jensen that she had wanted to record the tennis games and parties of her youth, as well as the old houses of Staten Island, because she realized even then that her world was not going to endure for ever. Her real achievement is that she accomplished her goal: her fifty years of work have given us a unique record of a world that vanished forever with the Depression and the second World War. When her photographs first gained public attention, Paul Vanderbilt, curator of photographs at the Library of Congress, commented to a *Life* reporter:

"The point about Alice Austen's work is that it is handed down to us in such an attractive package—a systematic account of family life. . . . She provided the best, connected photographic story of elegant family life of the '80's and '90's that I have ever seen. . . . She was exceptionally good in her choice of subject matter. And she had a sense of humor and a kind of observation of what was worth taking a picture of that were ahead of her time."

How early in photographic history her "time" began is worth emphasizing. Alice

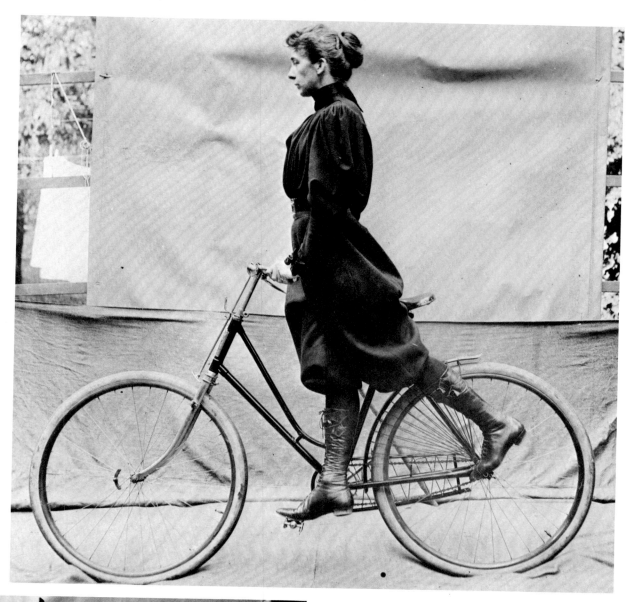

Coasting ("*Wheeling from the pegs*").

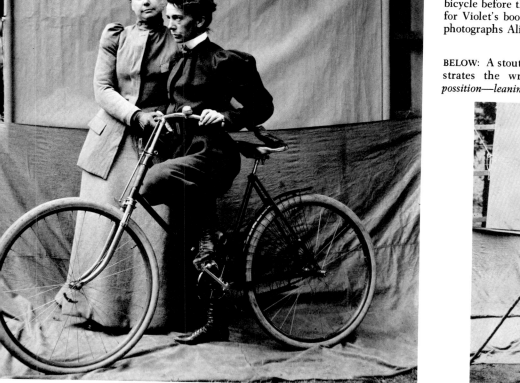

Violet Ward lends a supporting hand to Daisy Elliott's bicycle before the gymnast starts posing. The illustrations for Violet's book on cycling for ladies are among the few photographs Alice ever had commercially published.

BELOW: A stout pole and a rock brace Daisy as she demonstrates the wrong way to round a curve ("*Incorrect possition—leaning against the inclination*").

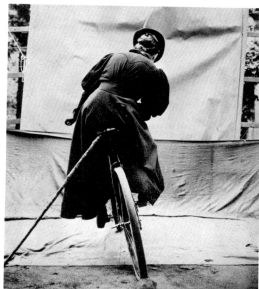

Austen was an experienced photographer by the time Alfred Stieglitz, her contemporary, exposed his first negative. She took her first photographs in the late 1870's—some twenty years before Edward Steichen bought his first camera in Milwaukee or Eugène Atget began to record the streets and people of Paris, twenty-five years before Jacques-Henri Lartigue (aged seven, so short that he climbed on a stool to focus his camera on its tripod) began his album of family and friends on the beaches and in the gardens of middle-class France.

Alice Austen has earned her own place in photographic history, and in the history of Staten Island which also was, coincidentally, the vacation home of Civil War photographer Mathew Brady, the resting place of Brady's famed assistant Timothy O'Sullivan, and the home of Dr. John William Draper who photographed the first satisfactory picture of a human face (a portrait of his sister in 1840).

Alice's reputation might have been established sooner if two or three thousand of her most valued glass plates had not been lost or destroyed because of the misfortune that overwhelmed her in her later years.

Less concerned with decorum than with getting a good picture of the auto speed trials, Alice perches on a fencepost while Gertrude Tate quizzically watches the second photographer. Alice's camera seems to be the one on page 140.

CHAPTER SIX:

The Later Years

As she reached the age of fifty, Alice Austen increasingly found herself playing the role of a prominent member of Staten Island society. Beginning in 1910, Miss E. Alice Austen of Number Two, Pennsylvania Avenue (she steadfastly refused to call it Hylan Boulevard, even years after the name was changed) was listed annually in New York's *Social Register*. She shared her house with Captain and Mrs. Müller until their deaths in 1912 and 1918; but even while they lived, Alice herself quite clearly became, as the years passed, the resident who counted. Miss Austen was well known on Staten Island and in Manhattan; she was interesting, well liked and busy. Photography had to compete for her time with many other interests. She was involved in so many activities that some Staten Islanders, who knew her only in later years, were quite astonished, when fame touched her in 1951, to discover that her principal hobby had always been photography.

She frequented the Richmond County Country Club in Dongan Hills, the social center for tennis tournaments, fox hunting and the newly popular sport of golf. She and Gertrude Tate joined the Colony Club in Manhattan, and fell into the habit of lunching there before shopping or social engagements in the city. Every Saturday afternoon they went to the Metropolitan Opera. Alice often accompanied Gertrude to the dancing classes she gave at Delmonico's on Fifth Avenue, at Sherry's, the Spence School, the Essex Club in Montclair, New Jersey, and in Garden City, Long Island. They visited friends and resorts, and in the summers, most years before the first war, they enjoyed holidays in Europe.

From spring through autumn, when she was at home, Alice Austen worked almost

(Wisteria taken from window upstairs. No sun, but not far away. A sort of Indian Summer day, glimmering. 2.40 p.m., May 21st, 1914. Stanley Ortho, Azo Hard G Matte. Counted 20)

every day to improve the garden her grandfather had laid out. Wearing an ancient, almost threadbare skirt and a disreputable old hat (worn under protest at Gertrude Tate's insistence, as protection from the sun), she wielded a spading fork and thought little of turning over a whole flower bed before lunch. She set out seedlings, separated the iris roots, and lavished particular attention on the giant wisteria that had arrived from Japan, as a seedling in a pot, on a sailing ship many years before. With indignation, she refused an offer to sell it (transplanted) for $1500. She photographed the tree-like vine lovingly when it blossomed with thousands of delicate lavender flowers, and refused to listen to visitors who pointed out that its tendrils were treacherously destroying the stone and wood of the building that gave it support. But on any other gardening topic, be it pruning or propagation, she would talk at length to the part-time gardener or to the many friends and acquaintances who came to admire the horticultural showplace that "Clear Comfort" had become.

She founded the Staten Island Garden Club in 1914, and regularly entertained its members (ladies with whom she did not always see eye to eye, and whose occasional linen exhibitions bored her). She gave them countless cuttings, and encouraged them in 1915 to raise funds to help buy and restore the 17th-century Perine House (headquarters of the Antiquarian Society, which she also helped to found and supported as a life member). Then she spurred the Garden Club members on to landscape the grounds of the Perine House with suitable shrubs and flower beds.

Once the Perine House had been restored and opened to the public, Miss Austen and Miss Tate were the moving spirits behind the opening of the Box Tree Tea Room in the colonial building. Gertrude Tate (who by this time had moved permanently into the Austen house) was actually its manager. The tea room prospered (although profits were not its main reason for existence), and it was mentioned in guidebooks as an interesting destination for motorists. By 1920, the running of the restaurant had become too much of a task for Alice and Gertrude to continue on a volunteer basis. So the management of the tea room was turned over to a professional caterer, who ran it ostensibly on behalf of the Antiquarian Society, but secretly in her own financial interest. When evidence of this dishonesty became clear, Miss Austen and Miss Tate were so disgusted that they had the tea room permanently closed. Its closing coincided with the merger of the Antiquarian Society and the newly revived Staten Island Historical Society, a merger of which the two ladies did not wholeheartedly approve.

Events of these years, in any case, diverted everyone's attention away from historical interests towards more current affairs. The world beyond Staten Island had abruptly changed. At the end of July, 1914, Miss Austen had stood on her lawn to photograph the German ship *Vaterland*, at that time the largest liner in a peaceful world. One month later, the Great War broke out in Europe. On October 11th, at work in her garden at half past eight in the morning, Alice Austen photographed another ship, the Cunard liner *Lusitania*, steaming out of the Narrows; some time after May 1915, when the *Lusitania* was torpedoed by a German submarine off the coast of Ireland, with the loss of over one thousand lives, Alice added a terse note to her penciled caption—"Last voyage."

Two years later, in April 1917, the United States abandoned neutrality and joined

the horrifying conflict in which at least ten million soldiers and European civilians died. The first troops of the American Expeditionary Force, commanded by General "Black Jack" Pershing, sailed for France in June 1917. The old *Vaterland*, captured and renamed the *Leviathan*, painted in camouflage, reappeared in the Narrows as an American troopship. Fort Wadsworth down the shore hummed with military activity. Edith Eccleston's husband, with a fresh promotion as Colonel Albert C. Blunt, visited "Clear Comfort" with his son Mat, both of them wearing new uniforms.

Alice Austen herself put on the grey-green uniform of a Lieutenant in the service of the Richmond County Red Cross and drove an ambulance for its Motor Corps, serving at the same time as a hostess at nearby Fox Hills hospital through the war years. Some time before 1917, she had organized classes of women volunteers to study driving and mechanics, in the event that they might be called on to help with a war effort. She had foresight. The wartime work done by Alice and her friends is well remembered by John A. Morton, Jr., nephew of the woman who acted as deputy to the hard-boiled Britisher in charge of the Motor Corps. Although he was a boy at the time, he can recall the scene when the troopships slid into anchorage by the Quarantine station, bringing wounded doughboys home for transfer to the Fox Hills hospital (a temporary complex of wooden buildings erected on the hillside above Brady's Pond).

"The ships loomed out of midnight, no lights showing, grey and silent," he remembers. "The sound of engines, running-off chains and the splash of anchors sounded across black water. Waiting on the blacked-out pier were the women of the Motor Corps and the army drivers from the base hospital, as well as doctors, medics, and women with hot coffee for the working crews. They were all wrapped in stout coats, to keep out the water-chilled wind. The ships usually came in after midnight, with little advance notice. Telephones would ring, the volunteers would dress and drive to the pier, then wait for the ship which might be an hour late. Miss Austen was one of the ambulance drivers—a good one. Living almost next door to Quarantine, she could sometimes see the ship out in the channel as she went to the ambulance she kept, when on duty call, in her back yard. She would join the waiting group on the pier and see, at last, a boat coming out of the dark, its coxswain guiding its load of misery as gently as possible alongside the pilings. Swiftly the stretcher cases were swung up to waiting hands and carried to ambulances. With a bell pealing, and a siren's scream at the gate on to Bay Street, they would head for the hospital. Ambulatory cases, no less pathetic, would be helped into army vehicles and follow. It would be dawn or breakfast time before all the men were transferred safely into wards. It was a nasty bit of work: there is nothing pretty about the wounded. The women of that Motor Corps did their share and more. Miss Austen was, as always, dependably *there*. In her uniform with big driving gloves, she drove with the gentleness of someone sensitive to pain. It was not easy to manage a cumbersome ambulance, heavy bodied on a Cadillac or White Truck chassis, around the sharp turnings of the road that snaked up that hill. The women who drove them never cracked up one vehicle. The men driving the army vehicles did, often. While it lasted, the Motor Corps was quite a deal."

Miss Austen's experience behind the wheel dated from her pre-war purchase of a

(*The Lusitania. Sun, fine. 8.30 a.m., Oct 11th. Zeiss lense, Stop 20, Slot 2. Last voyage*)

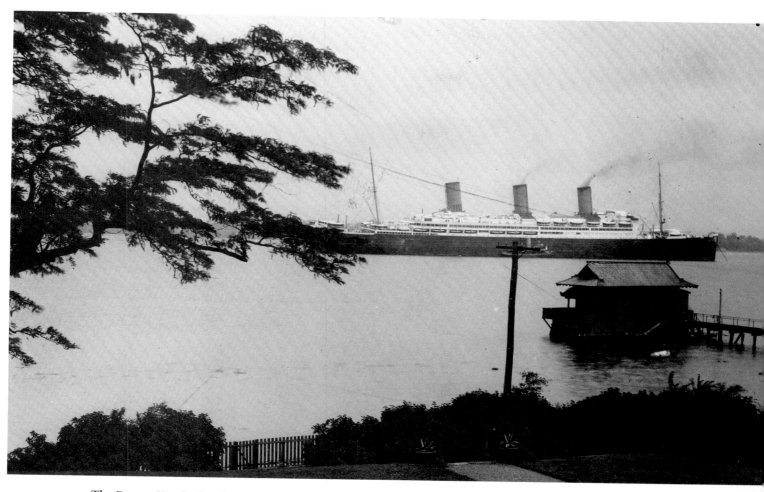

The German *Vaterland*, sailing past the old Yacht Club boat house, was the largest liner of her day. (*Vaderland* [sic] *on right, 3 pipes. Wind, no sun. 12 noon, July 29th, 1914. Ross Goerz lense, about 4 secs, Stop about 16*)

BELOW: Renamed *Leviathan* and repainted for use as an American troopship, the old *Vaterland* steams back to war-torn Europe. (*Leviathan, old Faderland* [sic]*, camouflaged. Fine. 3.30 p.m., Aug. 31st, 1918. Eastman Kodak Premo Film Pack*)

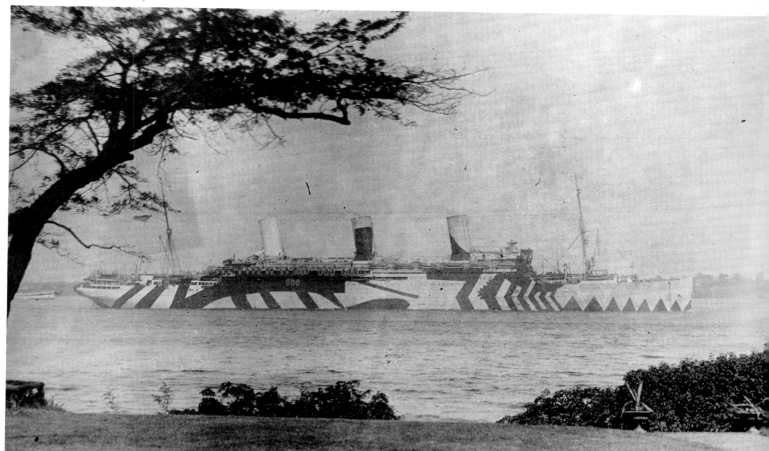

green Franklin, a model (and a color) to which she remained loyal during many years of car ownership. Hers was one of the first automobiles on Staten Island, and to her annoyance the civic authorities forced her to erect a solid brick garage built like a bunker—because of the common belief that cars were dangerously combustible. She took an almost childlike delight in her car, with its gas-lit brass lamps, its narrow stripe of yellow trim, and her initials in a delicate script monogram on the side panels between the doors. Franklin cars were manufactured in Syracuse, under the attentive eye of Mr. Herbert H. Franklin himself. Alice maintained that there was no better automobile, and she enjoyed the fun of provoking her male friends into arguments over the merits of its air-cooled engine and other fine points, as opposed to those of a Packard, Buick or Cadillac. Miss Austen's mechanic was equally devoted to the car—and to its unconventional owner, who enjoyed changing the tires and (with the help of manuals from the manufacturer) tackling simple repair jobs herself. She was quite correct when she argued that the Franklin's engine was unusually quiet, and that her car (unlike those whose owners she liked to tease) started in the worst weather.

In spite of the fact that it lacked a heater, Miss Austen's green car became a familiar sight on Staten Island's roads in all seasons, forging through drifted snow and up slippery hills in winter, stirring up yellow dust on leafy lanes in the summer heat. Always an energetic traveler, she exulted in the new mobility the car gave her. She and Gertrude drove all over the Island and beyond—on an excursion with friends to Centerport, Long Island, in 1910, for example, and frequently to the village of Mendham, New Jersey, for lunch at a small inn opened by Alice's old friend Julia Marsh (now Mrs. George Lord). Alice drove at a stately pace, and she always reached her destination. She particularly enjoyed the challenge of long excursions, driving to summer resorts such as Cooperstown on Otsego Lake, far northwest of the Catskills in New York State, almost two hundred miles away from Staten Island. The unpaved roads were by any standards too primitive for cars, but her vehicle (with a good eighteen inches of clearance above the potholes) managed them, slowly. (When her expected arrival at a resort hotel was delayed, doubting friends would speculate, "Alice and Gertrude must have had tire trouble; maybe they had to stop overnight somewhere." "Nonsense," a supporter would reply. "Alice NEVER has tire trouble!"). These journeys must have been uncomfortable—dust coats and scarves, goggles and gloves were considered essential even in mid-summer heat—but they were marvelous fun.

A typical scene as Miss Austen and Miss Tate embarked in their car for the journey home, after a winter's evening of visiting friends, is recalled by John Morton, one of the children who often helped to see the two motorists on their way:

"When the time for going home was finally agreed on, Miss Austen would fit herself into the high galoshes she wore, habitually flapping, then into her long and heavy greatcoat with a red fur collar, and a hat with a Tyrolean feather stuck into its band. She would stand waiting for Miss Tate who, bending over double until she almost lost her balance, always had trouble getting into her footgear. One of us would offer a hand and get the boots on and neatly buckled. Miss Austen would pull on her gauntlet gloves of raccoon fur while we got her friend ready, and in her left hand she would grasp the

handle of her big handbag, heavy with its flashlight, screwdriver, pliers and other essentials for emergencies. She would grow visibly impatient as all the goodbyes were said and repeated. As everyone kissed Miss Tate goodnight, Miss Austen would affectionately pat a cheek here and there and ask us, 'Hurry Gertrude along, now; it's late.' Out into the night we'd go, usually Father and I, to see them securely into their car with its odd winter enclosure of glass and metal. Generally the Franklin started at once, but there had to be a decent interval while the engine warmed up (and we froze). Then Miss Austen's big gauntlet glove would come out through an opening in the side window, like a bear's paw out of a cage, as she called out some parting remark to make us laugh. Slowly she would guide the car out of the dooryard into the driveway, and our family group would stand watching until its lights lit up the gates at the street corner and vanished down the hill. This procedure, slightly easier on everyone in the summer, went on for years."

These years of Alice Austen's maturity passed pleasantly, swiftly, as she filled them with visits, hobbies and travel. Her social circle included Staten Islanders such as Jessie and Charles Dewar Simons, Jr., Jessie's sister Faith and her husband John Morton, Effie and Reginald Bonner, the Comforts and the Monells, the Parmeles, Prices and Primroses, the Hortons and the Ortons, members of the Heineken and Bechtel families, Mr. and Mrs. Edward Stettinius, Sr. (parents of the Secretary of State), the naturalist William T. Davis and local historian Charles Leng. Her male friends were financiers and industrialists, brewers and shippers, managers of railroads, doctors and authors, whose wives were members of the Red Cross, the Daughters of the American Revolution, and the Women's National Republican Club. They built fine houses on Emerson Hill or on Dongan Hills near the Country Club, they prided themselves on their gardens, and supported charities and the arts. They lived in a world that was comfortable and orderly, with a benevolent (and generally Episcopalian) God in secure charge. Their world was, in the words of one participant, "as sound as Mr. J. P. Morgan's bank on Wall Street, as assured as Mr. Taft in the White House, as predictable as rib roast for Sunday dinner at one o'clock." Its confident watchwords were Prosperity and Progress. None of its inhabitants foresaw, even when war came, how soon their world was to crumble.

In tune with the society around her, Alice Austen's life followed an established rhythm. Every Christmas, she attended the eleven o'clock church service at St. John's, then drove to the big house in Dongan Hills where the Simons and Morton families gathered for dinner (with as many as sixteen adults and eight children at the tables). Presents were opened, fathers and uncles dispensed five-dollar gold coins, and parts of Dickens' "Christmas Carol" were read aloud. The children's party at this season always included Santa Claus himself, arriving at the front door of the Mortons' house to the sound of jingling sleigh bells. The pattern was broken one year when the favorite uncle who always played this role was overseas, at the beginning of the war: Miss Austen came to the rescue and agreed to take on the part. One young boy who was present remembers that she seemed to have as much fun as the children. "After shaking the snow off her shoulders, and striding in and around the room with a great bag filled with packages," he

LEFT: Alice and Gertrude motored—sometimes with friends and sometimes in their own Franklin—all over the northeastern States and as far west as Ohio. 1910.

The serenity of pre-War life seemed secure. Staten Islanders in 1916 drove to the Richmond County Country Club to watch tennis matches on shaded grass courts.

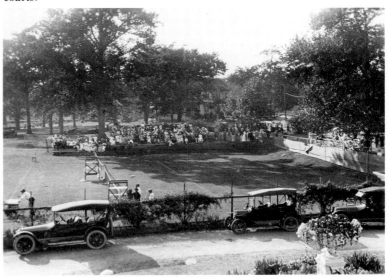

In the new uniform of a Colonel, Edith Eccleston's husband Albert Blunt came to visit "Clear Comfort" with his two sons (see page 63) after the U.S. entered the war.

wrote, "Miss Austen let out a loud shout (probably the only one she ever uttered) as a greeting to the children. This completely broke up the adults, and added to the mystery of *who* Santa Claus was—for none of the other kids or their mothers knew, at the time. I knew, of course, and burst with importance over it. Our servants laughed so much the cook started to cry and Mother had to pat her hard on the back. When it was over, and Miss Austen went out the front door to come in again by the kitchen, the children still had no idea that it had been she. Only the older folk knew, later on, and they didn't tell."

Picnics happened in the summers. One favorite site was a rural retreat belonging to Charlie and Jessie Simons, on a hilltop overlooking a wooded valley about three miles west of the Country Club. Because of its hundreds of fruit trees, mostly peach with a scattering of apple and pear, the place was named "Peach Farm." It was indeed a farm, with a barn and stables, and tenants to care for a few resident cows, pigs and many chickens. Mrs. Simons enjoyed ordering great hampers of food prepared in her house at Dongan Hills, then filling a horse-drawn carriage with friends for a rustic outing— complete with a coachman, domestic servants and white cloths on the wooden tables. Alice Austen liked "Peach Farm" (which today has vanished into the southern grounds of the Willowbrook State School), and she preferred it when it was less crowded. She used to drive there, alone, to photograph the fruit trees when they blossomed in the spring.

In large gatherings Alice tended to become a quiet observer, unless she was surrounded by young people. But her talent for organization sometimes led her into the thick of the crowd. On one memorable occasion she helped Jessie Simons and a charitable group of other ladies to organize a summer bazaar to benefit the St. John's Guild (sponsors of a floating hospital which carried poor city children out into sunshine and fresh sea air). They had an unorthodox idea. On the grounds of the Simons' house, a giant tent was erected over a raised platform and bleachers. Scandalous rumors began to circulate around Staten Island days before the occasion. Mr. Simons was so upset that he would hardly speak to Mrs. Simons. The rumors proved to be true—the main event was an exciting series of boxing and wrestling matches, the first public prize fights to which gentlemen of that day had ever been able to take their wives and daughters. They loved it. The bazaar was a huge, and profitable, success. "It took a good bit of nerve to pull it off," recalls Mrs. Simons' nephew. "And that was just exactly what Miss Austen loved. She aided and abetted my aunt through the whole affair, and was right there watching with glee when it happened."

More sedate affairs, but equally enjoyed by Alice, were the afternoon musicales offered by Margery Bonnell Flagg and her husband Ernest Flagg, architect of Scribner's bookstore, of the U.S. Naval Academy and of the 47-storey Singer Tower on Broadway (the world's tallest building when completed in 1908). The Flaggs' gardens were the showplace of the Island, "like a miniature Versailles" according to one awed visitor. The concerts given in the equally magnificent house were not amateur affairs, but carefully produced performances by fine singers and instrumentalists such as Fritz Kreisler and Mary Garden. Some of the Flaggs' close friends were proficient amateur musicians:

Mrs. Reginald Bonner (born Effie Caesar, granddaughter of Captain Jacob Vanderbilt, the Commodore's brother) was a well-trained opera singer. In the Flaggs' house was a particularly fine pipe organ, hand made of wood brought from the forests and mills of their own estates in Ohio. When Mr. and Mrs. Flagg undertook an automobile journey to visit their Ohio properties around 1910, Alice Austen went with them: that was just the sort of excursion she enjoyed.

Alice was a hostess at "Clear Comfort" as often as she was a guest in her friends' homes. A few of her parties were given on unusually short notice, on occasions of a very special sort—when her night-blooming cereus flowered. This cactus plant is a horticultural curiosity of which the Victorians seem to have been particularly fond. Alice photographed one that bloomed in the Van Rensselaer mansion at Fishkill, one night in July 1890, and several years later she prized one of her own that grew by the porch. When a rare and portentous bud appeared, she hurried to the telephone and warned as many as fifty friends to stand by, for that evening or the next. When the green bud enlarged and started to split, she telephoned again and her old friends put bottles of champagne on ice. A small cavalcade of cars proceeded down Pennsylvania Avenue to "Clear Comfort." Her guests were content to pass a long evening, until well after midnight, chatting in the cozy lamplight of the parlor or out on the porch where the breeze blew gently off the water. As the hours passed, Alice prowled around with an enormous electric flashlight in her grasp, inspecting the impending miracle at regular intervals and making sure that her guests were provided with enough champagne or ginger ale to keep them happy. Her Irish maid became quite distracted by all the fuss, stopping to stare at "the ugly old plant by the door" from time to time, obviously skeptical of Miss Austen's explanation of what would happen. Then the moment came when Alice shone her light on the cereus and triumphantly called everyone to gather around it. The huge bud, grotesque in its shiny green cover, split open before their eyes as if in a slow-motion film and the flower, with a strange semblance of dignity, bloomed into its full magnificence. Its exotic scent, an unforgettably heavy and sweet perfume, filled the night. When the tide in the Narrows was full, and the still water reflected the stars, not a breath of air moved to dispel it. The only disturbance was Alice herself, moving her heavy camera around the porch and igniting flash powders that burned with a blinding light, as she carefully recorded every stage of the event. The party ended soon afterwards. Next morning, the only remnants of the marvel were some wilted brown petals on a drooping stem.

Other parties happened in the Austen garden when ships of special importance sailed past—the Hudson-Fulton Celebration, Lindbergh returning in triumph from his first transatlantic flight, or the maiden voyage of a new passenger liner. These were summers when many Staten Islanders sailed for long holidays in Europe. After the expressmen had hauled away all the trunks and steamer rugs, hat boxes, satchels and walking sticks without which no journey seemed possible, and the travelers themselves had departed for the Manhattan piers, their remaining friends drove down to "Clear Comfort" to wave and celebrate as the ship passed out of the harbor. Youngsters loved to set off flares and to jostle one another for turns peering through the fine old telescope,

On the porch at "Clear Comfort," Gertrude Tate (holding binoculars) and the Blunts prepare to signal a welcome to returning troopships.

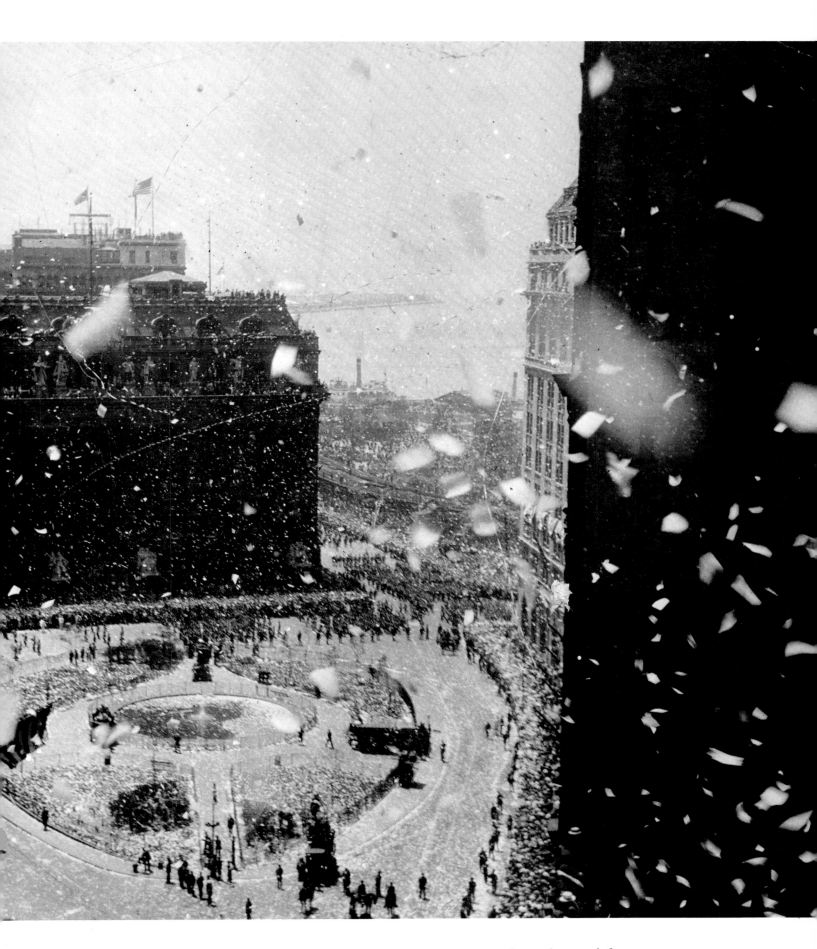

In Manhattan, the end of World War I is celebrated with ticker tape and a victory parade marching north from Bowling Green.

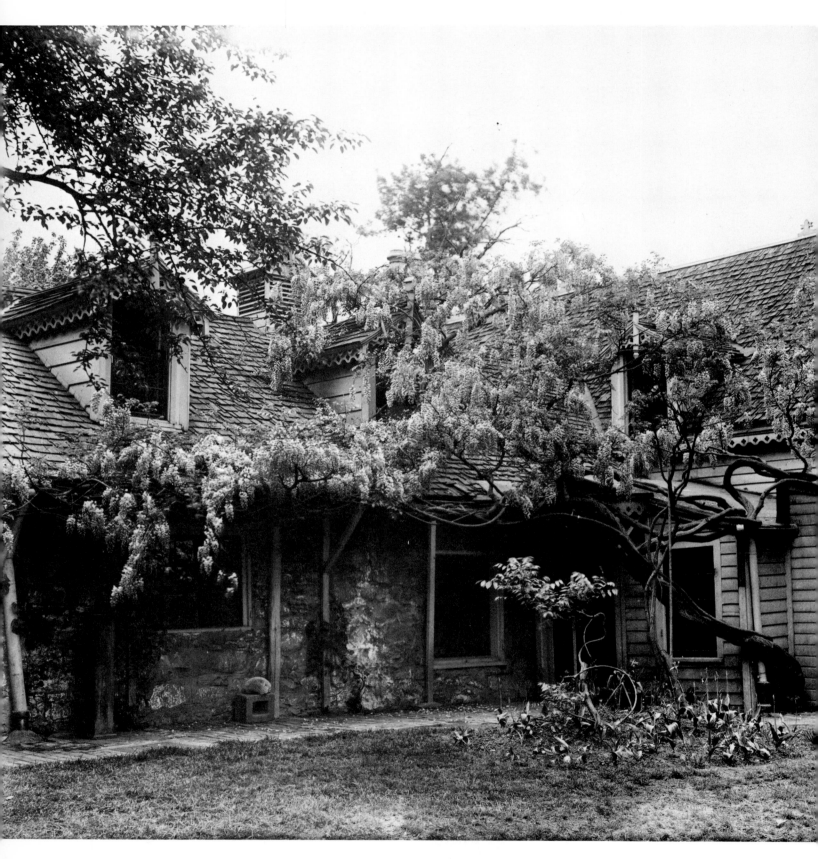

An ardent gardener, Alice treasured her wisteria vine even though its tendrils threatened the gingerbread and cedar shingles of her house. (*Kitchen. 3 dormer windows & part of fourth. Azo Hard G Matte. 1 min., 20 secs.*)

Flowers of any sort attracted her. She made many photographs of the blossoming fruit trees on Jessie Simons' farm (above).

still mounted on its tripod as it had been in John Austen's time, its leather covering now worn with years of use. Alice enjoyed herself as much as the children, carrying iced tea and sandwiches out onto the lawn, getting out her camera to take yet another photograph of the *Majestic, Berengaria* or *Lusitania*, the *Olympic* or *Doric*, the *Bremen, Europa*, or one of the cheerfully-colored Italian liners, the *Conte Di Savoia* or the *Rex*. When Jessie Simons sailed on the *Mauretania*, a particular favorite, she tried to persuade the captain to whistle an exciting salute. When Alice and Gertrude were themselves the passengers, their garden would be filled with well-wishers who exuberantly waved flags and handkerchiefs at the two friends on deck, then settled down to a comfortable picnic as the ship sailed out of sight beyond Fort Wadsworth.

The flower-filled garden and the shaded porch seemed always to welcome visitors, as did the owner of the house. Young people, particularly shy young men, seemed to feel especially at ease there. They confided their troubles in Miss Austen and brought their friends and sweethearts to meet her. Pieter Vosburgh (thirty-five years younger than Alice, the son of neighbors who had met her at the Cricket Club) brought his fiancée to "Clear Comfort" so often that they nicknamed the place "The Coop"—slang they had picked up from a police biography, meaning a place where one could always find shelter in bad weather or when the going got rough. On arriving, the young couple would gleefully ring the large bell by the back door, then play a routine joke of hiding in the garden to puzzle Alice and Gertrude—who knew perfectly well who their unexpected visitors would be. John Morton, forty years Alice's junior, was a regular visitor to "Clear Comfort" whenever he got leave from the Navy in the second World War. "There was always an air of adventure, something special about visiting that atmosphere of antiquity and comfort," he reminisces. For him and for others, the half-hidden cottage behind its high board fence and trees occupied a place apart from the real world. "It had the feeling of a stage setting for a special play that progressed over the years," he remembers. "No other old house in my experience has the charm that 'Clear Comfort' had when sun glittered on the water and was reflected on the underside of the porch through the vines. It gave you a feeling of serenity, the peace of complete contentment. I'd walk in from the gate and smile with utter satisfaction at the reassurance of the old place. I loved the drowsy hum of insects and birds in summer, the delicate movement of leaves in the little breeze off the bay, the sunshine on the grass and the flowers that looked as if they were on parade."

But as the summers drifted by in the apparently timeless setting of "Clear Comfort," something unexpected and somehow incomprehensible happened. Time touched Miss Austen: her brown hair turned grey, and she grew old. "She was so vital, so energetic and strong, that it wasn't possible to imagine she would ever be otherwise," one of her friends remembers. Even in her middle age, she had possessed the exuberant energy of a Teddy Roosevelt. To watch her slowly lose her physical vitality was distressing. Her normal stride—that of a young woman used to walking long distances or of a tennis player who could stay on the courts all day—slowly turned to a more measured pace. She seemed a little unsteady at times, and she began to bend slightly forward instead of standing upright.

Her friends began, secretly, to worry about Alice, although they made a joke of the fact that in the evenings—even in the middle of a bridge game—she often fell asleep. Gertrude kept her knee conveniently close to Alice's leg under the card table and tried inconspicuously to nudge her whenever her head nodded. When Alice received a particularly sharp poke, her head snapped up as her eyes opened: she grumbled that she wasn't sleeping, just thinking, and then startled her partner, Pieter Vosburgh, by finessing a nine-spot and winning the trick. At the Simons' or Mortons' houses, Gertrude Tate and Jessie Simons would amuse themselves with a Ouija board, while Faith Morton knitted and Alice sat in a high-backed chair by the fire and the drowsing dogs, her head nodding and rising, occasionally opening an eye to wink conspiratorially at a youngster or to glance at Gertrude's activities with benevolent cynicism. As Alice snoozed, the other women asked Gertrude quietly: "Ought she to sleep so much? Is she well?" Gertrude's answer, with a sigh, was always the same: "She says I mustn't *fuss* so much. She won't see a doctor." Then Alice would raise her head abruptly, saying "It's time to go home, isn't it? Come along, Gertrude."

One younger friend suspected that Alice was not really asleep during these evenings, but just relaxing with her own thoughts in the comfortable atmosphere of repetitive chit-chat that she found a little boring. At home she would wake once an hour, on time for the radio news to which she would pay absolute attention, then check her watch to make sure exactly how many minutes would elapse before the next broadcast—and doze off again. Her private thoughts may well have been absorbing, and somberly out of keeping with the apparently secure and comfortable surroundings. She was distressed by the arthritis that was beginning to hurt her hands, making it difficult for her to hold her camera steadily: she knew the truth, although she snapped irritably at Herbert Flamm in Weitzman's Photo Shop that her blurred negatives were the fault of improper processing or the inferior quality of the new films. She brooded over the way the neighborhood of Clifton seemed to be changing. Local politicians kept bringing up the threat of the shore-front road, children invaded the garden and threw stones at the large vases, while tramps slept in the Yacht Club's old boathouse and fishermen made a nuisance of themselves on the beach at night, roasting fish over open fires, drinking too much and making an unpleasant noise. When they fell on the rocks and hurt themselves, some of them had even sued her for damages. A barrier of garden shrubs seemed to be all that protected "Clear Comfort" from an increasingly hostile environment. She had been ordered to tear down the high board fence along Hylan Boulevard (how she loathed that name) because a malicious neighbor had reported that it was unsafe; instead, she had had it repaired and painted barn red, as a gesture of defiance. The harrassment made her angry, but sometimes it drove Gertrude to tears. They were beginning to feel vulnerable, at times slightly isolated, in a changing world. Her closest married friends, Trude Eccleston Barton and Julia Marsh Lord, had moved away from Staten Island. A few of those who had remained, single, had (like Sue Ripley and Violet and Carrie Ward) retreated into personal eccentricity and become unreachable. The supportive figures from the Austen family were dead: Alice transplanted ivy from the garden to the Moravian Cemetery, to cover the graves of her grandparents and mother,

Oswald and Minn, and young Uncle Peter who had died in 1907 at the age of fifty-five. Now, as she dozed by the fire, a woman past fifty-five herself, Alice worried about the upkeep of the home they had all loved so much.

Money was the worst problem, although she tried not to think about it too much. The once substantial income from the capital left by her grandfather in 1894 had lost value and dwindled to a modest sum by the 1920's. And the luxuries that gave Gertrude so much pleasure—from the Franklin car to season tickets at the Metropolitan Opera—were becoming increasingly expensive. Because of "Clear Comfort's" waterfront location and its desirable proximity to the docks to the north, she had received several extraordinary offers for the house and land. In 1918 the real estate operator Joseph P. Day offered $100,000; a few years later, the dry dock dredging company of Merritt Chapman & Scott made a proposal of $125,000, and the American Chicle Company offered $175,000. Alice did not want to sell her family's home at any price. But the stock market did look increasingly attractive . . . even though knowledgeable friends reminded her of the old New England maxim that Principal Should Never Be Touched. Alice was stubborn and perhaps afraid that she might lose the chance to gain the profits she needed. A broker she knew spoke persuasively about the high interest rates that could be earned with only modest risk, and she allowed him to invest her money, on margin, in railroads and such enterprises as the New Mexico & Arizona Land Company. When the market crashed in 1929 she lost everything. She was sixty-three years old.

Accustomed to financial and emotional independence, she was at first, like many others in those dark days, unable to comprehend the enormity of what had happened to her. She was reluctant to talk even to close friends about what she called her "reverses." Like many people she may have believed that the beginning of the great Depression was no more than a temporary recession, and that the shares she owned would soon regain their former value. Only a few months after the crash, she took the fateful step of mortgaging "Clear Comfort"—not to pay for essentials of daily living, but to finance another summer holiday in Europe with Gertrude.

It was the last holiday they took. On their return, they had to face the realities of the United States in the 1930's: industry operating at less than half its 1929 volume, more than 13 million workers unemployed, bread lines growing longer every day and five thousand banks closed. The Austen investments were not worth the paper they were printed on. The two sisters in Brooklyn who held the original mortgage were sympathetic to the plight of Miss Austen and Miss Tate, and excused the payment of interest charges. When the mortgage was transferred to a bank, an officer there was equally sympathetic—but monthly payments of interest on the loan, plus principal, had to be paid. An old friend and former suitor of Gertrude's, Guy Loomis, came to the rescue and made payments on the ladies' behalf—until the awful evening when Gertrude and he had a stupid argument about whether dinner that night at "Clear Comfort" should be eaten by graceful candlelight or more illuminating electricity. ("Don't tell me what to do in my own house," flared Gertrude, in the heat of the moment. "Very well," snapped Guy, "and remember that it *is* your house!" He never came back again, and never made

another payment, in spite of pleas from friends and relatives and Alice herself, all of whom went to beg him to reconsider.) The day came when the mortgage payments could not be met. In a Brooklyn court, Alice's lawyers pleaded for more time, under Section 74 of the Bankruptcy Act (designed to prevent sacrifice sales of private property), while the Daughters of the American Revolution sent telegrams to Washington, urging housing officials to let the house stay in the ownership of the Austen family (even though Alice was not a member of their organization). In vain. In foreclosure proceedings in 1934, the Bankers Trust Company became the new owners of "Clear Comfort" for $20,000. Even then, an officer of the bank gave Miss Austen his promise—in a gentleman's agreement—that she and Miss Tate could live in the house as caretakers of the property for the rest of their lives. All they had to do was maintain the building (paying for repairs as necessary) and pay a token monthly rent of ten dollars.

That was difficult enough. It was even a problem to meet the expenses of daily living. Alice adopted a haphazard method of financing. Piece by piece, she sold (to friends, to museums and to dealers) the silver, art works and furniture with which her grandparents and the Müllers had filled "Clear Comfort." A Chippendale armchair went to the Metropolitan Museum of Art in 1933. The Duncan Phyfe settee was sold. Alice was not used to managing her own money, and she often made bad bargains, for times were hard and valuable antiques sold for far less than their real worth even when both parties to the transaction were honest.

And still Alice and Gertrude could not, at first, give up their accustomed way of life. The lunches at the Colony Club and the afternoons at the Opera continued, for a while, and when the *Queen Mary* sailed into New York harbor on her maiden voyage in the early summer of 1936, Alice and Gertrude invited over one hundred guests for lunch and their first view of the world's largest liner. The new hardships were difficult to accept. The last household maid, 68-year-old Mary, left that year because there was no more money for her salary. Nice young Raymond Fingado from the telephone company kept calling up to remind Miss Austen, with polite apologies, that her bill had not been paid for several months. Alice would procrastinate, promise him that the matter would be attended to immediately, and even mail him a small check; but when things got really bad, the phone service was suspended until more money was forthcoming. The strain began to tell. Alice adopted the habit of carrying her valuable jewelry with her, in a small chamois bag with a draw string—and one day, on her way to the opera, she forgot it in a phone booth. The loss was a financial, as well as an emotional catastrophe.

Gertrude's dancing classes were the most reliable source of income for many years. She held them at the Staten Island Academy, the Women's Club and the Richmond County Country Club until she was in her mid-seventies (afraid to reveal her age, in case her former pupils from Delmonico's and Sherry's—who now sent their own children to her—would withdraw their support if they realized how old she was). Her age was actually no handicap. Even in her seventies, Gertrude could perform a perfect court curtsy with ease, bending her knees and raising the hem of her full-skirted white dress in a practiced, fluid motion that few could imitate. At home at "Clear Comfort", she would sometimes dance around the kitchen or dining room in a fit of exuberant good

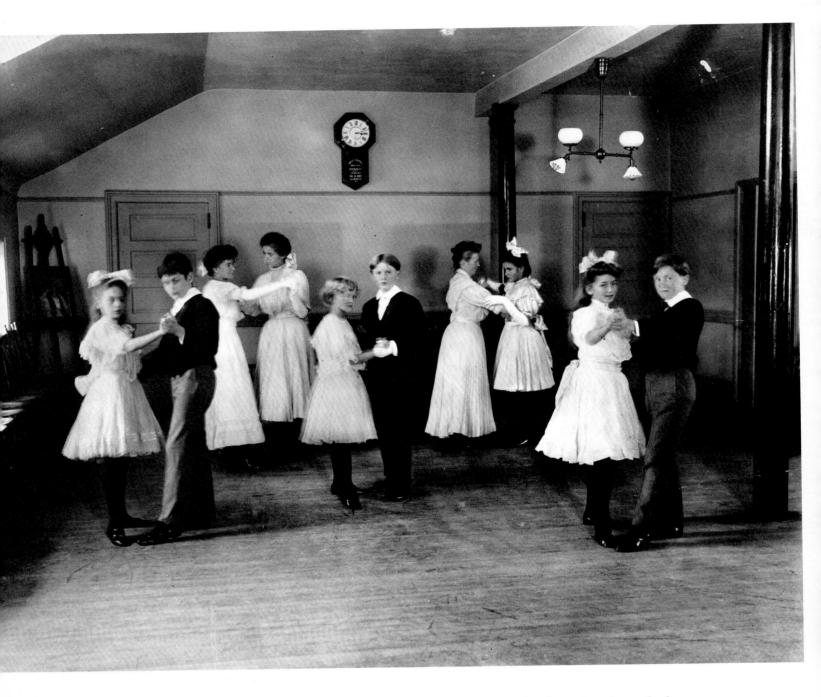

Classes in dancing and deportment were given by Miss Tate for nearly fifty years. After the stock market crash, they provided urgently needed income. (*Children dancing waltz at Womans Club. Fine day. 3.10 p.m. Flash 1½ boxes No. 2. Daylight also. Stanley O., 2nd largest stop*)

OPPOSITE: Parties and a pleasant social life continued in the 1930's, but financial worries and arthritis began to distress Alice.

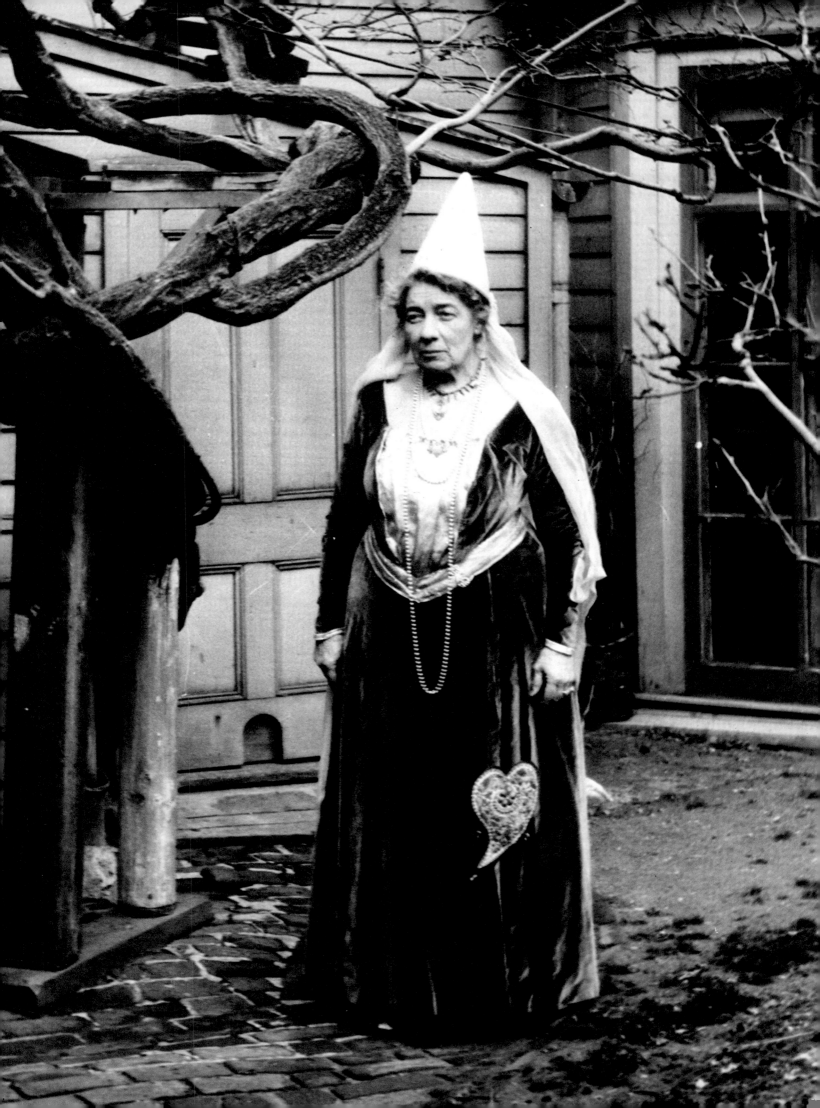

spirits, demonstrating the intricacies of the ballroom steps she taught. On the job, she was a sterner figure—wearing long white kid gloves, carrying a little bouquet of roses or lilies-of-the-valley and a small castanet-like object of ebony and silver which she clapped whenever she wanted her pupils' attention (or when she spotted a rebellious boy tripping up a fellow sufferer or trying to untie one of the girls' bows). She believed in upholding standards of etiquette—as local president of the Dance Masters of America, she blackballed Arthur Murray from membership because his standards did not meet hers—and she instructed her students in social manners or "deportment" as strenuously as in the art of dancing. Alice was always present, dressed in a simple long gown of violet or blue silk, at the classes in these later years. She watched the youngsters with those wide hazel-grey eyes that smiled with impish humor and missed nothing. She helped the accompanist by drumming out the rhythms emphatically on the floor with her cane, occasionally using it to poke a wayward boy who came within her reach. Almost inevitably, she would doze off before the final minutes of the class had ticked by, and would snore quite audibly in her corner chair, to the amusement of the children.

Gertrude was resourceful as a bread winner. At one point during the worst of the Depression, when attendance at her dancing classes had dropped drastically, she had an original idea and offered one evening of basic instruction to over one hundred adults—at one dollar each. In 1933, she broadcast a brief series of "charm courses" over the WOR radio station in Newark, New Jersey. Remembering the success, fifteen years earlier, of the Box Tree Tea Room in the Perine House, she conceived the plan of opening a restaurant in "Clear Comfort." Alice reluctantly agreed, at first insisting that only teas would be served. They bought round cafe tables with matching chairs and striped umbrellas to shield guests from the sun, set them up on the newly-cut lawn, and opened their second tea room. "Watch the ships sail by at 'Clear Comfort' (the old Austen homestead, built prior to 1669)," they invited, on modestly printed postcards. "Tea will be served from 3 until 6 o'clock every day (including Sundays); Luncheons, dinners, bridge parties may be arranged for. Telephone St. George 7–1329. Take Bus No. 2 at St. George to Hylan Boulevard, via Bay Street, then walk one block toward the water." It seemed like a good idea, which Alice elaborated somewhat by opening a small shop for gifts and antiques, set up inside the house. The lawn overlooking the water became a popular, picturesque setting for afternoon parties of ladies from Manhattan and the more prosperous families from Staten Island. Alice enjoyed arranging garden flowers on the tables and talking to the guests as they arrived. Gertrude busied herself buying the food and running the kitchen. She achieved a certain culinary reputation for her Shrimp or Lobster Newburg, a precious recipe she had obtained (with a bribe of $75 paid to the chef) from Delmonico's restaurant, one happy night when she dined there with a group of friends in the pre-Depression past. The local girls who helped in the restaurant were never allowed to watch as Gertrude prepared this dish; only one trusted waitress, eighteen-year-old Rita Beschner, was let into the secret—after being solemnly sworn to silence on a Bible placed on the kitchen table. The "Clear Comfort" Tea Room became faintly fashionable (the *New Yorker's* restaurant guide mentioned it as a good place to go), even though it operated only in summer, in fine weather.

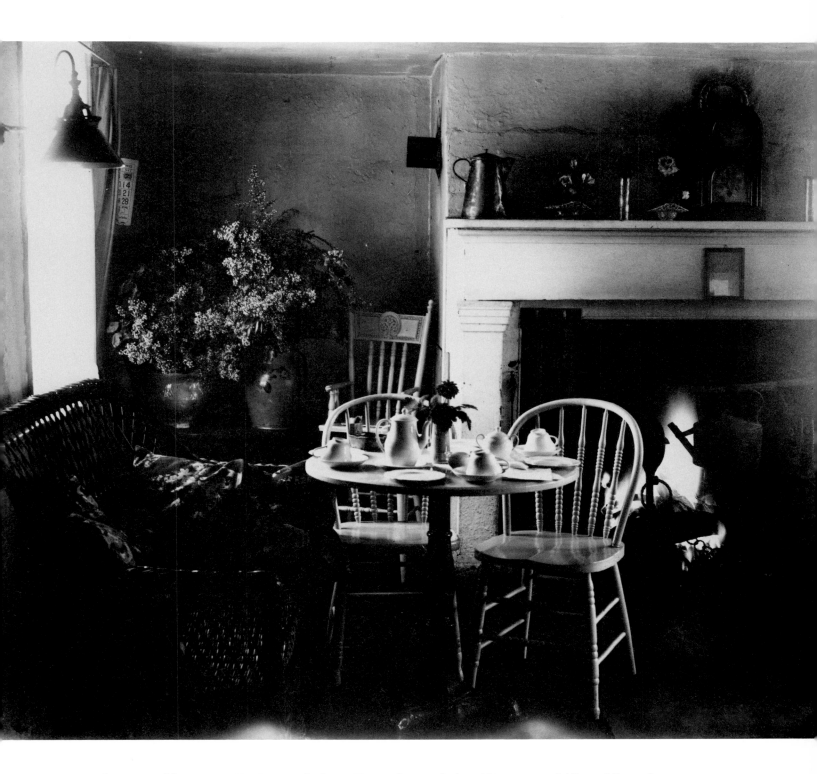

The success of the Box Tree Tea Room in the Perine House, photographed in 1922, encouraged Alice and Gertrude to open a restaurant at "Clear Comfort" when they needed money.

But the restaurant never yielded enough profit to support the household. The expenses of living became harder and harder to meet. Gertrude adopted a little euphemism, telling close friends from time to time that she needed "oil for the lamps of China"—a small loan of cash for a few days. The car—kept for years in its garage, but painstakingly polished every Saturday by the teenaged brothers Vic and Mario Prevosti, until it shone like a jewel—was finally sold. So was the piano. In the cold months of 1940, when the tea room was closed, Alice swallowed her pride and wrote several begging letters to her distant but rich cousin Rogers Winthrop—a descendant of her grandfather's younger sister Mary Austen and Isaac Townsend—who had met Alice in the 1920's while he was having the family genealogy traced.

"I am trying to sell the Chinese & Japanese vases etc.," she explained to her cousin, "but the War has turned people against buying them. We use oil for heating & Electricity for starting the oil burner & for cooking, the telephone for protection as we are so alone here—it is very serious when threatened with everything being cut off, as we are now. . . My Arthritis prevents my walking far, & with no car, I cannot take around my samples of Preserves, rubber goods, silk stockings etc. People promise to come here & see them, but they do not. I dread the winter! there was no heat in the house during the cold days we had, because I could not pay for oil, & the cold makes me very stiff. . . To try to save oil, I have closed up half the house. . . Old age & poverty are very hard to cope with, but I keep trying, & am thankful I am allowed to stay in my dear old home."

Some of the furniture from the old home was auctioned at the Anderson Galleries in Manhattan. And in a two-day sale in February 1941, the Kende Galleries sold Alice's Italian apothecary jar and Royal Doulton water pitcher, a Minton porcelain bouillon service and a German oil painting of a military scene, a nineteenth-century American mahogany wall clock, three Chinese teakwood stands, a tureen, an English tea service, two Lowestoft porcelains, a Japanese bronze teapot and more than twenty-five Chinese and Japanese vases from the house and garden. Many of these objects, unfortunately, were slightly cracked, chipped or repaired. According to pencilled notes in the margin of Miss Austen's copy of the catalogue, the proceeds of the auction were just over $300.

The money did not last long. In May 1941, Alice had to write again to Rogers Winthrop. "There is no profit in the Tea Room, but a trifle comes in now & then. The weather is so cool & damp, that people do not come, all waiting for warm weather. I am thankful to be able to stay in the house, as I have not a cent to board anywhere if driven out. The situation is very terrible, & I do not know what to do. I would work at anything if I could, but arthritis handicaps me, so I cannot walk far. My friend Miss Tate's Dancing Classes were so small this winter that they did not meet our needs, though she used all to keep us going. Am trying to sell things, but buyers are few. . . I trust you will understand how hard it is for me to write this, & how much I appreciate all you have done for me in the past."

The two women gave up their last remaining luxury, to which they had clung tenaciously, and resigned their memberships in the Colony Club. After the short summer respite, matters became worse than ever. "About three weeks ago my Oil

Burner gave out," she wrote to her cousin in November 1941. "It is over twelve years old, & the Service man who put it in says it is 'completely shot.' A new Burner, 'The York,' will cost $200.00, a reconditioned one with a year's guaranty $125.00. We have had no heat in the house for a month & it is very cold, making my arthritis very stiff & painful. The Edison Co demand a minimum payment of 25.00 on Monday on my $45.00 bill. The Telephone Company also wishes an immediate installment. . . . The local trades people have not been paid for a month. No business in the 'Tea House,' we close it for the winter, so that small revenue is gone. The Bankers Trust Company who hold the mortgage refuse to do anything or make any repairs, just tell me to vacate, & they will pull the house down. . . This house, built before 1669, the oldest on the Island, should be preserved. My cloth coat, & my old fur coat are in storage, & I cannot pay to take them out. There is an old fashioned range in the kitchen but it must have coal, a wood fire in the Parlor, but the wood of an old tree must be cut. I am trying for an old age pension, but they insist on knowing what I had twenty to thirty years ago, where it came from, & what it was spent for, who my brokers were (H. L. Horton & Co, now out of business). I have tried to sell things but dealers pay almost nothing, and the many Red Cross interests prevent others buying. Some of the working people pay from $30.00 to $40.00 a month rent down here & have to supply heat & light. My only wish is to stay here for a few years more. As I am 75 they cannot be many. My friend Miss Tate is trying to organize her Dancing Classes. Can you help me over this dreadful situation. . . ."

In the summer of 1942, when Alice was seventy-six, the tea room never really reopened. Gertrude, too, was aging, and she was not experienced in the hard economic lessons of running a restaurant for profit. She found it increasingly difficult to manage the kitchen smoothly. Guests with reservations for lunch were disheartened to meet her running out to buy last-minute provisions as they arrived in the driveway, and the increasingly long wait between arrival time and the meal discouraged the most tenacious patrons. "Clear Comfort" had no liquor license. Both Alice and Gertrude were still too proud to accept money from well-meaning close friends, and would press meals upon them without charge. Friends and guests of whom Alice approved were treated to her most courteous reception, but many people who had never been invited to "Clear Comfort" on social terms now felt perfectly free to visit the restaurant as patrons and sightseers—and Alice did not try to disguise her resentment. She never saw herself as a restaurant keeper, but as the owner of a private home they were privileged to visit. She was horrified when unknown visitors wandered through the open doors of the house, staring at the antiques, possibly commenting on the dust that tended to creep into the recesses behind the bric-a-brac, sometimes dropping cigarette ashes and accidentally breaking small objects. On one occasion, when a group of women wanted to linger over coffee, enjoying the advertised view of the Narrows and chatting as the afternoon wore on, Alice curtly announced that she needed their table at once—even though no other guests were in sight. When other people of whom she did not approve telephoned to make a reservation, she told them the restaurant was closed that day. It was always closed in the winter. Before long, it was closed for good. Unwilling or unable to

acknowledge their failure, Alice and Gertrude told their friends that they had closed the tea room, at the request of the commanding general of Fort Wadsworth and of the FBI, because German spies found their garden an all too convenient spot from which to watch the movement of troop ships out of the harbor. (There may have been at least some truth to this account, for in the early years of World War II some Nazi espionage agents were indeed captured in the waterfront bars and restaurants of Staten Island).

Only one other means of earning enough money to support themselves in the house occurred to them. They refurbished the Müllers' old apartment at the north end of the upper floor, and asked the administrator of the local U. S. Public Health Service hospital to find a young doctor who was looking for a place to live. The candidate was Richard Cannon, an intern. "Honey, I've found an extraordinary place in an old house with two old ladies, and you may hate it. . .," he told his young wife, when she arrived from Tennessee to join him. "Well, I loved it—and them—just to pieces," Mary Cannon remembers. During the long evenings of 1944 when her husband worked late at the hospital, Mary kept warm by joining Gertrude and Alice in front of the one functioning fireplace. She listened for hours to their memories of the past (summers in Paris, parties at Delmonico's), admired dozens of the photos that Alice would carry out from her bedroom on the ground floor, and became in effect a member of the family. She understood the financial distress the two women were in—although it was not a subject that could be openly discussed—and she tried discreetly to offer helpful suggestions. Coming down the interior staircase on cold, damp mornings, when Alice's arthritis was so aggravated that she could not get to her feet without help, Mary watched with horrified admiration as Miss Austen crawled on her hands and knees from one room to the next rather than give up the struggle. "It was nothing but sheer determination that kept them going in that house," she remembers.

Gertrude's screams of terror reached Mary's startled ears as she rested upstairs in the late afternoon of July the Fourth that year. Rushing down the stairs she heard Gertrude's voice receding toward the driveway, calling for the police and shouting that someone was trying to murder Alice. Sounds of scuffling came from the porch. Mary raced out there to find a drunken sailor (a Canadian, whose nationality had seemed to other servicemen a good enough reason for making him drink too much on Independence Day) reeling about and hitting the old lady in his stupor. Alice, her jaw clenched with determination, was whacking him with her cane. "She was a fighter to the end," Mary Cannon laughs now, although at the time it was far from a joke.

The fighting spirit was most roused in Alice Austen when her home was threatened. And the ultimate threat came when the Bankers Trust Company—in the absence of the sympathetic officer who had given Miss Austen his word that she would never be asked to leave—sold "Clear Comfort" to Miss Grace Mandia of Stapleton. The motive for the sale hardly seems to have been profit on the bank's part, for the value of Alice's waterfront land had dropped drastically after the district was zoned for residential buildings: the property was sold for a mere $7,500. The Mandia family, owners of a successful tavern on Bay Street, were rumored to have been considering opening a post-war roadhouse there. The new owner, in any case, told the housing authorities that

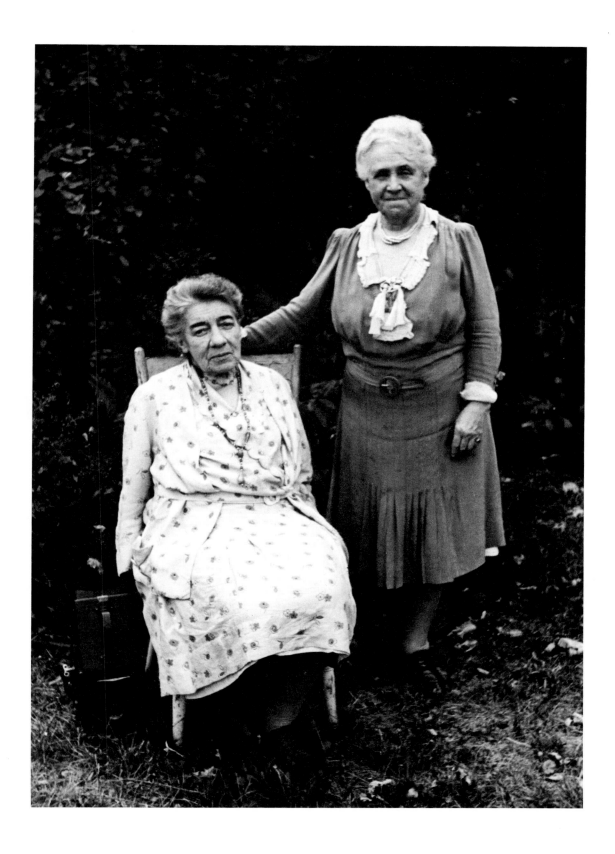

Alice Austen (photographed by the young doctor boarding upstairs) rests in the garden with Gertrude and her camera. She had been recording the hurricane damage of September 1944. The next summer, at age 79, Miss Austen lost her home and most of her possessions. (Courtesty of Dr. Richard O. Cannon)

she wished to live in the house, and the first eviction notice arrived in Miss Austen's mail box in May 1944. She was given ninety days to move out. Aghast, she applied to everyone she knew who might be in a position to help. But nothing could be done. . . until a "For Sale" sign, erected by a real estate agent, appeared on the property. Since the new owner clearly had changed her mind about living on the premises, the rent control division of the Office of Price Administration had the authority to revoke the eviction order. They reassured Miss Austen that she could occupy the building, at least for the duration of the war. Alice had won the first round, but she remained shaken. "I never really believed that I would have to leave this house," she told a *World-Telegram* reporter (to whom she had proudly shown a 'porte feuille' of her Staten Island photographs, explaining that in the future she wanted to experiment with color photography). "But, you see, I'm up against it." She threw up her hands in a weary, laconic gesture. "I have no pull; I can't stop people from doing things, and it's an infernal nuisance."

Sympathetic stories about Miss Austen's plight and last-minute reprieve appeared in several New York newspapers. Instead of being pleased, Miss Austen was furious— because one over-zealous reporter had dug up a nineteenth-century account of the house and had reprinted a quaint description of the old Delft tiles around the parlor fireplace. "Now they know those valuable tiles are in the house, they'll be more anxious than ever to get me out," she raged. Vowing that no upstart owners would get their hands on her tiles, Alice summoned Gertrude and Mary Cannon to help her: for two evenings they watched as she painstakingly chiseled the delicate ceramic squares off the facade of the fireplace. She refused to let either of them handle the tools, but gravely handed them the tiles, one by one, to be wrapped and carefully stored in a box. It was her first perverse admission of her knowledge that, sooner or later, she was going to have to leave.

The weather itself conspired against her. In September 1944, the month the Cannons moved back to Tennessee, a hurricane hit Staten Island. A large tree came crashing down across the stone wing of "Clear Comfort," damaging the kitchen so badly that firemen had to be called to cut the dangerous electric wiring. For over two months the house had no light, no heat and no hot water. The radiators froze and burst. Miss Mandia, naturally enough under the circumstances, was reluctant to make extensive repairs with her two unwelcome tenants in the house and she pressed them, instead, to leave. The cold and damp afflicted Alice so badly that a doctor sent her to a hospital for six weeks. The fight was over.

"She is putting me out as soon as possible," Alice wrote to her cousin in May 1945. "We have rented for a short time, but she says she wishes to live here so we are helpless. . . . I have not been able to find any place to live, & do not know what to do, the Army & Navy take every available place so I am dreadfully upset. Miss Tate is with me, & we are in despair. Things will have to be sold to meet rent & moving. My Arthritis is so bad that I cannot go upstairs to a walk up apartment. There is a tremendous demand for everything, & expensive, so we are in great distress. . . I shall miss my home more than I can tell you."

One person who did her best to help was twenty-six-year-old Rita Beschner, who had become fond of Miss Austen and Miss Tate during her days in the tea room. They

liked and trusted her, and they approved of the young man with whom she was keeping company, too (partly because young Edward Newell's grandfather had been the Austens' coachman, and he reminded them of happier days). A few days after the hurricane did its damage, Rita was appalled to find Miss Tate trying to prepare food on a single-burner cooker in the upstairs apartment. Through the following weeks, as often as she could, she cooked hot meals in her home a block away on Maryland Avenue, then carried them quickly on a tray across the short cut to "Clear Comfort." "I did it just because I liked them," she says shyly; "they were really very nice people."

When they knew they had to leave, Alice and Gertrude turned to her for help again. Day after day, that spring, Rita walked down to "Clear Comfort" to help with the unhappy task of sorting and packing objects that had accumulated in the house for a century. "In a way it was fun doing it," she remembers. "Miss Austen's bedroom. . . you couldn't get into that room! She saved *everything* in that room. And in the house there were closets that I guessed hadn't been opened in years. I remember we opened one, and in it they found a chest of silver which they sent off to the bank vault."

The apartment they had finally found was not too far away but it was small, and many things had to be sold for reasons of space, if not for money. Too proud to see her family's belongings auctioned in front of old friends and neighbors on Staten Island, Alice located a dealer named Jaffe in Newark, New Jersey. He came, looked around the crowded, chaotic house, and said he was interested in buying its contents. The "disgusting bargain" they made (in the words of a frustrated friend who would have helped Miss Austen to do better, if she had asked him) was that Alice would set aside in one area the personal possessions and furniture she wanted to move, and that Jaffe would get everything else—for $600. Mr. Jaffe was presumably pleased with his bargain, until he stopped by the house some days later and saw with astonishment just how many objects Alice was proposing to jam into the small apartment. Her standards of what constituted a proper amount of furniture and decorations for a room were very different from his. Mr. Jaffe began to come by almost every day, grumbling with increasing forcefulness that Alice was not keeping her bargain.

He began to be unpleasant about the matter, even vaguely threatening. So Alice enlisted the help of Rita and of Roy Canlon, a teenager from nearby Shore Acres who had in happier times cut the grass at "Clear Comfort" and for ten cents a week delivered the daily newspapers. After dark, long after Jaffe had departed for the day, Rita and Roy returned to the house. Under Alice's direction, they carried boxes and treasured objects out of the kitchen door, across the backyard and up through a gap in the fence to the house next door, where young Mimi Howland joined the conspiracy and opened the door to her basement. The young accomplices worked quickly and quietly for more than an hour. A few of the treasures they removed may have been worth some money, but most of them (such as gardening tools, children's books and old clothes) were simply of sentimental value to Miss Austen. The objects that were of inestimable value—to Alice and (if they ever come to the light again) to posterity—were many small, heavy boxes containing perhaps two thousand of her glass negatives, many of them eight-by-ten inches in size. Alice showed them to Rita in her crowded bedroom on the ground floor,

urging her to carry them out carefully, "because," she said, "they must go to the museum." But no museum was ever notified about their existence.

Mr. Jaffe returned to Staten Island. Somehow, he heard about Miss Austen's attempt to keep these belongings out of his hands (had an unfriendly passerby spotted light from the kitchen door and seen two shadowy figures moving back and forth across the driveway?). He pounded on the door of the neighboring house, furiously accusing the young woman who opened it of hiding stolen goods that he had paid for. Young Mimi Howland, alone at home with her mother-in-law while her husband Edward was away during the war, was intimidated; she quietly told the angry man to go down to the basement and remove whatever he believed belonged to him. The precious photographic plates that Alice had chosen to save may have been sold in New Jersey later in the summer of 1945—or they may have been destroyed by a man who understandably enough had no appreciation of their real value.

Moving quickly and forcefully to collect the rest of his purchases, Jaffe arrived with his truck at "Clear Comfort" on July 17 to pick up his share of the contents of the house. Miss Austen was not ready for him. Distraught and outraged at the spectacle of her belongings being carried swiftly out of the house, the seventy-nine-year-old woman hobbled from room to room, snatching up small vases and decorative objects, dropping them into the apron she held up and carrying them to the sanctuary of the room where her selected possessions were stored. She had made a mistake about this item, she pleaded; she had not meant to leave that souvenir out in the parlor. Mr. Jaffe became angrier and rougher. Gertrude's sister, Winifred Tate Baker, with her teenaged son Tate, were there to help as best they could, and young Tate ran willingly from room to room picking things up as Alice pointed at them. But they were no match for the outraged dealer. An anguished phone call was made to the Rev. Lefferd Haughwout, who called Loring McMillen of the Staten Island Historical Society; McMillen in turn phoned his brother and Ray Safford, another member of the Society. Within the hour, the four men with their cars had arrived at "Clear Comfort" to help the nearly hysterical occupants. While the minister tried to restore an atmosphere of calm and seemly behavior, McMillen and Safford summoned the Society's lawyer, to come and formalize the vague verbal agreement made between Miss Austen and the dealer. In the meantime, McMillen and Safford made the best use of their time, carrying from the downstairs rooms to their cars some of the treasures that Miss Austen insisted she wanted to keep.

Exploring upstairs—in the dark, little used central room between Gertrude Tate's bedroom and the sitting room recently vacated by the Cannons—Loring McMillen almost tripped over a stack of dusty cardboard boxes. He opened one. Inside was a row of glass plates, four-by-five inches in size. He slipped a couple out of their brown paper envelopes and held them up to the daylight at the dormer window, seeing the sharp negative images of some young women in turn-of-the-century dress, a horse and buggy, a Victorian country house. He ran quickly down the stairs again. "What are you going to do with those old photographs upstairs?" he asked Miss Austen, while Jaffe was out of earshot. She seemed confused, or too dazed to make up her mind. She said something

about having to leave them behind. "Do you mind if I take them?" McMillen pressed. "No, not at all . . . you might as well have them," she answered. McMillen and his brother climbed up and down the narrow staircase, carrying boxes of plates (as well as an old camera, some photographic journals and catalogs), until they had filled the trunks and back seats of both their cars. They drove them for safekeeping to the basement of the Staten Island Historical Society's main building, the restored old court house in Richmondtown. The dreadful day was over.

Miss Austen and Miss Tate moved out. Mr. Jaffe took what he wanted of the possessions they left behind. The back yard and lawn of "Clear Comfort" remained littered with a few old chairs, broken lamps and vases, some smashed photographic plates and torn prints, postcards and cancelled checks—the abandoned memorabilia of the photographer's life and work—and the front door swung open to admit curious children or fishermen from the beach, until the Mandia family took possession.

In apartment 5-C, 141 St. Mark's Place, two miles away in St. George, Alice and Gertrude tried to restructure their lives. Their small rooms were bright and sunny. Mr. Jaffe's $600 was in the bank, and an allowance of $100 was promised monthly, raised through the generous help of old friends like C. Dewar Simons 3rd (Charles and Jessie Simons' son), Alice's cousin Rogers Winthrop, and the Rev. Alexander Frier, rector of St. John's Church. Gertrude continued her dancing classes, and the city welfare board finally authorized small payments to Alice. Life was, in many ways, more comfortable than it had been for several years. Rita Beschner came to help with the unpacking, young Roy Canlon arrived with a box of candy, and many other old friends and acquaintances came in a steady stream to visit.

Gertrude seemed to reconcile herself quickly to her new surroundings, with relief that the dismal days of struggle were over. "Our love and congratulations," she wrote cheerfully to Dick and Mary Cannon on August 7, on the birth of their first baby. "You'll see that we have been put out of 'Clear Comfort' at last, after a bitter fight. We have a lovely apt.—all outside rooms—& a water-view from them all. We miss you always." Alice did not sign the card. Perhaps the arthritis made writing painful; more likely, she was simply unable to rise to Gertrude's level of good cheer. She had begun to use a wheelchair, and sitting in it, staring with unseeing eyes at the view of the harbor two blocks away, she mourned for the home in which she had spent her life. Even the name of their apartment building—the Wisteria—conjured up painful memories of her much-loved vines, which had won prizes in the New York flower show only a few years earlier. She treasured two small oil paintings of "Clear Comfort," showing the wisteria climbing to the roof. But she could not bear to go back and visit the old house, now in the possession of strangers. Her characteristic calmness, her ready grin and quick sense of humor disappeared under her bitterness. Friends were startled to hear an unaccustomed querulous tone in her voice ("You like it?" she would ask, peevishly, when visitors praised the new apartment. "Well, you can have it!"). They wondered what had happened to the old Alice—and they forgot how old she really was, nearing her eightieth birthday, ill as well as miserably unhappy. Powerless to give her back the one thing she wanted, friends became impatient when she appeared ungrateful for the generous help

she did receive. Listening to Alice grumble that the rooms were always cold, they muttered to each other that the landlord was probably turning down the heat in a sly effort to get rid of the difficult old lady.

If there was any truth to that, time was soon to accomplish the landlord's aim for him. The city welfare authorities, for unexplained reasons, cut off Miss Austen's payments. Gertrude fell on an icy sidewalk and broke her arm, then became hospitalized with severe bronchitis (sister Winifred came to look after Alice). She was finally, aged seventy-five, unable to continue her small dancing classes. And, after giving Alice love and companionship for the more than thirty years they had lived together, she was no longer able to give her the nursing care she needed. In 1949 Alice moved into the Mariners' Family Asylum on Tompkins Avenue. Gertrude, later that year, gave up the apartment and went to live with her sister and brother-in-law in Jackson Heights, Queens—the other side of the city. "Miss Austen is desolate at having me go," she wrote to a friend that December, "for we kept in touch daily by telephone. She dined with me once a week & I went over to the Home at least once a week."

Lonely for her friend, and used to being independent, Alice irritated the staff of the home by refusing to obey the rules (particularly the regulation about retiring to bed early). She could wander about slowly with two canes, still, and she refused to stay where she was supposed to. For most of her life she had been used to giving orders to servants, never to receiving them. Since she was not technically eligible to stay in the home (not being a mariner's wife or daughter), the administrator soon found reason for asking her to leave. In April 1950, she moved to the Pleasant Haven nursing home. Things went no better there ("She is so lonely, it's pathetic," an upset Gertrude wrote to a friend), and soon she was in the Dresden House on West 74th Street, Manhattan. The matrons of more than one of these homes apparently issued an ultimatum about their difficult patient—"Either that woman goes, or I do!"—and the administrators inevitably sided with their staff. Back on Staten Island again, the Lighthouse Nursing Home near Richmondtown kept Miss Austen for only a very short time before asking her to leave—this time, for inability to pay. Gertrude, receiving welfare payments herself, was powerless to help much and no friends were willing to undertake the whole responsibility of providing board and nursing care. Alice had reached the end of the road. She signed her remaining money and possessions over to Gertrude's legal ownership. Then she took an oath swearing that she was a pauper, enabling her to live on the city's charity; on June 24, 1950, the eighty-four-year-old woman was admitted to the hospital ward of the local poor house, the Staten Island Farm Colony.

The institution—housed in a complex of slate-roofed stone buildings erected at the turn of the century—was not as inhospitable as it may sound, even though many people regarded it as a prison for failure, a punishment for being poor. Frequent visitors were allowed. Gertrude came from Queens every week (bringing ladyfingers, chocolate cakes and fudge), Uncle Peter's daughter Patty came all the way from upstate New York, and dozens of friends came regularly from Manhattan and Staten Island. But nothing could make the place home-like or even agreeable for Alice, who was by now confined to a wheelchair or her bed, in a long, bare ward for many old women.

After the day on which Loring McMillen rescued the photos from "Clear Comfort," the boxes containing some 3,500 of Alice's glass plates and many of her film negatives lay in the basement of the Staten Island Historical Society, gathering dust for three years. No one really knew what was in the boxes, much less what to do with the contents. In the autumn of 1948, C. Coapes Brinley, a middle-aged engineer who was a new volunteer member of the staff (and later president of the Society), began to sort through the thousands of negatives, looking at first for pictures to add to the Society's file on old Staten Island houses. He did not find as many as he had hoped (many of Miss Austen's records of local architecture were presumably among the missing plates lost from the Howlands' basement). But he did report to the board that they had in their hands an extraordinary photographic collection of aesthetic and presumably financial value. Since the pictures did not even belong to the Society, the first transaction was to obtain a bill of sale from Gertrude Tate, who on payment of $50 in May 1950 assigned to the Society "all those objects and collections heretofore deposited for sake-keeping with the Society." An understanding was reached that any profits from the sale of photographs not illustrating Staten Island would be turned over to Miss Tate for Miss Austen's indirect benefit (since she was now a pauper, any funds received by her would have been confiscated by the city). The local pictures, which the Society members knew they wanted to keep, became their outright property. Miss Austen, confined in the poor house the month after the agreement was signed, may not even have had a clear idea of what was happening. Brinley may have been the only person who was really confident that the collection was worth something.

He approached his self-appointed task with optimism, writting letters in the summer of 1950 to museums, libraries and historical societies that held substantial photographic collections, asking them if they were interested in acquiring all of Alice's extant pictures (with the exception of the Staten Island material). The response at first was very promising—but when it became clear that Brinley was not offering to give away Miss Austen's work for nothing, it all but evaporated. Although no price was quoted, the Society was secretly willing, then, to sell the entire collection for $500. But Beaumont Newhall at George Eastman House cancelled several appointments because of a busy schedule, Grace Mayer at the Museum of the City of New York offered to purchase thirty-five city scenes for $25, Arthur Carlson made a larger selection that seemed of interest for the New-York Historical Society but was apparently never authorized any funds at all, and Paul Vanderbilt of the Library of Congress—an Austen enthusiast who had selected several of her copyrighted pictures for a traveling exhibition the previous year—was able, after a visit in August during which he set aside more than a thousand negatives, to offer the Society nothing more than $100-worth of contact prints and the cost of packing and shipping.

Undaunted, Brinley packed a good selection of the New York City "street types" into his briefcase, and carried them around Manhattan (when he could spare time from his full-time job at the Lamson Corp.) to the editorial offices of the *Herald-Tribune,* the *Ladies Home Journal, This Week Magazine* and a dozen other newspapers and magazines. He offered them exclusive publication rights for $5 a photo. He did not know his way

The high quality of Alice Austen's vision was discovered, around 1950, by museum curators and by editors. "The publication of her pictures brings Alice Austen, the first important American camerawoman, into the ranks of great American photographers," announced *Life* (September 1951). The editors of *Holiday,* a year later, acclaimed "this country's first great woman photographer, a sensitive artist with a camera, [who] drew an affectionate nineteenth-century portrait of her native land—a gentle and long-vanished America."

(Old Boston Stone. No sun, cloudy. 4.30 p.m., Tuesday, June 28th, 1892. Stanley 35, Waterbury lense, 2½ secs., 20 ft.)

(Road and monument, Bennington. Clear, sunny day. 1.30 p.m., August 8th, 1890)

Stark ruins of fourteen houses destroyed by fire in Hoboken so intrigued Alice that she worked for nearly two hours, scrambling through the debris, to make a series of photographs. (*Fine sunny day, interior medium light,* she recorded; *Stanley 50 plates, Ross Goerz lense, Stop 32*).

OPPOSITE: Stalwarts from the Salvation Army sing hymns on the beach at Atlantic City, a bit early in the season: it is March 18, 1910.

OVERLEAF: (*Mrs. Snively and buckboard, boys and Laddie. 28 August, 1890. Bennington*)

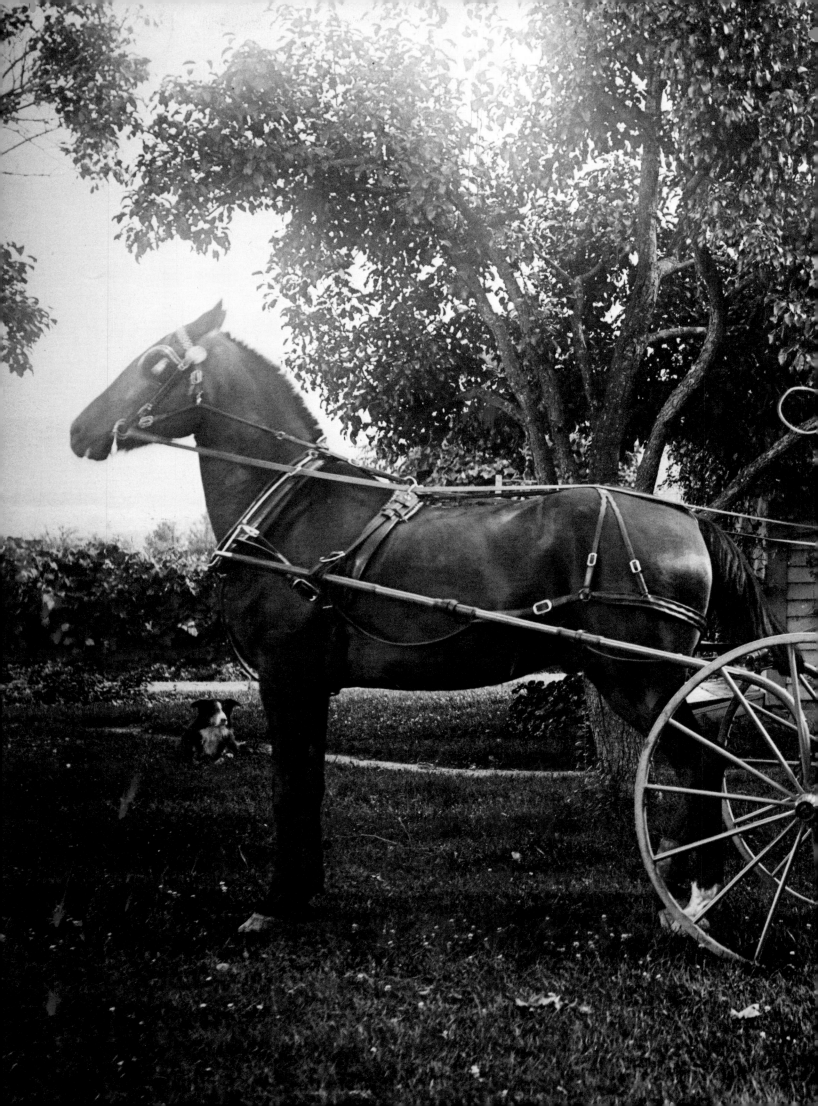

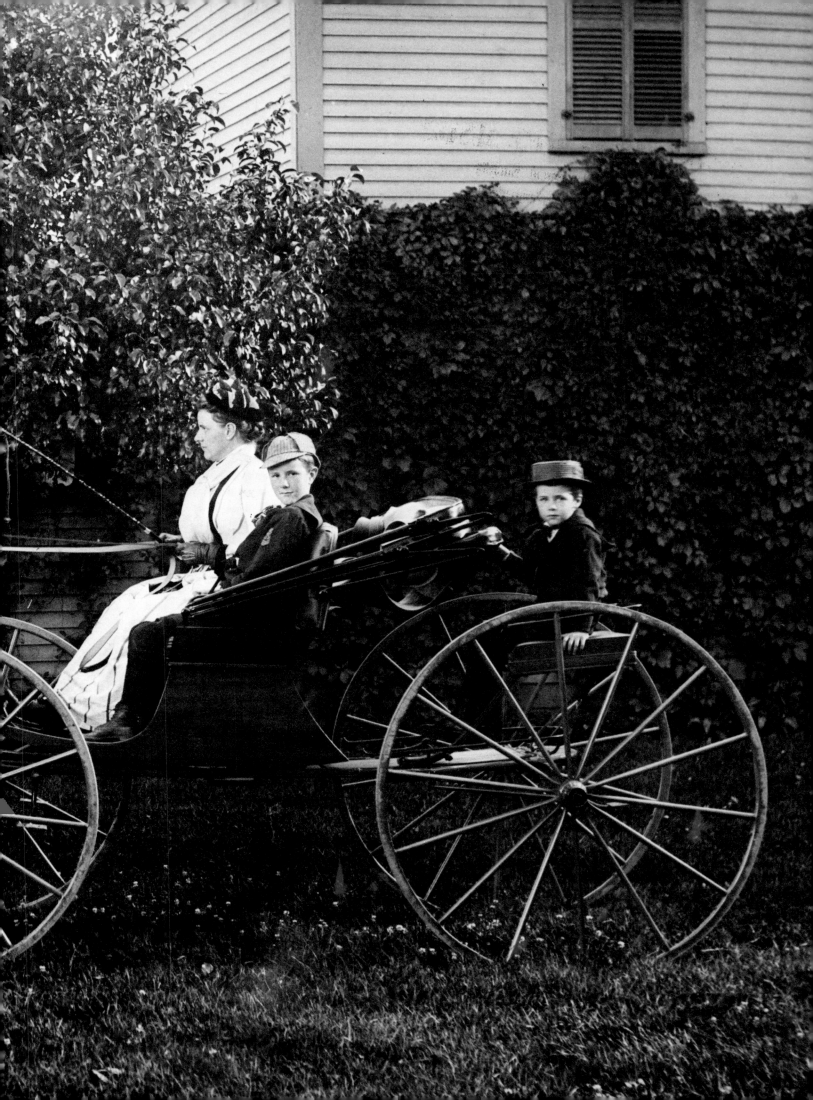

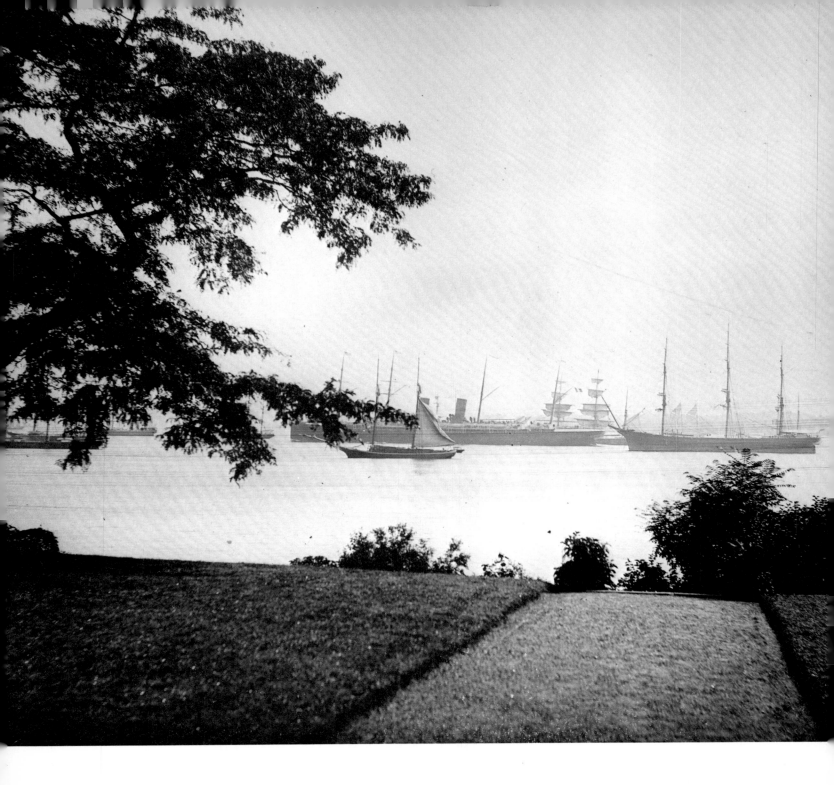

ABOVE AND OPPOSITE: Ships passing through the Narrows were Alice Austen's favorite photographic subject for more than half a century after her grandfather and Uncle Oswald taught her, as a child, to identify different vessels. She witnessed the great change from sail to steam. Frigates and schooners, racing yachts and tugs, warships, fishing boats, luxury liners and immigrant ships—over the years she saw and recorded them all.

OVERLEAF: (*Fawn's Leap Falls, Catskills. Bright, clear sunny day. 11.50 a.m., August 28th, 1889*)

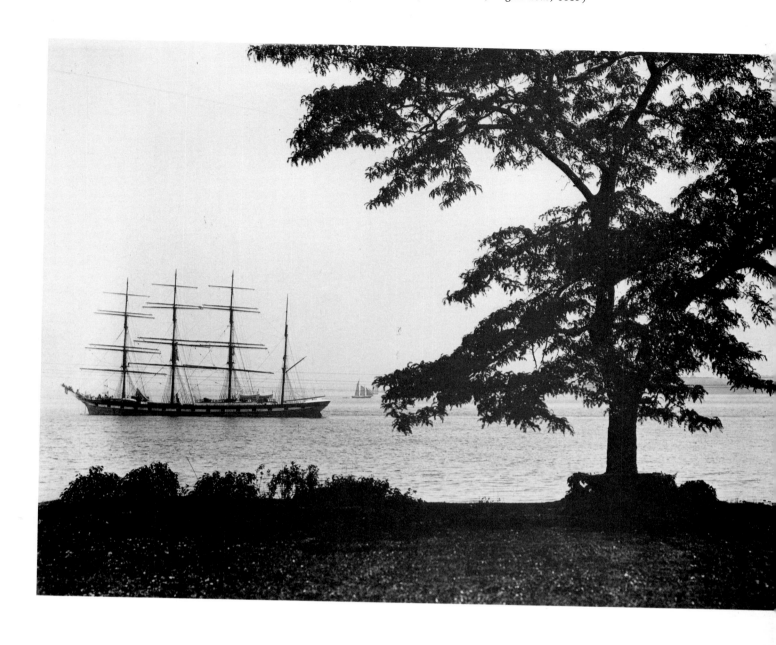

BELOW: (*Yew, Grandpa and ships in bay. Fine, bright, clear sunny day. 10.45 a.m., Monday, March 19, 1888*)

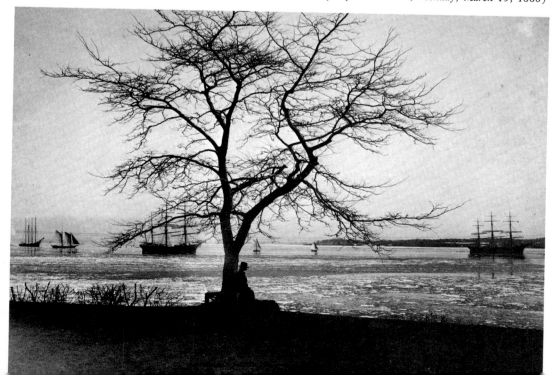

around the publishing world, and he failed. Only the *Daily News* (responding because "by coincidence" Brinley's introductory letter "arrived almost the very day we started a series of Old New York compared with today") bought the rights to print 30 of Alice's photos of New York people in the 1890's. Brinley proudly sent a check for $150 to Miss Tate. It was his only success, in spite of his perseverance in trying to sell other selections—three hundred plates and film negatives of ships were offered, in vain, in December 1950 to the Mariners Museum, the U.S. Naval Academy, the Marine Historical Association in Mystic, and the Smithsonian Institution.

Success knocked at the door at the very end of the year, in the form of an inauspicious-looking letter from a small new publishing company called Picture Press. One of the two partners, Oliver Jensen, asked the Staten Island Historical Society (and fifty other local groups, by duplicate letter) whether it owned any old photographs suitable for a forthcoming book on the history of American women. Brinley had never heard of Picture Press, but he mailed an encouraging response, saying he would do his best to show their collection to a representative even though the museum was officially open only on Sundays, from 2 to 6 p.m. Jensen had never heard of Alice Austen, but he dispatched his researcher, Constance Foulk, to Staten Island to have a look. The story of her exciting discovery in the basement, of the way in which many Austen photos came to be published for the first time in Jensen's *The Revolt of American Women,* of how Jensen met the photographer he had believed was dead and found a way to rescue her from the poor house, are described by him in the introduction to this book. Signing an agreement with the Society that gave him the authority for five years to sell publication rights to her photographs, Jensen succeeded quickly in placing an eight-page story (with later sequels) in *Life,* and six pages of Alice's travel photos in *Holiday,* raising over $4,000. Miss Austen's third of the proceeds, delivered to Miss Tate, were more than sufficient to release her from the Farm Colony in August 1951 and to establish her in Mrs. Carrie Park's pleasant home for old people in Livingston, where the charges were a modest $100 per month.

Oliver Jensen admired Alice Austen's courage and vitality as much as her photographs, and he derived particular pleasure from treating her to lobster dinners in a Staten Island restaurant. ("There is nothing wrong with her appetite," he reported to Brinley). He made an extraordinary human contribution, as well as a financial one, to the old photographer whose natural liveliness and wit returned as she was given back a sense of dignity and pride for the last year of her life. In a way, he restored to her the pleasures of her past life, by listening to her talk for hours about the people and places in her photographs, and even by placing a camera in her hands again for a moment. When he visited the Farm Colony with *Life* photographer Alfred Eisenstaedt, he encouraged the famous photojournalist to show Miss Austen how to use his Leica. After brief coaching, she raised the camera. She had not lost her eye—she impatiently gestured at the two surprised men as they posed. "I don't care to take a picture of you with a tree sticking out of your mouth." They moved, she clicked the shutter. "Too easy," she is reported to have said.

Mrs. Park's home, at 102 Bard Avenue, acted as another link with Alice's past, for

she remembered the house from the days when it had been the fashionable residence of her friends Reggie and Effie Bonner. She had been to many parties there, and the room she now occupied she remembered as the library; traces of its past elegance remained in the wooden paneling. Just down the road was the park once occupied by the Cricket and Tennis Club. And across the way lived old friends, Lee and Stella Orton, who visited her and invited her to teas, with all the chocolate cake and apple pie she cared to manage. From her comfortable new base, where regulations were relaxed and the proprietor was patience itself, Alice Austen set out to enjoy the pleasures of the present. In the home, she derived enormous enjoyment out of watching wrestling matches and the World Series on television, a new toy for her. When she made her own appearance on television—interviewed by Dorothy Doan on the CBS "Vanity Fair" program on October 7—she was delighted with all the attention, at seeing her photographs projected on the screen, and not the least with having earned $100 for an afternoon's work. Two days later, she was driven off (with an attendant nurse, in the car of Historical Society staff member Raymond Fingado) to see an exhibition of her pictures in the Richmondtown museum and to meet three hundred guests who had been invited there to celebrate Alice Austen Day. "Isn't the whole idea like a fairy tale?" exulted Miss Tate, as she prepared a guest list for Loring McMillen. In spite of Miss Austen's temporary reluctance to attend (she was tired, and a bit overwhelmed at the last moment, so she arrived an hour late and left her orchids behind in the rush), she enjoyed the Sunday afternoon party enormously. Gertrude was there at her side, and so was Trude Eccleston Barton ("There I am! that's me in the petticoat, there," chuckled the old rector's daughter, as she spotted the photo of the youthful joke played in her bedroom more than half a century before—then she brought tears to Alice's eyes as she impulsively stooped to kiss her old friend's hand). There were speeches, presents, punch and cookies. "Miss Austen, we celebrate your recognition," said C. Coapes Brinley. "I am happy that what was once so much pleasure for me turns out now to be a pleasure for other people," responded Alice. *Life* had sent another photographer and reporter. "Done?" she asked, as she posed for Yale Joel's camera. "They're so fast these days, I don't know what to do." Then she smiled at the young man and joked, "If I were a hundred years younger, I'd be doing *this* photography myself."

Alice was not a hundred years old, but she was eighty-five, and she was tired. In December 1951, two months after the party, she suffered a slight stroke and developed pneumonia in her right lung. Good medical care and the solicitous concern of Gertrude Tate, who went to stay in the Bard Avenue home herself for the month of January, restored her to health. She required help to get from her bed to her chair, but otherwise she was alert and as independent as possible, and in fine weather she enjoyed spending her days out on the porch in her wheelchair. It was one of the ironic cruelties of fate that she was not allowed to end her days in a peaceful state of mind.

The "dismal story" was reported by Miss Tate to Oliver Jensen, to whom she appealed for help on June 4. "The Dept. of Hospitals, City of N.Y., has cracked down on the Home—for having Bed Patients (Miss A. is one, for she doesn't walk from the bed to the chair). True they are not a nursing home—don't make any such claim—They are

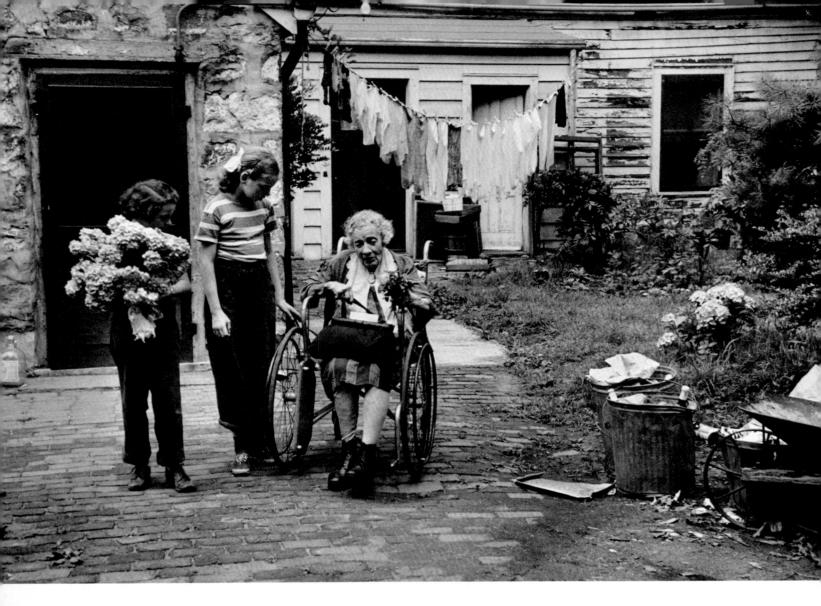

Taken by journalists to see strangers living in "Clear Comfort," Alice wept. (Photo by Alfred Eisenstaedt, Time-Life Picture Agency, © Time Inc.)

OPPOSITE: The last photograph Alice ever took. In 1951, using a borrowed camera, she captured the *Life* photographer, Alfred Eisenstaedt. (Time-Life Picture Agency, © Time Inc.)

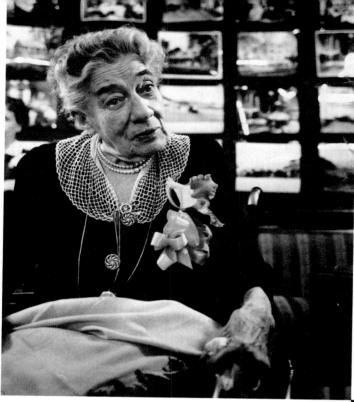

Surrounded by an exhibition of her life's work, and greeted by three hundred guests and old friends, the photographer enjoys Alice Austen Day in Richmondtown, October 9, 1951. (Photo by Yale Joel, Time-Life Picture Agency, © Time Inc.)

BELOW: Alice Austen, 85 years old and crippled by arthritis, in the poor house, July, 1951. (Photo by Alfred Eisenstaedt, Time-Life Picture Agency, © Time Inc.)

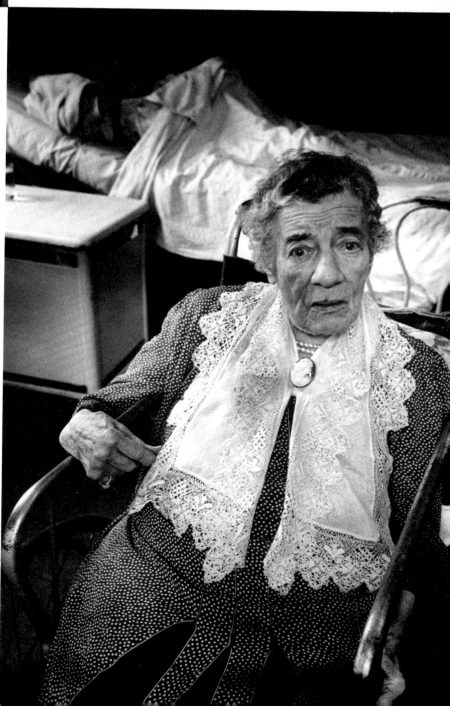

Alice Austen watches her world from the foot of her garden.

a Home for Elderly People. The Dept. is most severe, orders these poor souls evacuated immediately. I've arranged with Miss Austen's nurse to take her into her home & care for her—at double what I pay at Bard Ave. The Nurse is giving up all her other work to do this. It's a miracle. But—she can't do this until June 22nd & unless the doctor can stave them off, till then they'll send her to Welfare Island. It means just murder, for she wouldn't survive the journey. . . . The whole situation is certainly tragically sad—at 86 to be up against anything like this. . . ."

Alice would not be moved again. Five days after Gertrude's cry for help, on Monday, June 9, 1952, Alice was wheeled onto the porch and simply died there, quietly, in the morning sun. Miss Tate was just leaving her sister's house in Jackson Heights, setting out for one more trip to Staten Island, when a phone call brought her the news. "My heart is so full of sorrow at my deep sense of loss," she wrote to Jensen. "She was a rare soul, and her going leaves me bereft indeed. She's at peace now. . . . God was good to spare me these long years when she needed me so much, so I can only thank him for answering my prayer, that I might be with her to the end. And, too, I feel that he gave us just one more friend in you—Thank you always."

Obituaries appeared in all the city newspapers, reflecting her recently won fame. "Now at the age of eighty-six she has passed on to the family and friends who people her cherished scenes of long ago," concluded the *Herald-Tribune*. A simple funeral service was conducted beside the Austen family plot in the Moravian Cemetery, where, honoring Alice's own request, the Rev. Alexander Frier of St. John's read Tennyson's "Crossing the Bar."

> Sunset and evening star,
> And one clear call for me!
> And may there be no moaning of the bar,
> When I put out to sea,
>
> But such a tide as moving seems asleep,
> Too full for sound and foam,
> When that which drew from out the boundless deep
> Turns again home.
>
> Twilight and evening bell,
> And after that the dark!
> And may there be no sadness of farewell,
> When I embark;
>
> For though from out our bourne of Time and Place
> The flood may bear me far,
> I hope to see my Pilot face to face.
> When I have crossed the bar.

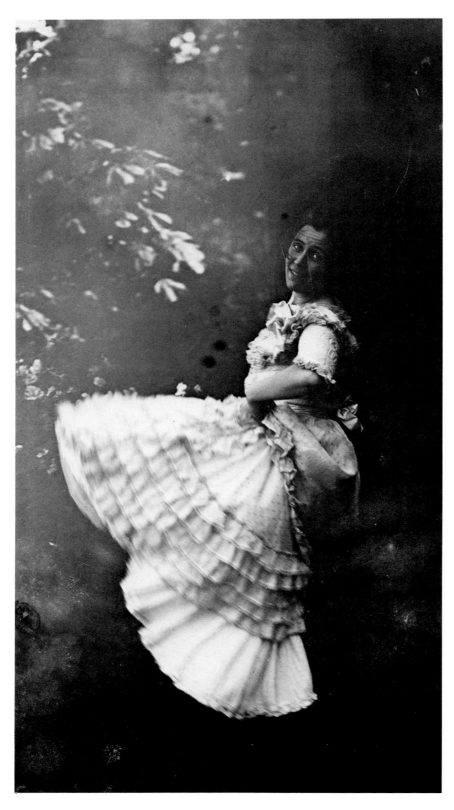

A characteristic but indistinct image of Gertrude Tate, merrily dancing on the porch at "Clear Comfort" soon after 1899.

Epilogue

Gertrude Tate lived for ten years after Alice Austen's death—at first with her sister and brother-in-law in Queens, then with Pieter Vosburgh and his family in East Orange, New Jersey, where, still full of liveliness and affection but nearly blind, she ended her days in a nursing home. After death, she received one final blow from the indifferent bureaucracy of the twentieth century: the red tape and expense of burying her next to Alice (as they both wished) proved to be too formidable for her sister Winifred to surmount. Gertrude lies in the Tate family plot in Brooklyn's Cypress Hills Cemetery, fifteen miles away.

The Staten Island house in which they had spent their lives together started to show signs of neglect as early as the 1930's and 1940's, because of their inability to spend money on its upkeep. The porch started to sag a little. The woodwork of the house began to deteriorate. The hurricane of 1944 washed away a large section of the lawn and damaged the house so badly that the Müllers' sun porch and outside staircase had to be torn down by the Mandias. No subsequent owner of "Clear Comfort" would ever care for the place as Miss Austen had done; when Oliver Jensen took her there in her wheelchair in 1951, so that Alfred Eisenstaedt could photograph her in the garden, she wept.

No bar or other restaurant ever opened there. In 1961 the property changed hands and, for some months, until tenants moved in, the house stood empty, milkweed growing tall on the littered lawn, an old comic book lying on the unmade bed left behind inside. People who cared about the historic buildings of Staten Island were concerned about the Austen house, and in September 1966 it was included in a list of fifteen structures

discussed at a hearing of the Landmarks Preservation Commission. The proposal that the old cottage should be protected, as a landmark of historic and aesthetic appeal, was vigorously opposed by its owners—the Bevex Realty Corporation of Manhattan and an investment syndicate whose aim was to raze the building. Since its site was zoned for high-density housing, they intended to sell the land to developers, who would erect a cluster of high-rise apartments in the Austen garden and on the grounds of the old Yacht Club next door, which they also owned. A "For Sale" sign was nailed up at the end of the driveway. The property was assessed at $700,000—but one newspaper account estimated it might be worth as much as $1 million in the marketplace.

Opposition formed as New Yorkers protested the threatened loss of the historic building and of one of their city's few undeveloped stretches of waterfront. In the forefront of the fight were the current tenants of the Austen house, Hugh and Elizabeth Humphreys, who joked that they would lose their home if they won or lost the fight; they preferred to lose it to an historic landmark than to an apartment complex. With Hugh as their legal counsel, the Friends of Alice Austen House formed, embarking on a struggle that was to last for more than four years. Edward Steichen, dean of American photography, consented to be honorary head, while Jensen was chairman; photographers Alfred Eisenstaedt and Berenice Abbott joined the committee, as did Grace Mayer of the Museum of Modern Art, architectural historian Margot Gayle, Regina Benedict of the American Society of Magazine Photographers, critic Jacob Deschin, and more than fifty other angry Staten Islanders and Manhattanites. Theirs was probably the first effort made in this country to preserve an historic house as a museum of the work of one photographer. They set out to raise $100,000 to restore "Clear Comfort"—which first had to be saved from the bulldozers—with the idea of setting up a permanent display of Alice Austen's pictures, changing exhibitions by other photographers, and perhaps one room furnished in the Victorian decor of Alice's youth.

Their first goal was to persuade the city to buy the four-acre site as a public park. The Friends painted an enticing picture of a waterfront esplanade for walkers and bicyclists, of summer outdoor concerts and winter sledding on the sloping lawn of the Yacht Club (which could be converted into a restaurant), and of a popular recreation area that would serve the needs of all the people who already came down Hylan Boulevard to watch the cargo ships and tankers riding at anchor, to eat picnics and to hold hands, to fish for striped bass or to pick up rocks and other treasures at the water's edge.

This dream has not yet become a reality. The Friends raised modest amounts of money and a good deal of public concern by exhibiting Alice's photographs, publishing a portfolio of them in the ASMP's magazine *Infinity*, entertaining 135 guests at a punch-and-supper garden party which Alice herself would have enjoyed, and fixing a commemorative plaque to the house in ceremonies that included the brigantine *Black Pearl* under sail in the Narrows below the garden. Step by step, they worked their way through the agencies of local, city, state and federal government—the Borough President's office, the Landmarks Preservation Commission, the City Planning Department, the Department of Parks, the City Planning Commission and the Board of Estimate, the

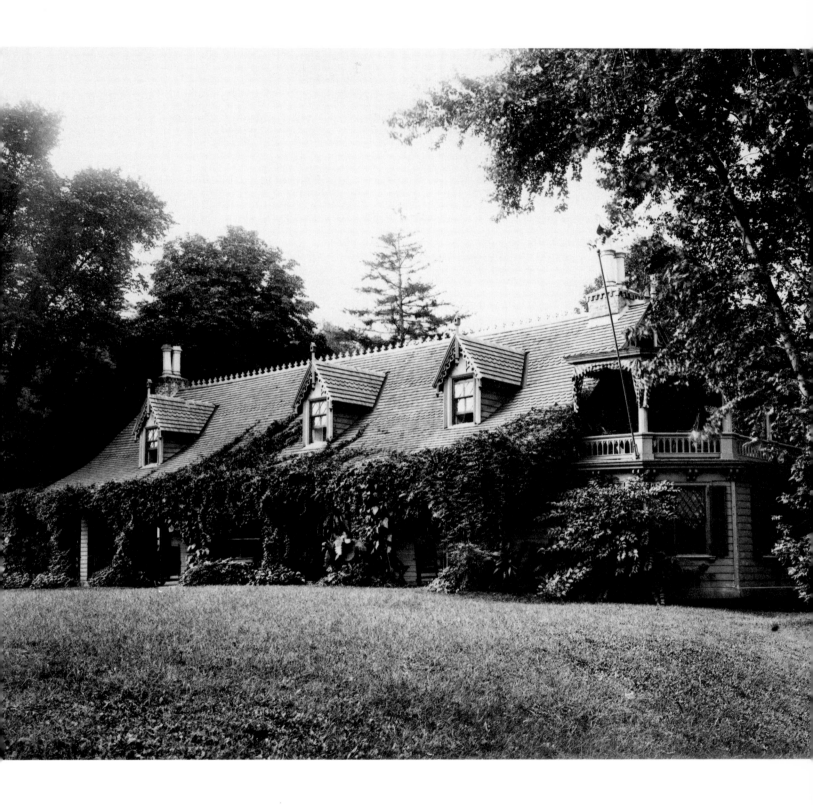

The cottage that still stands. (*Our house. Wide angle lense. Cramer Banner. Print 22 mins. in sun, fresh paper for platinotype*)

New York State Parks Commission—and even the Highway Department, which was *still* threatening to run a shorefront road across the garden. And they won. . . .

The Austen house was recognized as an historic and architectural landmark by the New York State Historic Trust, the National Park Service and the City Landmarks Preservation Commission. The U.S. Department of the Interior granted the city $367,000 in matching funds for the acquisition of the four-acre site. More help from Washington—reimbursement of half the cost of restoring the building—will come from the Department of Housing and Urban Development, when renovation begins. No work has yet been done, because the other half of the funds for the renovation so badly needed still remains to be raised.

The enemy of "Clear Comfort" now is time—whose passing will see the lovely old cottage decay into an irreparable ruin if nothing is done soon. The tenants who succeeded the Humphreys in 1968, attorney Richard Hall and his family, quickly gave up using the two small upstairs rooms once occupied by maids, because they feared the old kitchen ceiling below them was too weak to stand the slightest strain. As long as the house remained the property of developers who wished to see it disappear—and the City of New York did not legally take title to the house until 1975—there was, naturally enough, no money forthcoming for its maintenance. Because of the present financial plight of the city, there is still no money. Termites have moved in, as well as new tenants, who struggle with the problems of warped window sash and decaying foundation sills. Interior dampness is serious. The two-year-old daughter of Henry and Holly Stephenson, the current tenants, found and ate one large mushroom growing in the kitchen, and had to be rushed to a doctor who did not quite seem to grasp the manifold hazards of living in an historic monument.

As Alice Austen's name and photographic work become increasingly well known, the chances are improving for raising money to save her house from this slower form of destruction. Many Americans saw a small selection of her work for the first time in an exhibition, "Women of Photography," which traveled, in 1975 and 1976, from the San Francisco Museum of Art across the country to New York and New England.

Staten Islanders, in particular, have come to know and to be proud of Alice Austen, celebrating her new fame in rather touching gestures of affection and pride. The Staten Island Garden Club, which she founded in 1914, honored "Our Alice" with a special flower show in the parish hall of St. John's Church. The community college exhibited her photographs. And her name has been given to the Island's newest elementary school, Public School 60, which opened in December 1974. For more than a year after the opening, teachers and parents considered the problem of finding an appropriate name for the school. They agreed that they should honor a Staten Islander, but they rejected military heros, murdered police officers and many others unhappily linked with war or violent death, in favor of a person whose interesting life could serve as a model for the school's five- to ten-year-old pupils. Many young mothers in the community wanted to select a woman. The solution was elusive until, on Christmas Day 1975, a half-hour documentary film, narrated by Helen Hayes, on the life and photography of Miss E. Alice Austen was broadcast on the "51st State" program of the city's educational station,

WNET/Channel 13. The teachers and parents who watched the show were unanimous in their enthusiasm: the Community School Board passed a resolution designating P. S. 60 The Alice Austen School.

Dedication ceremonies were held on the evening of April 8, 1976—complete with songs and dances by children in Kindergarten through Fifth Grade, speeches and benedictions by the adults, and a brief pageant featuring a little girl dressed up as ten-year-old Alice Austen, clutching a cardboard "Victorian" camera. The children themselves had celebrated the naming of their school in their own way, three weeks earlier. On the morning of March 17, the 110th anniversary of Alice Austen's birth in "Woodbine Cottage," eight-hundred young voices joined in the traditional chorus and piped, "Happy birthday, dear Alice, happy birthday to you." She would have liked that.

OVERLEAF: (*View of South Shore Road. Clear fine day, sun came out. 11.30 a.m., Monday, Oct. 29th, 1888. Harvard plate, Perken lense, 1 sec short, Stop 22*)

AUTHOR'S ACKNOWLEDGEMENTS

The name of the person who introduced me to Alice Austen's work—the picture researcher who told me I might find photos of immigrants in a little-used collection on Staten Island—has slipped from my memory. But I remember with pleasure my first visit to the Island in 1969, when Michael Koledo helped me to find the photo I needed and showed me the collection then in his care at the Staten Island Historical Society. With infectious enthusiasm, he pulled from the shelves some of the 3,500 Austen glass plates that comprise the bulk of the collection, and he showed me the boxes crammed with her film negatives, her old camera, and the contact prints that were being made by volunteer photographer Herbert Van Cott. His admiration for the work of the dead photographer was catching, and I knew then that I wanted to see a book of Alice Austen's photographs in print.

My thanks are due to all the current staff members of the Staten Island Historical Society who have helped to turn this wish into a reality: director Loring McMillen answered many questions about the past, administrative assistant Raymond Fingado allowed me easy access to the collection, while curator Louis Dury, photographer Tony Lanza, secretary Georgia Jonas, assistant librarian Eunice Swift and treasurer Margaret Robinson offered help and encouragement in many ways.

Oliver Jensen's liberal help made this book possible: with extraordinary generosity, he lent me files of notes, letters and other papers he had saved for 25 years for a book he had once hoped to write himself. He gave me dozens of the photographic prints he had had made in 1951, with permission to reproduce them in these pages, and he spared time from his work as a senior executive of American Heritage to share his memories of the past, and to extend practical help of all sorts.

Members of Alice Austen's and Gertrude Tate's families offered all possible assistance. Alice Austen's first cousin, Mrs. Walter Miller Sr., spent three days giving me invaluable material from family photo albums, genealogical books and her own diaries, while her sons and daughters-in-law—Walter and Jo Miller of Mexico, N.Y., and David and Ruth Miller of Skaneateles, N.Y.—offered warm hospitality. More information about the Austens and their relations came from conversations with George Austen III and Reginald T. Townsend. Gertrude Tate's younger sister, Mrs. Ellwood Baker, offered interesting anecdotes as well as her enthusiam for this project.

Many old friends remember Miss Austen and Miss Tate as they were in their later years with affection and admiration. Alice was in the room with her friend Faith McNamee Morton when John A. Morton Jr. was born; as he grew up he came to adore Miss Austen and to spend much time in her company. His insight into her personality, the pages of notes he wrote for me, and, not the least, his natural gift as a mimic of voice and gesture, were invaluable. From Pieter C. Vosburgh in Missouri (whom I located with the kind help of Renee Tucciarone) I received a series of long letters, filled with revealing and amusing stories of the past that supplied fresh material for Chapter Six. In Manhattan, Fenton L.B. Brown added his memories of "Auntie Al and Auntie Gert," listed names of other acquaintances to contact, and identified many of the antiques Alice photographed in the rooms of "Clear Comfort." Mrs. Maurice I. Pitou offered warm hospitality on Staten Island, and, together with Mrs. Norman H. Donald, Miss Stella Orton and her brother Lee Orton, and Mr. and Mrs. Edward Howland, brought to life the social world in which Alice Austen lived. Miss Dorothy Valentine Smith supplied generous help and encouragement in person, while one of her books, *Staten Island: Gateway to New York*, provided much material for Chapter Two. Mrs.

Ernest Flagg interrupted a busy day to help identify some of the people in Alice Austen's photos of early automobile excursions.

Other people who shared their memories include Dr. and Mrs. Richard O. Cannon, who kindly sent old letters and photographs from Nashville and described the year in which they lived at "Clear Comfort." Mrs. Edward Newell recalled the tea room and the sad year of 1945. Victor Prevosti and his brother Mario, like Raymond Roy Canlon, told me about mowing the lawn and polishing Miss Austen's car, and described the appearance and manners of the two old ladies through the eyes of youngsters, as they showed me treasured souvenirs they had been given by Miss Austen as she packed to leave her home. Herbert Flamm reminisced about the photographer's visits to Weitzman's Photo Shop. Miss Adele Forsyth, Henry Rogers Winthrop's former secretary, went to the trouble of locating letters Alice had written to her former employer. Rudolph Raphael Cender Jr. supplied me with some old postcards and cancelled cheques written by Alice at the turn of the century, and with his memories of fishing on the beach below "Clear Comfort." Dorothy Doan recalled the day she interviewed Miss Austen for the "Vanity Fair" program on CBS television.

I am grateful for the assistance and encouragement of many other people, particularly Henry and Holly Stephenson, current occupants of "Clear Comfort," for their hospitality; Hugh C. Humphreys, for the research he did while he lived in the house in the 1960's and for the old letters he sent to me; Margot Gayle and Regina Benedict, for their memories and efforts as founding members of The Friends of Alice Austen House; Marian Whitley, for lending me the precious Austen family Bible; Stuart Hersh, producer of the WNET/Channel 13 documentary film on Alice's life and work, for suggesting the title of this book; Helen Mathez, for lending me her research file on Staten Island history; Angela O'Dowd, principal of the new Alice Austen School, for her encouraging enthusiasm; Pat Silvernail, whose exhibition of Alice Austen's work in the community college library led several helpful Staten Islanders to contact me; George Novotny, for his careful and professional reading of the manuscript; and Deborah Maine, who gave me a quiet place in which to write it.

Research help came from many hands. Joan St. George Saunders pursued the elusive Edward Munn in London; in Washington, George Hobart located the photographs copyrighted by Alice; Toby Wertheim tracked down old *New York Times* stories and obituaries, while Nancy Robinson used her special expertise to do research on some of the ships Alice photographed; Sara Patricia Copeland brought order to mounds of newspaper clippings and photographs. At the Staten Island Institute of Arts & Sciences, Gail Schneider and George Pratt offered insights into local history. Charles F. Cummings at the Newark Library searched for traces of Mr. Jaffe, the auctioneer, in New Jersey.

The master printer (in my eyes), Axel Grosser of Westwood, N.J., used Alice Austen's glass plates to make the new prints which appear on all too few pages of this volume. Expert technical advice about old cameras and photographic techniques was generously given by Harvey Zucker, Eaton Lothrop, Raimondo Borea and by Paul Rayner of George Eastman House.

My biggest debt is to my friend and business partner, Rosemary Eakins, who uncomplainingly allowed Alice Austen to dominate more than a year of her personal life. She spent countless days and long evenings transcribing Alice's original jacket notes (which appear in italics below the captions on the preceding pages), using her professional skill to open up new avenues of research, conducting interviews with many of the people named above, and helping me through all the exacting and exciting stages of making this book. I can never thank her enough.